THE ARTS IN EARLY AMERICAN HISTORY

Needs and Opportunities for Study

The Institute of Early American History and Culture
is sponsored jointly by the College of William and
Mary and Colonial Williamsburg, Incorporated.

NEEDS AND OPPORTUNITIES FOR STUDY SERIES

WHITFIELD J. BELL, JR.

Early American Science

WILLIAM N. FENTON

American Indian and White Relations to 1830
with a bibliography by L. H. Butterfield,
Wilcomb E. Washburn, and William N. Fenton

BERNARD BAILYN

Education in the Forming of American Society

WALTER MUIR WHITEHILL

The Arts in Early American History
with a bibliography by Wendell D. Garrett
and Jane N. Garrett

PUBLISHED FOR THE
Institute of Early American History and Culture
AT WILLIAMSBURG, VIRGINIA
BY
The University of North Carolina Press
CHAPEL HILL

THE ARTS
IN EARLY AMERICAN
HISTORY

Needs and Opportunities for Study

AN ESSAY BY WALTER MUIR WHITEHILL

A BIBLIOGRAPHY BY WENDELL D. GARRETT

AND JANE N. GARRETT

Copyright © 1965 by
The University of North Carolina Press
Library of Congress Catalogue Card Number: 65–63132
Printed by Kingsport Press, Inc.
Manufactured in the United States of America

FOREWORD

During the past dozen years the Institute of Early American History and Culture has held several conferences on needs and opportunities for study in various fields of early American history. From these has evolved the publication of Whitfield J. Bell's *Early American Science* (1955), William N. Fenton's *American Indian and White Relations to 1830* (1957), and Bernard Bailyn's *Education in the Forming of American Society* (1960). A similar conference on the arts was held at the Conference Center at Williamsburg on March 7, 1964, under the joint sponsorship of the Institute, Colonial Williamsburg, Incorporated, the Archives of American Art, and the Henry Francis du Pont Winterthur Museum.

In preparation for it, I drafted an essay and Mr. and Mrs. Wendell D. Garrett a bibliography, designed to induce discussion, that were circulated in advance among the participants. Edgar P. Richardson, Director of the Henry Francis du Pont Winterthur Museum, was invited to comment upon them from the point of view of the practicing art historian, and Whitfield J. Bell, Jr., Associate Librarian of the American Philosophical Society, to perform the same function as a social and cultural historian. Wilcomb E. Washburn, Curator of Political History at the Smithsonian Institution, who with Lester J. Cappon, Charles F. Montgomery, and me had been involved in the earliest planning of the conference, was asked to sum up the discussion. John A. Munroe of the University of Delaware, Clifford K. Shipton of the American Antiquarian Society, Frederick B. Tolles of Swarthmore College, and Lawrence W. Towner of the Newberry Library

were invited to take part in the discussion as writers of general colonial history; Abbott Lowell Cummings of the Society for the Preservation of New England Antiquities, Frederick D. Nichols of the University of Virginia, and Alan Gowans of the University of Delaware as architectural historians; Andrew Oliver of New York City, Jules D. Prown of Yale University, and Charles Coleman Sellers of Dickinson College as scholars particularly concerned with painting and portraiture; Howard C. Rice, Jr., of the Princeton University Library as an historical editor who has often invoked the testimony of the arts; and Marvin D. Schwartz of the Brooklyn Museum as an art museum curator whose researches have led him into history. In addition some thirty officers and staff members of the sponsoring institutions participated in the conference. These from outside Williamsburg who attended included William E. Woolfenden and Garnett McCoy from the Archives of American Art; E. McClung Fleming, Charles F. Hummel, Jr., Milo M. Naeve, Frank H. Sommer, III, John A. H. Sweeney from Winterthur; and Stanley W. Abbott of the National Park Service.

The discussion, both in the morning and afternoon, was lively and fruitful. In the draft of my essay I expressed some doubt that the early American arts, because of their provincial and derivative nature, could successfully compete with their European prototypes as subjects for study by any great number of art historians. Edgar P. Richardson, in pointing out what can be learned from a colonial or frontier scene when the arts are viewed not as an end in themselves but as an element in human society, convincingly dispelled that doubt. This approach, quite unlike the art history of my youth, cleared the way for hopeful collaboration among social, cultural, and art historians. Ivor Noël Hume and Frank H. Sommer, III, rightly called attention to the role of archaeology which had been insufficiently emphasized in my draft.

In general, the comments on essay and bibliography, which came from nearly everyone present, were in amplification rather than contradiction of the drafts submitted. It was generally felt that, although the Institute normally concentrates its activities upon the British Empire, the colonies which became the United States of America, and the new nation down to approximately the

year 1815, the bibliography should take broader account of the French and Spanish colonial traditions in the arts, and extend at least to 1826. Numerous suggestions offered at the conference and since made specific by correspondence have been incorporated in the bibliography by Mr. and Mrs. Garrett.

The essay, in the light of discussion at the conference, subsequent correspondence with participants, and conversations with Edgar P. Richardson, Alan Gowans, Wilcomb E. Washburn, and Lester J. Cappon, has been extensively revised and enlarged. Rather than reporting ideas and suggestions verbatim, in the manner of the *Congressional Record*, I have incorporated them where they seemed naturally to belong, sometimes in the form of quotation, and in others without specific acknowledgment. Consequently I here offer collective thanks to all participants who enriched the conference by their comments, and to the sponsoring institutions for having brought so congenial a company together in such hospitable surroundings.

<div align="right">Walter Muir Whitehill</div>

Boston Athenaeum
20 April 1964

CONTENTS

Foreword vii

AN UNEXPLOITED HISTORICAL RESOURCE
by Walter Muir Whitehill 3

A BIBLIOGRAPHY OF THE ARTS IN EARLY AMERICAN HISTORY
by Wendell D. Garrett and Jane N. Garrett 35

I. WRITINGS ON THE ARTS IN EARLY AMERICA, *1876–1964* 35
Scope and Intent of the Bibliography 41

II. GENERAL WORKS 42

III. ARCHITECTURE
A. General Works 47
B. Architects 50
 1. WILLIAM BUCKLAND
 2. CHARLES BULFINCH
 3. HENRY CANER
 4. MAXIMILIAN GODEFROY
 5. PETER HARRISON
 6. THOMAS JEFFERSON
 7. BENJAMIN HENRY LATROBE
 8. SAMUEL MCINTIRE
 9. ROBERT MILLS

10. WILLIAM SPRATS
11. WILLIAM STRICKLAND

C. French Canada and Maritime Provinces 55

D. New England 58
 1. GENERAL WORKS
 2. MAINE AND NEW HAMPSHIRE
 3. VERMONT
 4. MASSACHUSETTS
 5. RHODE ISLAND
 6. CONNECTICUT

E. Middle States 63
 1. NEW YORK
 2. NEW JERSEY
 3. PENNSYLVANIA
 4. DELAWARE
 5. MARYLAND
 6. WASHINGTON, D.C.

F. Southern States 68
 1. GENERAL WORKS
 2. VIRGINIA
 3. NORTH CAROLINA
 4. SOUTH CAROLINA
 5. GEORGIA
 6. FLORIDA
 7. KENTUCKY

G. Old Northwest 74

H. Spanish Southwest 75

IV. TOPOGRAPHY 78

V. PAINTING
 A. General Works 81
 B. Painters 87
 1. WASHINGTON ALLSTON
 2. EZRA AMES
 3. JOSEPH BADGER

4. JOSEPH BLACKBURN
5. JOHN COLES
6. JOHN SINGLETON COPLEY
7. ANSON DICKINSON
8. PIERRE EUGÈNE DU SIMITIÈRE
9. RALPH EARL
10. ROBERT FEKE
11. JOHN GREENWOOD
12. JOHN VALENTINE HAIDT
13. JOHN WESLEY JARVIS
14. RICHARD JENNYS
15. CHARLES BIRD KING
16. EDWARD GREENE MALBONE
17. REUBEN MOULTHROP
18. CHARLES WILLSON PEALE
19. TITIAN PEALE
20. MATTHEW PRATT
21. CHRISTIAN REMICK
22. C. B. J. FEVRET DE ST. MÉMIN
23. SHARPLES FAMILY
24. JOHN SMIBERT
25. GILBERT STUART
26. THOMAS SULLY
27. JEREMIAH THEUS
28. JOHN TRUMBULL
29. BENJAMIN WEST
30. JOHN WHITE

C. Portraits by Subjects 97
1. ADAMS FAMILY
2. BENJAMIN FRANKLIN
3. ALEXANDER HAMILTON
4. PATRICK HENRY
5. THOMAS JEFFERSON
6. JEFFERSON FAMILY
7. JAMES MADISON
8. INCREASE MATHER
9. OLIVER FAMILY

10. PITTS FAMILY
11. SALTONSTALL FAMILY
12. GEORGE WASHINGTON

D. Catalogues of Portrait Collections 100
 1. AMERICAN ANTIQUARIAN SOCIETY
 2. AMERICAN PHILOSOPHICAL SOCIETY
 3. ESSEX INSTITUTE
 4. MUSEUM OF FINE ARTS, BOSTON
 5. VIRGINIA HISTORICAL SOCIETY
 6. HARVARD UNIVERSITY
 7. HISTORICAL SOCIETY OF PENNSYLVANIA
 8. NEW-YORK HISTORICAL SOCIETY
 9. PEABODY MUSEUM, SALEM
 10. PRINCETON UNIVERSITY
 11. VALENTINE MUSEUM, RICHMOND
 12. YALE UNIVERSITY

VI. SCULPTURE AND CARVING 102

VII. GRAPHIC ARTS

A. Engraving 103
B. Caricature 108
C. Printing 108
D. Bookbinding 114

VIII. MEDALS, SEALS, AND HERALDIC
 DEVICES 114

IX. CRAFTS 116

X. FURNITURE

A. General Works 119
B. Cabinetmakers 122
 1. DUNCAN PHYFE
 2. SAMUEL MCINTIRE
 3. JOHN AND THOMAS SEYMOUR
C. Regional Studies 123

XI. SILVER

 A. General Works 127

 B. Silversmiths 129

 1. ABEL BUELL
 2. JOHN CONEY
 3. JEREMIAH DUMMER
 4. JOHN HULL
 5. JACOB HURD
 6. MYER MYERS
 7. PAUL REVERE

 C. Regional Studies 130

XII. PEWTER 133

XIII. OTHER METALS AND WOODEN WARE 133

XIV. POTTERY 135

XV. GLASS 136

XVI. LIGHTING DEVICES 137

XVII. WALL DECORATION 138

XVIII. FOLK ART 138

XIX. TEXTILES 140

XX. SERIAL PUBLICATIONS 143

Index 153

THE ARTS IN EARLY AMERICAN HISTORY

Needs and Opportunities for Study

AN UNEXPLOITED
HISTORICAL RESOURCE

Walter Muir Whitehill

FORTY YEARS AGO when I was a Harvard undergraduate the history of art seemed to fall into a neat pattern, according to which towering peaks of achievement rose at irregular but quite-well-agreed-upon points in time and space above valleys that were mostly obscured in mist. Egypt and Mesopotamia were the precursors of the glory of Greece. Between imperial Rome and Gothic France some not very thoroughly mapped highlands of early Christian, Byzantine, and Romanesque were known to exist. In the Renaissance, Italy towered above all neighbors, as France did in the centuries that followed. In various periods of time, minor peaks in England, Spain, and Germany were visible above the mist, but the superior altitude of classical Greece, Renaissance Italy, Gothic and post-Renaissance France, seemed to be recognized beyond dispute. Ireland, Portugal, Scandinavia, Russia, central Europe, hardly entered into anyone's calculations, while the United States, if considered at all, was regarded as a kind of mirage from the European foothills. Although the Orient had its unquestioned peaks, they were too far beyond the horizon to form a part of the same prospect.

Aesthetic and qualitative considerations were all important. If

3

great works of art did not spring, completely formed, from the forehead of Zeus, then Divine Wisdom must have played some part in inspiring their creators. Thus one tended to look at works of art for themselves, in a vacuum, with little consideration of the social, political, or technological elements that contributed to their creation. Bernard Berenson doubtless had his tongue slightly in his cheek when, in apology for reprinting an earlier essay, he wrote in the preface to the first series (1901) of *The Study and Criticism of Italian Art:*

I see now how fruitless an interest is the history of art, and how worthless an undertaking is that of determining who painted, or carved, or built whatsoever it be. I see now how valueless all such matters are in the life of the spirit. But as, at the same time, I see more clearly than ever that without connoisseurship a history of art is impossible, and as my readers presumably are to be students of this history, many of them in the aspiring state of mind that I then was in, I feel a certain justification in laying before them this juvenile essay.

Nevertheless, Berenson's attitude had its effect upon aspiring students later.

On graduation from Harvard I decided to make the history of art my career. It never once crossed my mind that what was near at hand in New England offered a suitable field of investigation. I went instead to Spain and spent the greater part of nine years studying eleventh-century architecture and Visigothic manuscripts. Returning home in 1936 because of the impending Spanish Civil War, I looked at my native New England with fresh eyes and for the first time found it absorbing. Thus although I spent a dozen years, including all my formal graduate work, in the history of art, the past twenty-eight years have been devoted to American history of quite a different sort.

During my Spanish years I wrote occasionally on Romanesque subjects for the *Art Bulletin*, published since 1913 by the College Art Association, which is the professional organization of historians of art on university faculties. As I remembered almost no studies on early American subjects in this quarterly, I recently leafed through its forty-five volumes, and found my recollection correct. The first contribution that in any way bears on the early

American arts is Alfred Mansfield Brooks's "Drawings by Benjamin West," which appeared in volume VIII (September 1925, 25–32). Nine years later Jean Lambert Brockway did a study of "Trumbull's Sortie" for volume XVI (March 1934, 5–13). The first architectural note in this field is Roger Hale Newton's "Bulfinch's Design for the Library of Congress" (XXIII, September 1941, 221–22). The only others are Clay Lancaster's "Oriental Forms in American Architecture, 1800–1870" (XXIX, September 1947, 183–93) and Paul F. Norton's "Latrobe and Old West at Dickinson College," (XXXIII, June 1951, 125–32). Theodore Sizer contributed three parts of "A Tentative 'Short-Title' Check-List of the Works of Col. John Trumbull" (XXX, September and December 1948, 214–23, 260–69; XXXI, March 1949, 21–37) and "Col. John Trumbull's Works, a Final Report" (XXXVIII, June 1956, 113–17). Robert Feke stirred up an interchange between James Thomas Flexner (XXVIII, September 1946, 197–202; XXX, March 1948, 78–79), W. Phoenix Belknap (XXIX, September 1947, 201–7; XXXV, September 1953, 225–26), and Barbara N. Parker (XXXIII, September 1951, 192–94), while Samuel Jennings's painting "Liberty displaying the Arts and Sciences" was described by Robert C. Smith (XXXI, December 1949, 323–26).

As that is all that the *Art Bulletin* has ever published on early American arts and crafts in the course of forty-five volumes, it is easy to see why so large a proportion of the titles in the bibliography are by architects, antiquarians, collectors, librarians, and museum curators. The field has been seriously neglected by the academic art historians, even though historians of art have greatly extended their horizons since I was an undergraduate. They have pushed on through the baroque period and the nineteenth century to the present day. They now consider primitive art, the first millenium of our era, the Orient, and even America. But the art historians who still think in terms of comparative quality of artistic production or who confine their interests to new periods of style are bound to find America a less attractive field for study than Europe or Asia. Anyone who defines architecture in terms of the Parthenon, Chartres, and St. Peter's, and seeks monuments of this kind in America, is doomed to frustration and

disappointment. Although George Sandys translated Ovid's *Metamorphoses* at Jamestown, one is as unlikely to find Inigo Jones building banqueting halls there as in Pilgrim Plymouth or Puritan Boston, or to discover Rembrandt painting portraits in New Amsterdam.

However, works of art can, and should, be studied not only as the achievements of gifted individuals, but as the creations of members of a particular society, whose requirements the artists have had to meet. What was built, painted, carved, or made in British, French, or Spanish North America and in the United States prior to 1826 was normally a reflection or adaptation of something that was also done in Europe. Yet when the early American arts are viewed as elements in the society that created them, they become of major importance. The work of a seventeenth-century Boston painter, considered as part of the life of colonial New England, may prove a more stimulating field for study than the altarpieces of an obscure follower of Giotto. To discover what works of art were here, what prints and design books were imported and offered for sale, what artistic ideas crossed the ocean, and what the American craftsman did with them, may prove extremely rewarding. The Monticello of 1782 that caused the Marquis de Chastellux to say "that Mr. Jefferson is the first American who has consulted the Fine Arts to know how he should shelter himself from the weather" was the work of a man who had seen only the buildings of his native Virginia and had "consulted the Fine Arts" only through the pages of Leoni's edition of Palladio and the English architectural books of James Gibbs and Robert Morris. Later, when Thomas Jefferson had lived abroad and had seen European architecture as it stood in masonry, his tastes changed. He then created his own Maison Carrée in Richmond, his Pantheon as the heart of the University of Virginia, and rebuilt his English-Palladian Monticello in a style inspired by Louis XVI interpretations of Roman classicism.

Such reflections and adaptations have always been part of the fabric of Western civilization. It is worth underscoring this fact because of an illusion common today that only the new and the untried can be considered creative. A frenzied search for new forms, however ill-adapted to their function, for new materials,

for new techniques; a passion "either to tell or to hear some new thing" has become as general in the United States today as it was among St. Paul's audience on the Areopagus. Thus in contemporary criticism the roles of novelty and creativity often become confused, even when they are not absolutely equated. As any study of the early American arts must squarely face questions of reflection and adaptation, the following comment by Edgar P. Richardson will be helpful in clearing the air:

When Lord Burlington, for instance, built his villa at Chiswick in the seventeen twenties, he did nothing that could be called in the slightest degree original according to current definitions of originality. His design was borrowed outright from Palladio, chiefly from the Villa Rotonda, but with a few elements taken from other buildings by Palladio, some taken from Scamozzi, some from ancient Roman structures—a work totally destitute of novelty, creativity, or invention. Yet it introduced a fresh impetus of such power into England that it resulted in hundreds of buildings in England and in English colonies throughout the world which delight the eye and give all evidences of architectural excellence except, perhaps, novelty, and functionalism in the twentieth-century sense.

Civilization has often been likened to a seamless fabric; but a fabric has both warp threads and weft threads, continuity and change. Our criteria of judgment are based entirely upon the weft threads that introduce new bands of color into the fabric—new periods of style, new personal traits, new materials, new inventions—to the exclusion of the warp threads which give continuity and perhaps for thousands of years have persisted as inspirations and fructifying forces. What are these forces? It is what I call the frontier fallacy to feel that only the frontiersman is an American and only the elements in our civilization bearing no relation to Europe are really American.

The expansion of the arts from Italy to England, from England to the Americas (or from France to Canada, Spain to Latin America) in the sixteenth, seventeenth, and eighteenth centuries, with slight and often most interesting changes, cannot be properly understood in terms of regret that there is a connection. Charles L. Sanford, in his *Quest for America 1810–1824*, in the "Documents in American Civilization Series," has a bad case of the frontier fallacy, when he says regretfully that perhaps the whole Greek Revival movement in our architecture was a "mistake."

A "mistake" in whose terms? Those who built and lived in the buildings, or those who subsequently attempt to fit human experience to a Procrustean theory of stylistic evolution?

The "frontier fallacy," joining hands with the budding chauvinism of American studies programs, creates the danger of isolating the early American arts, which should be studied in terms of their European roots and of their relationship to the West Indies and the Maritime Provinces. While historians have for some decades been writing in terms of an Atlantic culture, students of the arts have not as yet generally followed suit. Professor Alan Gowans observes that while the European scholar in art history

relates his immediate subject—no matter how local—to the whole history of Western civilization as a matter of course, the typical scholar in the American field is still narrowly concerned with "Americanism." "Americanism" will never be understood until it is studied as an equal matter of course within a context of the whole history of Western civilization. The New World was not populated by Adams and Eves, but by Western Europeans, who brought their traditions with them to create not a new kind of art, but a distinctive national variant of the historical arts of the West.

Narrowly viewed, the early American arts would furnish—in W. S. Gilbert's phrase from Act II of *The Mikado*—"merely corroborative detail, intended to give artistic verisimilitude to an otherwise bald and unconvincing narrative." When more broadly considered, as elements in the society of their time, they offer a rewarding field to the art historian. During the conference Dr. Richardson pointed out how in early America one can watch, as in a laboratory experiment, the slow reconstruction on this side of the Atlantic of the social structure of the arts, as evidenced in the training of the artist, the development of sources of his tools and materials, the migration of works of art across the ocean to serve as his models. W. P. Belknap's linking of English mezzotints and American eighteenth-century portraits is a case in point. In America too one can see the evolution of the institutions of art, the academies, art schools, museums, dealers, collectors, and patrons. As society evolves and merchants prosper, certain arts naturally follow suit. The high quality of eighteenth-century Philadelphia

cabinetmaking is not surprising when one remembers Carl Bridenbaugh's remark that "on the eve of the American Revolution, Philadelphia with its forty thousand inhabitants was larger than any city in England except London itself and had taken its place not only with the largest provincial cities of the British Empire but with those of western Europe." It is less easy to place in context the rarer survivals of the American seventeenth century. Because so few buildings of the period are still intact, those that remain are sometimes mistakenly thought to be uniquely American products, rather than examples of the evolutionary process normal to a society rooted in Europe. In such instances only the scholar with a wide acquaintance with European origins can put matters in perspective.

Professor John Coolidge's article "Hingham Builds a Meetinghouse," in the December 1961 issue of the *New England Quarterly*, sets forth in admirable details the circumstances that led to the building of the Old Ship Church in Hingham, Massachusetts, in 1681. On the basis of a wide knowledge of architectural history, he makes this appraisal in his conclusion:

> The Old Ship Church is neither individual nor original. Almost nothing about it reflects the local peculiarities of Hingham. In New England alone there must have been a score of virtually identical structures. Almost nothing about the edifice is demonstrably American. The form was traditional. In Europe there were once dozens of similar buildings.
>
> We know little about the source of the form. Its roots lay in eastern France or western Switzerland; probably it was perfected by the Huguenots. Whether the American colonists learned of it directly, or through Dutch or English examples is not yet known. What this meetinghouse reveals is how faithfully New Englanders reproduced a known international type of building for dissenting Protestants.

The eastern French or western Swiss buildings that Professor Coolidge suggests as the source of the New England meetinghouse would be of little moment in the general sweep of French architecture. Neither would the timber houses in southeast England that Martin S. Briggs described in *The Homes of the Pilgrim Fathers in England and America* loom very large in the broad picture of English post-Renaissance architecture, yet they

help mightily to explain what Englishmen built in the Massachusetts Bay in the seventeenth century. Professor Gowans is, in fact, about to devote his sabbatical leave to an investigation of some of the lower- and lower-middle-class buildings of England and Scotland that are rarely photographed and published but are precisely the kind that influenced the formation of American traditions. The contributions of Scotland to the fabric of American culture have hardly been explored, yet, as he rightly observes:

We know that there was a great and continuous immigration to this country from Scotland, particularly after the act of Union in 1701. In eighteenth-century Williamsburg it is estimated that two thirds of the population was Scottish in origin. You need only look at the place-names of Tidewater Virginia (Kilmarnock, Montross, etc.) to realize that there was a high percentage of Scots everywhere. One of the great creations of eighteenth-century American architecture was the cruciform Anglican church-type of Virginia, exemplified in some forty-odd examples—some known from documents, others extant, and especially the magnificent Christ Church (Carter's) in Lancaster County. Yet this was a rare if not non-existent type in eighteenth-century England. On the other hand, Ian Hay's study of *Post-Reformation Scottish Architecture* (London, 1959) shows that the type was common in Scotland.

Professor Gowans has already studied Scottish architectural influence in Nova Scotia, and has reason to believe that "much of what we call Pennsylvania German building was actually Scottish in origin."

Investigations of such subjects by historians of art can help to determine the true proportion of spontaneity and adaptation in the early American arts. They will, as Dr. Richardson pointed out, increase our understanding of what occurred in North America when the social structure of the mother country, on which the arts rest as organized skills, was left behind, becoming only a memory. In this area lies a great opportunity for study.

From the generation of George Ticknor onward, young Americans have gone to Europe for extended periods of study in preparation for academic careers. In the early nineteenth century, the meager resources of American colleges and libraries made this

essential. As it is unquestionably pleasant, many continue the practice today although the necessity has largely passed. There is much to be said for young scholars cutting their teeth at home upon familiar material that is readily at hand, and only venturing abroad when they know more precisely what they are trying to find, and how to find it. When I first went to Spain in 1927 I was singularly ill prepared by formal instruction at Harvard to make any sense out of an unfamiliar scene beyond enjoying its beauty. I was sent off to study eleventh-century Romanesque architecture with a knowledge of where the principal monuments were, what they looked like in photographs, and precious little else. The linguistic, palaeographical, and archival techniques that I badly needed I had to pick up along the way through the kindness of friendly classical scholars, archaeologists, musicologists, librarians, archivists, and Benedictine monks. Fortunately I stayed long enough in Spain to absorb a useful amount of its geography and history. Had I not spent the greater part of nine years there, my acquaintance with the country would have been too superficial to have served any useful purpose. There is no substitute, for long years of familiarity with the topography, buildings, people, documents, and artifacts of an area. An archivist, librarian, curator, or architect who is genuinely fired with affection for his region develops a nose for unearthing evidence and a skill in recognizing its significance that is generally denied the wandering scholar who travels rapidly, ordering microfilm for use on his return home. The deeds, wills, and inventories of probate records reluctantly yield their secrets concerning the arts and crafts only to those who can repeatedly return to them. Hence there is merit in the young scholar, whether pursuing social or art history, choosing a subject that can be adequately developed among materials that are within easy reach. A wider acceptance of this principle would lead art historians to increased investigation of the American arts as part of American life.

There are, of course, many studies that would be highly useful to the social or economic historian, or to the historical editor, that will never attract historians of art, and that will be carried out, if at all, by local antiquarians and by devoted amateurs. The general historian can find grist for his mill in all kinds of information,

good, bad, and indifferent, so far as taste is concerned. He may need to know something about the personal tastes of Warren Gamaliel Harding, even though they would universally be considered less cultivated than those of John F. Kennedy. It may be quite as important for him to know that one set of circumstances produced ostentatiously vulgar buildings as that another led to the subtleties of the Pierpont Morgan Library. A daub by an itinerant limner may give him the only clue to the features of his subject; a rough sketch may equally furnish the only evidence for the appearance of a destroyed building. Thus he seizes happily upon evidence that might not in any way attract the historian of art, who is concerned chiefly with excellence and quality.

The historical editor—of, let us say, the Adams Papers, or any similar project—is in constant need of portraits, of views of buildings and places. He needs precise identifying material about craftsmen and artists of all kinds, from pottery makers through portrait painters, including printers and booksellers. He often needs to know about craftsmen, and objects, that are, in Lyman Butterfield's phrase, "below the level of historical scrutiny."

Much of what we know about the appearance of American sailing vessels, for example, comes from portraits in water color or oil, painted in European, Mediterranean, or Chinese ports by craftsmen who were on hand to turn an honest penny when a foreign vessel arrived. Even the best of these ship portraitists— and some of them handled the medium of water color with great skill—would not in their day have been numbered with artists; they were rather considered to be relatives of the hydrographer, chart maker, or ship chandler. The Roux family, who for several generations did admirable water colors of American vessels at Marseilles, do not appear in works on French painting. M. V. Brewington, Assistant Director of the Peabody Museum of Salem, has for some years been engaged in compiling a biographical dictionary of such craftsmen. Even though in some instances he can unearth nothing beyond the signatures and dates on paintings, he has, through wide examination of public and private collections here and abroad, amassed a considerable body of information that will, when published, have great reference value. Similarly his *Shipcarvers of North America*, which appeared in

1962, and his *The Peabody Museum Collection of Navigating Instruments with Notes on Their Makers*, published in 1963, bring together for the first time in usable form, information about certain maritime craftsmen. An illustrated catalogue of the sixteen hundred ship portraits in the Peabody Museum is in active preparation. Such works are a boon to historical editors.

Just as ship portraitists were allied to ship chandlers in European ports, so some American craftsmen had other means of livelihood. The Townsends and Goddards combined cabinetmaking and farming. An eighteenth-century cabinetmaker, regarding wood as his medium, might make a coffin or hang a door quite as readily as he would undertake a highboy, for in a simple society it often took considerable versatility to piece out a living. Traces of this still survive in northern New England, where one sees outside farm houses signs stating that saws are filed or pianos tuned by the occupant. Ideally, studies of craftsmen should go beyond names, dates, and places to include whatever can be recovered of their products and of the milieu in which they worked. Here the social and economic historian should be recruited as an ally, if possible. Such periodicals as *Old-Time New England* and *Antiques* have, over the years, published a mass of information on various subjects that could profitably be pulled together to determine chronological and regional dimensions.

A lot of fine nonsense used to be written about the anonymity of medieval craftsmen subordinating themselves to the glory of God, until scholars like Wyatt Papworth, W. R. Lethaby, and John Harvey began digging in records and uncovered the identities of a good number of English Gothic masons, carpenters, painters, and the like. There is still plenty to be done in this direction concerning American artists and craftsmen before 1826.

Although mere lists of craftsmen, like reproductions of silversmiths' marks, have unquestioned usefulness for collectors and dealers, they furnish little nourishment to the historian. Ideally he wants as much biographical information as can be unearthed about the craftsmen, where they came from, how they were trained, for whom they worked, what position they held in the community. Until such spade work is accomplished by local curators and antiquarians, it is difficult for the historian to reach

general conclusions. Lawrence W. Towner's studies of apprenticeship in the eighteenth century would, for example, be greatly facilitated by the uncovering of more specific information about the life and works of craftsmen in many fields.

The museum curator in a regional institution who figures out what he can about the objects in his care and publishes his findings, is a stalwart ally of the historian. The record of Charleston, South Carolina, is a fine example. E. Milby Burton, in odd moments snatched from his duties as energetic director of the Charleston Museum, has published highly useful studies of local furniture and silver. The Carolina Art Association has sponsored *This is Charleston*, one of the best architectural surveys yet achieved of an American city, and has published Beatrice St. Julien Ravenel's *Architects of Charleston* and Samuel Gaillard Stoney's *Plantations of the Carolina Low Country*, which records in photograph and architectural drawing the coastal country houses of the region.

Few of the great manuscript collections in historical societies and university libraries are so organized as to permit the rapid discovery of evidence concerning the arts. Over the past hundred and seventy-three years American historical societies, in recognition of their responsibility not only to acquire and preserve sources but to make them available to those who need them, have edited and published hundreds of volumes of the documents in their possession. Museums concerned with the American past have an equally compelling responsibility to make their objects widely available through publication. This cannot be too strongly emphasized at a time when the thoughts of many American museum directors are more concerned with the exhibition and popularization of the objects in their institutions than with research and publication. The program of the 59th annual meeting of the American Association of Museums, held at St. Louis in May 1964, is symptomatic. Sessions dealt with such topics as "Museum publications for the general public," "Problems in establishing and developing a museum sales desk," "Packing and shipping agents," "Who, what, where, when, why and how in museum design," "Achieving higher standards in the exhibit field for children's museums," "How to succeed in the planetarium," and "The public in public relations." The history museums sec-

tion chose as its topic "Dismantling and moving historical buildings"; the science museums discussed "the non-curatorial staff" of their institutions. Almost lost in this midway of "how to do it" attractions was a panel on "the academic responsibilities of the fine arts museum" and a special and industrial museums section addressing itself to the theme "Who performs the curatorial role?"

The question is pertinent, for the curatorial role, except in the largest institutions, is at present in grave danger of getting lost in the shuffle. And without curators as competent in their fields as members of university faculties, with adequate time for research and suitable opportunity for publication, museums would soon revert to the "cabinets of curiosities," the *Wunder* and *Schatzkammern* from which they have painfully evolved.

In the banquet address at the same meeting of the association, S. Dillon Ripley, Secretary of the Smithsonian Institution, considered the question "What is wrong with museums?" and suggested:

Part of the trouble is that the word museum is a sort of barrier guarding the way to real understanding. The exterior, the facade does a selling job, showing its wares, its exhibits to public, to school children, to adult extension classes. This selling job is often excellent, even hucksterish at times, but therein lies the rub. The inner job, the research and higher education processes tend to be lost sight of. These inner tasks conducted behind the facade tend to be denigrated in the minds of educators, university administrators, foundation executives and others concerned with higher learning who see the museum merely as a sort of public show. If they know that scholarship exists behind the facade they tend to think of it as old-fashioned, whatever that means? I lay the cause of these feelings of university and foundation administrators at the feet of fashion and trends in scholarship. Too often these executives tend to flock together, following some fashionable bellwether of their own. Conformity is safer, and perhaps will guarantee finding a fiscal feed trough at the end of the pasture. It is therefore up to us museum people to be positive about our research programs, to support them in every way and to seek aid for them.

Publication is the logical sequel to a good research program. A museum may meet its responsibility to publish the objects in its possession on several levels and for different audiences. The

British Museum long ago set an admirable standard for definitive catalogues of collections, designed for the specialist, and simultaneously produced inexpensive but equally authoritative handbooks aimed at a wider audience. In museum catalogues, as in inventories of historical monuments, Great Britain is at least a generation in advance of the United States. The publications of the American School of Classical Studies at Athens relating to the Athenian Agora provide, however, a wholly admirable present-day American model. *Hesperia*, the journal of the School since 1932, contains annual reports on the progress of the excavations and many thoroughly documented special studies. A series of quarto monographs, entitled *The Athenian Agora*, at prices ranging from $7.50 to $17.50 per volume, describe systematically the portrait sculpture, coins, pottery, lamps, inscriptions, and the like, found during the excavations. Then comes a series of 32-page offset Picture Books, skillfully written by the same scholars and admirably printed by the Meriden Gravure Company, that, for fifty cents each, make hundreds of objects readily available to a wide audience. This is a pattern to emulate.

The definitive catalogue is always the ideal. Its preparation is invariably slow, for a missing fact concerning one object may retard the publication of what is known about hundreds of others. With perfection as the standard, curators frequently come to resemble General McClellan. When the last mule is shod, there is still the problem of finding the money for publication. Finally when such a catalogue appears, it is expensive enough to be beyond the reach of many scholars and most students. Hence the picture book has immense merit as the precursor of, or companion to, the definitive catalogue. Like the American School of Classical Studies, many institutions—the Museum of Fine Arts in Boston, the Massachusetts Historical Society, Old Sturbridge Village, Winterthur, and others—have embraced the Meriden Gravure Company picture-book formula as a means of presenting inexpensively, and sometimes even profitably, good reproductions of objects in their collections.

In speaking of picture books as an interim means of disseminating knowledge of museum objects, I wish there to be no confusion with albums designed to be filled with ready-glued

minature color reproductions of famous paintings, or similar widely advertised attempts to attract a public conceived of as less than literate. I refer only to carefully selected series of good offset reproductions, thoughtfully prepared for the general public conceived of as literate, that may very often prove valuable to the specialist. The Excavations of the Athenian Agora series are models of this type. So, in American terms, are Abbott Lowell Cummings's *Architecture in Early New England*, published by Old Sturbridge Village, and Frederick D. Nichols's *Thomas Jefferson's Architectural Drawings*, issued by the Massachusetts Historical Society. Mrs. Fales's *American Silver in the Henry Francis du Pont Winterthur Museum*, although issued as an offset picture book, not only illustrates virtually every form and most of the pieces of American silver in the Winterthur collection, but brings together for convenient comparison objects that are normally scattered through widely separated rooms.

Mrs. Fales's book suggests the singular utility of picture books describing types of objects, or organized around themes, in museums where period room installations prevail. As a frequent haunter of Winterthur over a decade I was aware of the remarkable American prints that contributed to the decoration of several dozen rooms, yet when I happened by in October 1962 and saw them temporarily cheek-by-jowl in the Rotunda to commemorate a visit of the Walpole Society, I became even more conscious of the remarkable richness of the Winterthur print collection. The recent reprint, *Prints Pertaining to America*, from *The Walpole Society Note Book* for 1962, contains 121 entries but only 16 of them are illustrated, and there would still be merit in having two or three picture books of the Winterthur American prints. Similarly students of the decorative arts would welcome a series of picture books that would reproduce, by types, the remarkable examples of cabinetmaking, silver, glass, textiles, and prints that adorn period rooms in exhibition buildings at Colonial Williamsburg. The Palace and the Capitol are necessarily geared for the accommodation of thousands of visitors. In normal seasons one braves the crowds in them for a regulated progress that permits little beyond a general impression of a handsome building, richly furnished. But in the winter, during the Antiques

Forum, when the ropes are down and the costumed attendants silent, one can study at leisure the furniture, the textiles, the silver, the porcelains that in full-blown tourist months simply contribute to the setting. A useful record of these collections is fortunately in active preparation. In continuation of the publication program inaugurated with Marcus Whiffen's first two volumes of the *Williamsburg Architectural Studies*, work is well advanced on definitive catalogues of the silver and rug collections, which will be followed by picture books on the same themes. The promise of forthcoming publication of a number of the detailed research studies by members of the Colonial Williamsburg staff is equally welcome to historians.

The greatest need in the field of this conference is for every institution possessing pertinent objects to publish promptly as many carefully prepared and liberally illustrated catalogues or picture books, or both, as their time and resources permit. These are, for the student of early American arts and crafts, what the great documentary series, like the Franklin, Adams, and Jefferson papers, are to the general American historian—the indispensable tools of their trade. Good stewardship imposes such an obligation upon the owners of valuable objects.

In the preparation of definitive catalogues, it would often be desirable for museums temporarily to import talent from universities. I have the impression that classicists move between teaching, excavation, research, and curatorial work more readily than humanists in later fields. It would be an advantage if such flexibility could be achieved between universities, libraries, and museums concerned with early American history.

Going beyond the inventories of single institutions, many opportunities exist for the preparation of comparative studies of the likenesses of people and places. Charles Coleman Sellers's *Benjamin Franklin in Portraiture* and Alfred L. Bush's *The Life Portraits of Thomas Jefferson* provide models that could widely be followed. Andrew Oliver, having systematized the portraiture of his own much-painted family, is now deep in a study of the portraits of the Adams family, that will be published as a companion to The Adams Papers. The six volumes of I. N. Phelps Stokes's *Iconography of Manhattan Island* present the most com-

plete study thus far achieved in the portraiture of an American city. Similar iconographies of other early cities would be uncommonly useful. The 116 illustrations in my *Boston: A Topographical History* are an interim step towards such an iconographical study of Boston that I hope may eventually be achieved through the cooperation of several institutions.

During the conference Whitfield J. Bell suggested the usefulness of extending the comparative studies of likenesses to tools. He observed:

We all know that the American axe is a great improvement upon the European axe. The curve of the shaft and the shape of the head both made an instrument that was easier to handle and more effective in work. Similarly the scythe underwent a significant improvement in seventeenth-century Massachusetts, when a curved blade was substituted for the old straight blade of Europe and a curved handle for the straight. As a result American farmers cut their grain in long, sweeping motions, while European farmers, as one can still see in southern Italy, cut theirs with short chops. The Farmers Museum at Cooperstown, the Bucks County Historical Society, and the Landis Valley Museum in Pennsylvania all contain large and instructive collections of farm implements. But there are not always enough, or they are not always arranged to show the development of particular implements.

I should like to see, for example, a picture book on several of these tools. Such a manual would arrange in chronological order illustrations of grain cutting instruments, showing what I am sure must have been a slow development and improvement from European sickles to American scythes, from the latter's straight blade and handle to the curved. An exhibition from sickle to scythe would show the evolution of functional design as well as the increase in relative efficiency. It would tell where and when these implements were used. It might give some idea of the relative efficiency of the instruments. Would it not be a legitimate research project, as it would surely be an interesting demonstration, for the historians at Old Sturbridge Village one summer to put two or three men, each using a different tool, to harvest a thousand square feet of grain, with a record made of time and effectiveness?

Mr. Bell further suggested the desirability of picture books in which paintings and prints would be presented by subject matter. From his recent experience in helping the Philadelphia Museum

of Art plan an exhibition of pictures of medical interest, he re-
marked:

While most of the portraits of physicians, as works of art, are
not especially different from portraits of merchants or soldiers,
it is nonetheless clear that the medical men as a group have a
different look from the men of other professions who were being
painted at the same time. More to the point, from a picture book
of, say, the doctor in art, we would learn, especially from
the less sophisticated paintings, something about instruments,
equipment, even professional manners, which constitute impor-
tant documentation for the social historian. Everyone knows, for
example, Thomas Eakins's two great paintings of the Gross and
Agnew Clinics. In the first, the surgeon appears in the amphi-
theatre in his black frock coat, the scalpel in his ungloved hand,
and his assistants also in ordinary street clothes. The Agnew
Clinic is quite different. Here, all are in antiseptic white. The
striking contrast is simply explained: the Gross Clinic was
painted in 1875, before Lister's lessons in antiseptic surgery had
been generally accepted; the Agnew Clinic was painted fourteen
years later. Not less instructive is an early nineteenth-century
painting at the Ohio Historical Society of a physician at a bedside.
We cannot see the patient, nor can the doctor, for the curtains
are tightly drawn; the patient is cooperating in the diagnosis: one
thin hand thrust through those tightly-drawn curtains allows the
physician to take the lady's pulse.

Turning from objects to architecture, there is even greater need
to learn from and to emulate the accomplishments of Great
Britain in recording historic monuments than in the area of
museum catalogues. Various governmental agencies there have
shown the highest degree of scholarly competence and public
responsibility in listing and describing archaeological and archi-
tectural monuments. The Royal Commission on Historical Monu-
ments has published, through H. M. Stationery Office, more than
twenty folio volumes of inventories of Buckinghamshire, Cam-
bridge City, Dorset, Essex, Herefordshire, Hertfordshire, Hunt-
ingdonshire, London, Middlesex, Oxford City, Westmorland,
and is now at work on York. Other Royal Commissions on
Historical Monuments have issued sixteen similar volumes on
Scotland and nine volumes on Wales and Monmouthshire. The
Survey of London, of which the thirty-third volume appeared in

1963, began seventy years ago when C. R. Ashbee, a disciple of William Morris, formed the Committee for the Survey of the Memorials of Greater London "to watch and register what still remains of beautiful or historic work in Greater London, and to bring such influence to bear from time to time as shall save it from destruction or lead to its utilization for public purposes." The London County Council soon took a share in the work, and since 1949 has been solely responsible for it. These latest volumes, prepared by Dr. Francis Sheppard and his staff, are justly described by Sir John Summerson as "the most remarkable work done on the fabric of London in recent years." While the earlier volumes smacked of what Sir John calls the "artistic-antiquarian approach," the later ones are so comprehensive as to record Edwardian theatres with the same care as Wren churches or medieval remains. In addition to these great works of record and reference, other government agencies have issued publications of great utility to scholars, students, and travelers. The Ordnance Survey maps of Ancient Britain and Monastic Britain are part of a series of National Period Maps that are remarkably helpful in locating monuments. The Ministry of Works has published a six-volume illustrated guide to ancient monuments in its ownership or guardianship, and such remarkably useful pocket guides as A. R. Birley's recent *Hadrian's Wall.*

Consideration of these British governmental undertakings only emphasizes the need for greater support and enlargement of our own Historic American Buildings Survey. Undertaken in 1933 by National Park Service architects using Federal unemployment relief funds and revived in 1957, this Survey has brought together in the Library of Congress thousands of measured drawings and photographs of American buildings, some of which no longer exist. The catalogues of the HABS, now in need of revision, are still the best general guide to graphic material concerning early American architecture. Working parties of the National Park Service and local preservation officers of the American Institute of Architects constantly seek to enlarge the record of the HABS. Nevertheless, there is still a mass of information in the hands of local organizations and of individuals that could usefully be fed into the HABS if anyone had the leisure to do so. Unfortunately,

in many cities people who are highly sympathetic to the purposes of the HABS are so urgently occupied with current crises in historic preservation that they do not find the time to transfer data to the Survey's forms and forward them to the Library of Congress. The New Hampshire Historical Society has recently published an up-to-date listing of the HABS material on that state; the Massachusetts Historical Commission hopes to perform a similar service for Massachusetts in the course of this year. But the fact remains that the HABS is shorthanded, and that its excellent work is too little known. A major "need and opportunity" is to complete its record and to establish several series of publications that will make its materials as readily accessible as the inventories of the Royal Commission on Historical Monuments or the *Survey of London.*

British scholars have likewise shown a sensitive appreciation of the qualities of landscape and the characteristics of regions that could well be brought to bear on studies of early American history and arts. In the early thirties Sir Cyril Fox, then Director of the National Museum of Wales, in *The Personality of Britain* conjured up a picture of the British landscape as it would have looked at the dawn of the Iron Age, 500–400 B.C., to traders or invaders who might have coasted along its shores. Such a technique has been carried to later times by W. G. Hoskins of Oxford who, in *The Making of the English Landscape* series, has studied the physical characteristics of regions in a manner that could profitably be brought to bear upon, say, the Connecticut, Hudson, and Delaware valleys, Chesapeake Bay, and other areas in which settlers and their arts developed some regional homogeneity.

The more thoroughly one brings to bear all possible techniques of history, geography, and archaeology upon the study of the early American arts, the more rewarding the results will be. Much early writing on the subject was the work of collectors and dealers, who were seldom conversant with the techniques of historical research. No amount of the aesthetic incest of sitting and gazing at a chair, or a pot, will tell one anything of great value about the object, beyond its existence. The pre-historian, who lacks written records, has to glue his pot together and then deduce from its existence what he can of the society that produced it, but when there are records it is the duty of the investigator to turn

archivist and seek them out. The Winterthur Program at the University of Delaware has done much to make its students, and the staffs of other institutions, aware of the necessity of relating manuscript and printed sources to the study of objects. The imaginative experiments by Mrs. Elizabeth A. Ingerman in indexing the manuscripts in the Joseph Downs Manuscript Library at Winterthur are a valuable step in facilitating such relationships. Abbott Lowell Cummings's *Bed Hangings, A Treatise on Fabrics and Styles in the Curtaining of Beds, 1650–1850*, which grew out of a seminar held at the Society for the Preservation of New England Antiquities in 1960, is an excellent example of the correlation of fabrics and documentary sources. In Lura Woodside Watkins's *Early New England Potters and their Wares*, archaeological as well as historical techniques were brought to bear upon the study of the pots in question.

Professor Grahame Clarke of Cambridge University, in his *Archaeology and Society*, observes that "archaeological methods can profitably be applied to any phase or aspect of history insufficiently documented by written records, however recent in time; indeed archaeology can not only be used to fill gaps in the documents, but also to check or corroborate them." The British archaeologist Ivor Noël Hume, since 1957 Chief Archaeologist at Colonial Williamsburg, clearly demonstrated this in his recent book *Here Lies Virginia*. At the conference Mr. Noël Hume made the statement:

It is my belief, and I think we prove it here in Colonial Williamsburg every day, that archaeology provides documentary evidence which is just as valuable to the historian as are the letters, diaries, bills of lading and so forth which are normally his sources. I do not suggest that the archaeologist is frequently likely to correct the historian—nor would he wish to do so. Documents are inevitably more precise and more easily read than is the evidence of the spade. Nevertheless, archaeology can frequently fill in gaps left amid the documents, and more often it will round out the historical evidence to give them a substance they might not otherwise achieve.

As an example he cited the inventory made when Anthony Hay died at Williamsburg in 1770 which calls for "2 large coloured stone tea pots," valued at 1/3, and excavations on the site of his

house that "revealed fragments of two Littler's Blue stoneware teapots, which give form and color to the otherwise equivocal wording." He noted, further, that it was possible to equate more than forty items found in the excavations with entries in the Hay inventory.

The student of early American printing has easier access to all of his sources than anyone concerned with other arts and crafts, for the *American Bibliography* of Charles Evans (1850–1935) lists chronologically in twelve volumes all books, pamphlets, and periodicals printed in what is now the United States from the beginning at Cambridge in 1639 through 1799. Clifford K. Shipton, Director of the American Antiquarian Society, not only prepared a thirteenth volume carrying the listing through 1800, but undertook in 1954, in cooperation with the Readex Microprint Company, to edit and publish on microcards the full text of every book, pamphlet, and broadside listed by Evans. Thus any library with ten thousand dollars to spare can place at the disposal of its readers the *corpus* of American printing from 1639 to 1800. This microcard publication, known as *Early American Imprints*, is capable of changing the whole direction of the teaching and writing of colonial history, for until it appeared, research in that field could only be satisfactorily carried out in a small number of institutions in the northeastern United States, because of the scarcity of many imprints before 1800.

Although no other cooperative undertaking has covered its ground as completely as *Early American Imprints* for printing, several have made valuable progress. The Historic American Buildings Survey has already been mentioned for the field of architecture. The widely flung net of the Frick Art Reference Library in New York City has since 1920 brought together more photographs of American paintings than exist in any other collection, including many pictures in private ownership. As no catalogue has been published, these are accessible only through visits or correspondence.

The Archives of American Art, housed at the Detroit Institute of Arts, seeks to place on microfilm sources of all kinds—exhibition and auction catalogues, private papers of artists, craftsmen, and dealers—thus attempting to bring together material that has

been widely scattered among institutions or has remained in private hands. Its progress has been hindered by lack of steady support, for too much of the time of its staff has to be devoted to raising funds for current projects. It has, however, succeeded in rescuing many papers of a relatively recent period that might not otherwise have found their way to a permanent manuscript depository. While the greater part of its activity will probably lie in the nineteenth and twentieth centuries, the Archives, as its searches expand, will doubtless come upon material for the period preceding 1826. In general, however, early manuscripts are more likely to find good local homes than relatively recent ones. Until the Archives consolidates its financial position, it is likely to confine its filming to papers that would otherwise be endangered, rather than copying what is already safely preserved elsewhere.

It is in the interest of learning that these cooperative undertakings be supported and enlarged. If, for example, Xerox copies of personal inventories owned by other manuscript depositories were added to the Joseph Downs Manuscript Library at Winterthur, unexpected pieces of information might emerge from them through Mrs. Ingerman's experiments in indexing.

Wilcomb E. Washburn, in summarizing the discussion of the conference, bore down on the importance of cooperative undertakings when he said:

There is a definite need for a centralized body to create the central guides and publish the studies that grace English historical scholarship. We have nothing to match the Historical Manuscripts Commission, the Victoria County Histories, and the various governmental guides to monuments and art treasures. The Historic American Buildings Survey is fine, but needs revision and greater support. The Smithsonian Institution would seem to be the logical governmental agency to provide the impetus to narrow the one-generation lead Great Britain has over us in the field of museum catalogues, inventories of historical monuments, etc., but it has never seized its opportunities in this field, or recognized an obligation. A National Union Catalogue of Objects, similar to the Library of Congress's National Union Catalog of Manuscript Collections, might be a valid, if difficult, undertaking for such an Institution, but only the future can tell how the Smithsonian will interpret its mandate to "increase and diffuse knowledge among men."

But however valuable these cooperative undertakings may be when perfected and completed, there is a great deal that the individual scholar can do here and now in the early American arts with the tools that are currently within his reach. When the arts are approached as an element in human society, the field for study widens limitlessly. J. F. McDermott's studies of frontier artists and Alan Gowans's recent *Images of American Living* are first-rate examples of imaginative ways of viewing and interpreting material that might by comparative aesthetic standards be found uninteresting. If one looks at regions, at urban centers and their trading areas, at seaports as centers for importing, distributing, and exporting, at religious and social ideals, at the personal habits of the people, many fields for investigation spring up. The conference, for example, indicated that some studies of the influence of religious ideas on the style of furniture or architecture were badly needed. Frederick B. Tolles, Director of the Friends Historical Society, observed of his co-religionist: "I for one would like to know how it happened that Quaker William Savery fashioned such ornate and indescribably beautiful highboys. I'm glad he did, but as a Friend he shouldn't have. Did the demands of his customers—who included a good many Friends—determine his style? No one has ever written much on the design of the colonial Quaker meeting-houses. They are simple, but often beautiful." It would be useful to bring together source material relating to the American attitudes towards the arts from the comments of visitors like Chastellux and de Tocqueville as well as from such native statements as Latrobe's *Anniversary Oration Pronounced Before the Society of Artists* (Philadelphia, 1811). Bibliographies and studies of the works *used* by American artists and craftsmen—design books and carpenter's guides among them—would be helpful; some of the works studied, like Asher Benjamin's, might warrant reproduction in offset facsimile. A new, and carefully annotated, edition of William Dunlap's *History of the Rise and Progress of the Arts of Design in the United States* would be welcome.

In architecture there are countless monographs still to be written on individual architects, but perhaps even more needs to be done upon the vernacular buildings of various regions, relating

the earliest work here to the differing traditions of groups of European settlers.

The early books of travel and exploration, with accounts of aborigines, have been studied from the point of view of the writers, but little consideration has been given to their illustrations. From Cortes, Jacques Le Moyne de Morgues, and John White in the sixteenth century, to Des Barres's *Atlantic Neptune* and figures like Bernard Romans in the eighteenth century, to the records of the Long Expedition, there is much still to be learned, as there is from illustrators of the American Indian and of the landscape, animals, and birds.

Although nearly thirty years have passed since the publication of Louisa Dresser's *XVIIth Century Painting in New England*, comparable work still remains to be done on New York painting of the period or on the Hudson River Dutch painters of the eighteenth century. Both the Delaware River and Chesapeake Bay country present important and puzzling groups of early portraits, from the sixteen nineties on. In the second half of the eighteenth century, a large quantity of unknown or misattributed painting, as well as the work of artists like Pratt, Benbridge, William Williams, Delanoy, Claypool, and Pine, still await study.

In the Federal period, the various members of the talented Peale family, other than Charles Willson Peale, form a great challenge. James and Rembrandt Peale especially are important artists whose work remains unstudied. Other artists who have not yet been studied seriously, or deserve further investigation, include Walter Robertson, Archibald Robertson, John Meng, Henry Pelham, Samuel King, Henry Sargent, John Johnston, Christian Gullager, L'Enfant, Robert Fulton, C. B. King, François Guyol of St. Louis, Peticolas in Richmond, John Izard Middleton in Charleston, and engravers like Lawson, Hill, and W. J. Bennett. Nor have critical accounts been written of the first great public commissions given to painters after the War of 1812, Trumbull's work for the United States Capitol, the commemorative portraits in the New York City Hall, and the portrait commissions for the North Carolina State Capitol.

Charles Coleman Sellers, as a result of his experience in un-

tangling the portraiture of Franklin, strongly urges the publication of the records of mints and of other primary sources relating to numismatics. These and other suggestions could be multiplied at length. In addition, the ground already covered needs often to be resurveyed in the light of later discoveries and new approaches. Dr. Foote's books on Feke and Smibert, for example, while good in description and biography, lack analytical artistic acumen. Some architectural studies describe admirably the buildings that exist, but fail to consider the social conditions that caused them to be built.

Mr. and Mrs. Garrett's bibliography which follows is subdivided by subjects, regions, and artists in an effort to show not only what has been accomplished but also the areas where work has not been done, and needs to be. Its silences automatically indicate needs and opportunities for study. Many of the books that it lists were printed in small editions and are now hard to find. Some could well be revised and improved; others need wholly new substitutes. It is extremely useful to have Russell H. Kettell's book on pine furniture available in a Dover reprint. The paperback market also offers valuable possibilities. The University Press of Virginia has just reprinted as a paperback Lawrence C. Wroth's *The Colonial Printer*, which has been inaccessible for two decades. A number of other books listed in the bibliography could usefully be brought out in similar form and serve a valuable purpose until new and better studies are produced to take their place. Many of the classic works are sadly out of date and in need of revision or replacement, for in this field, as A. Kingsley Porter wrote of archaeology in the foreword to his *Spanish Romanesque Sculpture* in 1928, "the data available today will be constantly only a part of the data available tomorrow; and the data of the last tomorrow will lead to conclusions likely to be reversed, could we have the vastly fuller data which have perished."

The historian, professional or amateur, who approaches the American arts by way of this bibliography, without previous experience, should be warned of some of the booby traps that may beset his new path. It is for him that this note on method is appended; others need read no further.

Like a military commander making an estimate of the situation

before reaching a decision, the historian appraises from many points of view a new document before putting his trust in it. Confronted with a manuscript that is not, like a love letter of Cleopatra's written in French on nineteenth-century paper, patently a forgery, he needs to know who wrote it; whether it is in the author's hand or whether it is a copy, contemporary or later. He must consider whether the author has a known reputation for telling the truth, or improving upon it; whether he was likely to have had firsthand acquaintance with what he describes or to have relied upon hearsay; whether he had the experience or education to understand what he is trying to describe. A footman's recollection of eavesdropping at the dinner table or keyhole may accidentally misinterpret; a partisan politician's public statement may do so deliberately. The *Harvard Guide to American History* thus describes the three procedures of the critical examination that is the historian's first obligation:

> (1) the authentication of the physical remains, or *external criticism;*
> (2) the analysis of contents, or *internal criticism;*
> (3) the *evaluation* of the resulting data as *evidence.*

The experienced historian uses written and printed documents so constantly that the stages of his critical examination often become as rapid, and almost unconscious, as the steps in a military estimate of the situation made under fire. Although the same critical examination must be made of buildings, pictures, and museum objects before they are admitted as evidence, even greater caution must be exercised with them, "since," as Edward P. Alexander of Colonial Williamsburg points out, "three-dimensional history is so believable." In emphasizing the high importance that "historical restorations be created in the spirit of historical accuracy," Mr. Alexander observed: "Visitors are accustomed to exercise scepticism toward the printed word, but they are not so ready to argue with brick and mortar. History in the round has blandishments that can easily mislead all but the most expert."

There always have been forgers of autographs and written documents, but their number is smaller than those who "fake"

objects. A forged manuscript, once identified as such, passes into
the limbo of valueless curiosities from which it seldom returns.
An equally unauthentic chair or table, even if anathema to the
connoisseur or curator, may still appeal to someone as household
furniture, and so remain in circulation to trap the unwary. The
man who supplies a missing leg to a Chippendale chair is com-
moner than one who would write a missing page for a Jefferson
letter.

Most letters and many documents are plainly dated; few ob-
jects can, by simple examination, be equally precisely placed in
time and space. Silver and pottery may bear hieroglyphs capable
of solution with the right reference books, but few pieces of
furniture can be as surely identified. Objects wander about so
freely, through dealers and collectors, that the place one finds
them bears no necessary relation to their point of origin.

Forty years ago there was, briefly, a brisk trade in trapping out
anonymous seventeenth-century European portraits with a little
repaint, the name of some distinguished New England subject,
preferably with solvent descendants who would like to own a
family likeness, and a plausible pedigree, usually with a few
missing links. Most of these portraits are now in limbo, but it is
still wise to remember that the trick was played.

While buildings stay put more readily than objects, it does not
necessarily follow that they represent what you expect them to.
Monticello today is a very different house from the one visited by
Chastellux in 1782, for Thomas Jefferson, although he began the
building in 1769, took forty years to create the mansion seen
today. Frederick D. Nichols's *Thomas Jefferson's Architectural
Drawings* shows how Jefferson not merely enlarged his house,
but completely shifted its style in the process. It was 1824, two
years prior to his death, before he added the terrace railings. Thus
Howard C. Rice, Jr., reproducing a photograph of Monticello in
his meticulously edited and illustrated edition of Chastellux,
conscientiously notes: "At the time of his visit Monticello had not
yet been completed in the form which has been familiar to
subsequent generations, as shown here."

Monticello changed more radically during the life of its builder
than in the years since his death. Other important buildings have

been less fortunate; hence the problems raised by restoration and reconstruction. The first Capitol at Williamsburg, built in accordance with an act of 1699, burned in 1747. A second Capitol on the same site, incorporating the surviving walls of the first but different in style and appearance, as one would expect after the passage of nearly fifty years, fell into disrepair after the Virginia government moved to Richmond in 1780 and was destroyed by fire in 1832. Years later the Association for the Preservation of Virginia Antiquities piously bought the site, put up a commemorative marker, and uncovered the top of the foundations. When John D. Rockefeller, Jr., sponsored the proposed rebirth of Williamsburg, the Association deeded the Capitol site to Colonial Williamsburg, Incorporated, with the proviso that the building be reconstructed within five years. But which building? On this point the current *Colonial Williamsburg Official Guidebook* forthrightly states:

Before reconstruction could be undertaken, Colonial Williamsburg faced a dilemma: should the first or second capitol building rise again on the old foundations? The second Capitol was of greater historic interest since it witnessed the events of the years before the Revolution, but the first Capitol could lay claim to greater architectural distinction. Long searching of the architectural evidence disclosed that voluminous files would permit the accurate reconstruction of the earlier building, whereas few records were available for the later. It is the first Capitol which is here reconstructed.

Thus the present Capitol, completed by Perry, Shaw, and Hepburn in 1934, reproduced, so far as surviving evidence permitted, the building destroyed by fire in 1747, rather than its successor in which George Washington, Patrick Henry, George Mason, Thomas Jefferson, and other members of the House of Burgesses played their roles in the shaping of the Revolution. Were their shades to return to the Capitol today they would not necessarily know their way around.

Nor, for that matter, would Paul Revere recognize the house in North Square, Boston, in which he lived from 1770 to 1800, were he able to see it today, even though it has long been preserved as a historic monument. Originally built about 1680 as a low-studded

two-story house of almost medieval appearance, with an over-hanging second story and leaded glass casement windows, it was entirely made over in the middle of the eighteenth century before Revere bought it. When the Paul Revere Memorial Association acquired it in 1907, it was a three-story building, with hung sash windows, in which the eighteenth-century modifications had all but concealed its seventeenth-century origins. Joseph Everett Chandler, the architect in charge of its restoration in 1907–8, having ferreted out the building's earliest features, including an early leaded casement window sealed into a wall, chose to "restore back" to the 1680 construction. Thus the third story was removed, leaded casements substituted for the hung sashes, and other changes made to achieve the hypothetical original condition of the house. The work was done with care, by a scholarly and conscientious architect, yet the result is a Boston house of the late seventeenth century rather than the building in which Revere lived for the last thirty years of the eighteenth. It would be as far from the truth to imagine Paul Revere sitting by this kitchen chimney as to picture the Marquis de Chastellux visiting the Monticello that we know today or Patrick Henry orating in the reconstructed Capitol at Williamsburg.

That buildings, excellent in themselves, may not represent what they are claimed to is demonstrated by an ancient house long considered the home of the poetess Anne Bradstreet, who died in 1672. This stands to the east of the road from the North Parish of Andover to Haverhill, Massachusetts. In 1930 the Massachusetts Bay Colony Tercentenary Commission placed a marker, with text by Samuel Eliot Morison, outside it. Yet when Abbott Lowell Cummings undertook the restoration of the house in 1956 for the North Andover Historical Society, and went to the deeds, he found that the Bradstreet house had stood to the *west* of the road. Before he was through he had established to everyone's satisfaction that the Bradstreet house no longer existed, and that the building in question had been built by the Reverend Thomas Barnard after 1714. The owners accepted his findings, changed the name to the Parson Barnard House and went ahead with the restoration, for with or without literary association it was as good a house as ever; in fact, better, because its chronology was

precisely established. The manner in which the attribution grew up is instructive. The Reverend Abiel Abbot in his *History of Andover* described the building in 1829 as "the house said to have been built and occupied by Governor Bradstreet." John Harvard Ellis prefixed as a frontispiece to his 1867 edition of *The Works of Anne Bradstreet* a charming lithograph of the house, called it "the oldest" house in North Andover, and said that "it has always been believed in the town that this was the Governor's house." Thus possibility oozed into probability, and thence into such seeming certainty that by the twentieth century everyone, including Professor Morison and myself (who had persuaded the North Andover Historical Society to buy it), thought that it *was* the Bradstreet house. Nobody before Mr. Cummings had checked in the Essex County Probate Records.

The degree of reliance that can safely be placed upon colonial portraits is diminished by the late W. P. Belknap's discovery that many of them had their prototypes in English mezzotints. As he showed, elegant details of costume, architecture, and landscape background were lifted sufficiently often from European prints to indicate that considerable scepticism is necessary before accepting these as authentic evidence of the colonial scene. Sometimes artists painted dead subjects whom they had never seen alive, as was the case with Benjamin Franklin's little boy. Even in portraits known to have been painted from life, physical defects, like Caesar Rodney's skin cancer, may well have been glossed over. Few painters can have been so fortunate as Goya who seems to have received continued commissions from the Spanish royal family in spite of having consistently represented them as both foolish and ugly. Just as Jared Sparks felt it appropriate to "improve" the spelling and grammar of the great men whose writings he edited, so painters have been known to "improve" likenesses.

Therefore let the student always beware of errors in ambush against his good faith when he relies on the arts to illustrate early American history.

A BIBLIOGRAPHY OF THE ARTS IN EARLY AMERICAN HISTORY

Wendell D. Garrett and

Jane N. Garrett

I. WRITINGS ON THE ARTS IN EARLY AMERICA, *1876–1964*

THE WIDESPREAD INTEREST of Americans in their early arts is of scarcely nine decades' duration, a scholarly concern about them only four. Artifacts and works of art are now an institutional treasure, their curatorship a specialized career, the historical writing based on them a corporate task. A large and sophisticated profession has grown up around them, integrating its activities through the seminar, the learned society, and the scholarly journal. This bibliography attempts to record the most important writings proceeding from these activities over the past forty years. Many are solid scholarship, and share the qualities of the best contemporary historical writing: suppleness, critical alertness, a searching for new formulations. These, hopefully, will speak for themselves.

Books and articles written from 1876 to 1924—from the Centennial Exposition to the opening of the Metropolitan Museum of Art's American Wing—are included in a much smaller proportion, and demand a short explanation. For the fault of that period lingered on and still guides much of what is written—the fault of insularity, of separation from the main currents of American historiography. It was a fault, begun not in carelessness or haste, but in a quest for "some good old golden age."

Interest in eighteenth-century American arts, broadly speaking, bloomed on the hundredth anniversary of the Declaration of Independence. After a generation of railroad wars and reconstruction, the "bloody shirt" and money madness, many longed to re-establish a continuity with the virtues of a stable yeoman republic. To most people who attended the Exposition in Philadelphia, the year 1876 marked the beginning of a new century. To record the passing one, writers strode onto the pages of the illustrated monthlies to re-create the image of that virtuous young country. Beside their text with a deceptive clutter of scholarship came the complementary engravings, in copper, steel, and wood, to picture the houses, furniture, and the period room—nostalgic set-pieces or props, arranged for historical association and "documented" by romantic nationalism. Mood outweighed historicity.

There had been earlier concern with the American portrait painters in the works of William Dunlap (1834), C. Edwards Lester (1846), Henry T. Tuckerman (1847), and others. But it was not until after the Centennial that interest centered on the Pantheon-like collection of founding fathers' portraits. William S. Baker published in 1880 works on the engraved portraits of Washington, on his medallic portraits in 1885. Four years later, with the approaching centennial of the Constitution's ratification, a galaxy of businessmen, lawyers, and clergymen planned a portrait exhibition of the participants in the Constitutional Convention. Charles Henry Hart (1847–1918), a Philadelphia lawyer, began research on the portraits through extensive correspondence with collectors, descendants of the Revolutionary generation, and historical societies. Though an exhibition catalogue never was published, Hart emerged at the end of the 1890's as the leading authority on colonial portraiture and did

publish check lists of the life portraits of Jefferson, Hamilton, and Franklin in *McClure's Magazine* at the turn of the century. These lists, the most comprehensive and authentic then compiled, capitalized on the papers of the Revolutionary statesmen published in scholarly editions during the last quarter of the century. Charles Francis Adams, Henry P. Johnston, Paul Leicester Ford, Worthington C. Ford, Franklin Bowditch Dexter, and Francis Wharton were only the more prominent representatives of a school of gentlemen-historians who were gathering and publishing these massive editions. This brief venture into the exploration of iconography with the aid of documentary publications proved fruitful but was short-lived; it was not revived until the post-World War II renaissance in historical editing.

But these historians and antiquarians, working and publishing largely on private incomes, were distant from the new methods and interpretations of the university professors. In the 1870's these patrician proponents of art found in American objects and architecture an inspiring chronicle that stirred their pride. These things buttressed the structure of the nineteenth-century culture of liberty, nationality, progress, the concept of development, high regard for the past, and a fondness for re-creating it in strikingly visual scenes. But the "scientific" historians, recently returned home from German seminars, worked another field. Devoted to fact-finding, the professors scorned artifacts as a quagmire of subjectivity and amateurish antiquarianism. European-trained, they found in America few ruins and little antiquity to warrant the attention of their thoroughly positivistic theories. Their emphasis was on the critical examination of original texts and bibliographical evidence. This divergence, not so much a parting as a never-meeting of the ways, has persisted, and more than any other feature characterizes the historiographical tradition represented by this bibliography.

A few examples of the manner in which the gentlemen-historians and their followers progressed might be noted. Their interest in early American architecture, for example, proceeded more slowly than in portraits. Between 1887 and 1897 Frank E. Wallis, E. E. Soderholtz, and Newton W. Elwell published volumes nearly identical in content and title (variations on "Colo-

nial Architecture and Furniture"). But the houses they illustrated and described were important for historical associations rather than for architectural quality, and the scope and methodology of the volumes differed little from the ordinary local history of the time.

The serious investigation of early American architecture advanced markedly in April 1910 when William Sumner Appleton (1874–1947) with seventeen interested men and women incorporated the Society for the Preservation of New England Antiquities. Dedicated to what has been a notably successful program of saving valuable antiquities and exceptional examples of domestic architecture, the Society began publishing a *Bulletin* immediately (renamed *Old-Time New England* in 1920) that has published increasingly sophisticated writing on architectural history.

Through the earlier years of effort by Hart and Appleton, neither the museums nor the universities were taking an institutional interest in collecting and research in the early American arts. That was to result from the Hudson-Fulton Celebration of 1909 in New York City. Four years of preparation went into the double anniversary (discovery of the Hudson River in 1609 and the first successful application of steam to its navigation by Robert Fulton in 1807). Robert Weeks de Forest (1848–1931), New York lawyer, businessman, president of the Metropolitan Museum of Art, and collector of American furniture, was appointed chairman of the celebration's art committee and assembled an American furniture exhibition "to illustrate the art of the Fulton period. . . . and to test out the question whether American domestic art was worthy of a place in an art museum." In 1905 the Museum's *Annual Report* included, probably at de Forest's instigation, the following significant recognition of a place for colonial art within a major museum collection:

Among the many directions in which extensions of our collections are desirable there is one which has peculiar claims upon our interest and patriotism, that is the art of our own country. Foreigners coming to America naturally expect to find in the chief museum of our country the evidence of what America has done and indeed the material for full appreciation of the development

of American art. Our own countrymen should expect nothing less. The achievements of American art, using the word in its broadest sense, and the position accorded to it at recent international expositions warrant us in giving it an important place in our American museum.

This is a direction in which the Museum should be able to appeal successfully for its needs to the generosity and patriotism of our private citizens, who own the finest American works of art, and many of whom will undoubtedly be glad to give their ownership a public use.

All the furniture for the Hudson-Fulton exhibition was borrowed from three extensive private collections: Eugene Bolles's of Boston, R. T. H. Halsey's of New York, and the de Forests'. Even though de Forest and the Metropolitan Museum had the highest aspirations for the serious study of American art in large public institutions, it seemed almost impossible to keep the subject divorced from filiopietism and sickly sentiment. Edward H. Hall, who wrote the official chronicle of *The Hudson-Fulton Celebration, 1909* (Albany, 1910), made the following incredible observation:

> The Hudson-Fulton Celebration . . . was a jubilee of happiness. The Nation was at peace with the world. Civil concord blessed our people at home. Material prosperity abounded. Even men's evil propensities seemed to be suspended and the best qualities of human nature to come to the surface, for it is a literal fact that during the two weeks of the Celebration in New York City, there were fewer homicides, fewer suicides, and less crime generally than in any other equal period in the year. There were also fewer accidents and a lower general death rate than usual. There was seemingly nothing to alloy the happiness of the occasion and the people practically abandoned themselves for a fortnight to a rational festival of patriotic sentiment.

The American Wing at the Metropolitan Museum of Art was a direct outgrowth of de Forest's vision and the success of the Hudson-Fulton Celebration. Before the exhibition had closed, the entire Bolles collection was acquired for the Museum; in 1913 Halsey was appointed chairman of the Committee on American Decorative Art. Before long, planning and construction of the American Wing, presented to the Museum by Mr. and Mrs. de Forest, was begun. A significant statement of the motives, some

noble, some questionable, behind this institutional recognition of the American arts as a field worthy of specialized study appeared in 1925 in *Addresses on the Occasion of the Opening of the American Wing* (on November 10, 1924). Mr. de Forest reminded his audience that fifteen years earlier in 1909, "Not a single piece [of American furniture] was then owned by our Museum. Everything was borrowed for the occasion." The purpose of the American Wing, he went on to say, was to provide a series of period rooms in which "to show in our Metropolitan Museum American domestic and decorative art in the environment for which it was intended, and to show its development from the earliest period through the first quarter of the nineteenth century." Halsey, author of the popular *Handbook of the American Wing* (between its initial publication in November 1924 and its third edition in March 1926, 32,000 copies were printed), in his address stated the educational aims of the building and his hope that it would provide "a realistic visualization of the past of America to every citizen of New York." He then resurrected the recurrent and tiresome theme of the didactic uses to which these objects could be utilized in the Americanization of immigrants and ethnic minorities. He warned: "The tremendous changes in the character of our nation and the influx of foreign ideas utterly at variance with those held by the men who gave us the Republic threaten, and unless checked may shake, the foundations of our Republic." The American Wing would be "invaluable in the Americanization of many of our people to whom much of our history has been hidden in a fog of unenlightenment." This rational conspiracy, simple and all-embracing, would hardly win followers today, but users of this bibliography should be warned that it did linger on in the pages of many of the earlier books on American decorative arts.

Shortly before the opening of the American Wing, Homer Eaton Keyes in 1922 launched *Antiques* magazine which significantly multiplied the opportunities for publication and recognition. These two events laid the foundation for a more widespread serious interest in the American arts. Amateurs and collectors began to undertake intense and thorough research and eventually produced scholarly articles and monographs, many of which are listed in the bibliography below.

Even so, art historians and social historians in colleges and universities continued to ignore the American arts, and the declension or cleavage with American historiography persisted. One can only speculate on what beneficial insights the writers on the American arts might have achieved had they followed Frederick Jackson Turner and Charles A. Beard's exciting investigations of social and economic life. These two historians revolted against the methodological assumptions of the "scientific" historians and turned their attention to popular movements, social processes, and economic conflicts. But amateurs and antiquarians showed slight interest or competence in the new trends in professional history. There was a general inertia induced by an inclination toward tangible particulars and a lack of training in theoretical analysis. But by the same token, the professional historians were utilizing very little of the historical materials on social life discovered by the amateurs. Even in the multi-volume *History of American Life* series (1927–48), edited by Arthur M. Schlesinger and Dixon Ryan Fox, the hiatus did not narrow much. Discussion of the fine arts and architecture occupies only about six pages in each of the five volumes dealing with pre-1830 America.

The recent burgeoning of American Studies programs has not yet completely solved the problem of insularity in the writings on the American arts. But the chasm has at least been recognized and partially bridged, and the conference which produced the present essay and bibliography is an encouraging development in the right direction.

Scope and Intent

The bibliography which follows is not intended to be complete in scope or definitive in depth. Its principal function is to point out the basic writings in a variety of fields and by its obvious gaps to single out the areas which need further work; in this sense, it is hoped that it will be useful to art historians and museum personnel. But it is not designed to guide the museum curator in his research. He usually knows the bibliography of his special field in great depth, and his institution, no matter how small, should have the bibliographical tools for researching, verifying, and cataloguing its objects. Neither is the bibliography intended to be a guide

for the dealer or collector who needs a reassuring photograph of "one just like it," or an identification of a touch mark to steady his nerves just before and after a sale. If it indicates to scholars and students areas that need further research and writing, if it suggests ways of expanding the conventional political, social, and economic interpretations of early American history, if it aids the historian in the preparation of a lecture or two on the arts in a college course, if it facilitates the selection of illustrations for a book, then it has served its purpose.

The terminal date of 1826 is an arbitrary one. It is of greatest significance for American painting, for it marks the transfer of leadership from Philadelphia to New York with the founding of the American Academy of Design. With the symbolic deaths of Jefferson and Adams, it also marks the end of the Revolutionary generation. It can, of course, be argued that later or earlier dates are more appropriate in other fields, but for purposes of consistency 1826 has been adhered to in all cases. Writings on English, continental, and Far Eastern products in porcelain and textiles that were imported and used widely in this country have been consciously omitted, as have those on the performing arts and many peripheral subjects.

Articles in periodicals are included only if they are of special significance, particularly if they are a model or ideal study in the way they have been researched, interpreted, and written. There are, of course, countless articles in such magazines as *Antiques* that are relevant but to make any sort of meaningful selection here would be nearly impossible. The section of the bibliography devoted to serial publications attempts to note in a collective manner the most important journals in the field. Picture books and exhibition catalogues are included only where they seem especially pertinent.

II. GENERAL WORKS

Barbeau, Marius, *Trésor des anciens jesuites*. Ottawa, 1957. Pp. x, 242.
A brief essay on the ancient treasures of the Jesuits in French Canada precedes an extensive *catalogue raisonné* of silver, em-

broidery, sculpture, and numerous other examples of the decorative and graphic arts. A publication of the National Museum of Canada.

Brimo, René, *L'évolution du goût aux États-Unis, d'après l'histoire des collections.* Paris, 1938. Pp. 207.

In the first part of this book, "Les Primers Mouvements de la Période Coloniale à l'Exposition de Philadelphie, 1876," Brimo brings together scattered information on early American collectors and collections; he attempts to answer the questions as to who collected art and why, and suggests what sorts of taste and fashion are reflected in these collections. He has opened an interesting field of investigation that has received little previous, and as a matter of fact scant subsequent, attention.

Christensen, Erwin O., *The Index of American Design.* New York, 1950. Pp. xviii, 229.

An outgrowth of the Federal Art Project, sponsored by the National Gallery of Art, Smithsonian Institution, this lavishly illustrated book examines the crafts and popular folk arts practiced in this country in furniture, silver, glass, ceramics, textiles, tavern signs, figureheads, cigar-store Indians, toys, lighting devices, agricultural implements, costume, etc.

Comstock, Helen, ed., *The Concise Encyclopedia of American Antiques.* 2 vols., New York, 1958. Pp. 543 [continuous pagination].

Useful because of its wide range of subject matter, large number of illustrations, and bibliographical references in each field.

Constable, W. G., *Art Collecting in the United States: An Outline of a History.* London, 1964. Pp. xi, 210.

In chapter 2, "The Pioneers," Constable discusses the relative lack of collecting in eighteenth-century America and its gradual increase in the early nineteenth century.

Cummings, Abbott Lowell, ed., *Rural Household Inventories, Establishing the Names, Uses and Furnishings of Rooms in the Colonial New England Homes, 1675–1775.* Boston, 1964. Pp. xl, 306. 14 plates.

The editor of this useful volume has reproduced in letterpress the 109 inventories of estates found in the Suffolk County Registry of Probate that list household items room-by-room, excluding those for Boston, an exact record of how rural New Englanders furnished their houses for the century preceding Independence. Cummings has prefaced the record with a lengthy, informed Introduction. Published by the Society for the Preservation of New England Antiquities.

Davidson, Marshall B., *Life in America.* 2 vols., Boston, 1951. Pp. xiii, 573; 503.

A compelling and revealing visual account of our national history from documentary paintings and prints. Davidson has concerned himself more with social forces than with politics, personalities, and military matters. He has therefore eliminated from his selection caricatures, cartoons, portraits, battle scenes, and historical reconstructions by artists working long after the events they describe. The great value of these volumes is that illustrations reproduce the work of eyewitnesses or of contemporaries well-enough informed to draw a scene faithfully. An accurate and well-written text accompanies the hundreds of illustrations. Published in association with the Metropolitan Museum of Art.

Detroit Institute of Arts, *The French in America, 1520–1880*. Detroit, 1951. Pp. 207.
An exhibition catalogue compiled by Paul L. Grigaut of objects brought together at the Detroit Institute of Arts to commemorate the founding of Detroit by Antoine de Lamothe Cadillac in 1701. The scope of the exhibition and book is extremely wide in concept: the French in the wilderness, in Canada, and in Louisiana; the French and the War of Independence; Americans in France; French writers on America; French Protestants in America; the French in America, 1790–1880; and Detroit, 1701–1840.

Dunlap, William, *A History of the Rise and Progress of the Arts of Design in the United States*. New edn. by Frank W. Bayley and Charles E. Goodspeed, 3 vols., Boston, 1918. Pp. xiv, 391; xi, 403; xi, 418.
First edition published in 1834; in the new edition there is an addenda listing "Painters, Sculptors, Architects and Engravers working in this country before 1835 and not previously mentioned in this work." A mass of material, much of it anecdotal, of varying quality, largely on painters of the early national period. Groce and Wallace should be used as a guide to other literature on artists in order to correct Dunlap's mistakes and prejudices. On crucial points the 1834 edition should be consulted; the modern edition is not a faithful reproduction of the earlier one, some entries having been shortened and occasionally changed substantively.

Gowans, Alan, *Images of American Living: Four Centuries of Architecture and Furniture as Cultural Expression*. Philadelphia and New York, 1964. Pp. xv, 498.
A big book in every sense of the words: its scope is wider than most books on "American" architecture; it takes in both the Spanish Southwest and New France. This is a highly original work, novel in its choice of materials and methods; it treats architecture, furniture, and

interior decoration, all together, as so many aspects of our "cultural expression." Gowans elaborates this concept with a thorough knowledge of American architecture and the decorative arts. He distinguishes "a pattern of basic traditions" that reflects our evolving relationship to Europe, broken down into the "medieval mind" of the seventeenth-century settlers, the "classical mind" of the eighteenth century, and the "literary" concept of styles usually called Victorian.

Gutmann, Joseph, "Jewish Participation in the Visual Arts of Eighteenth- and Nineteenth-Century America," *American Jewish Archives*, 15 (Apr. 1963): 21–57.

Jones, Howard Mumford, *O Strange New World. American Culture: The Formative Years*. New York, 1964. Pp. xiv, 464.
Jones takes an imaginative look at the great trends and components in the transit of culture across the Atlantic, from its Renaissance roots in the sixteenth and seventeenth centuries until its Romantic flowering in the nineteenth. The last chapter on "American Landscape" has an interesting discussion of the Hudson River School of landscape artists. The author's point is that these formative years were as rich in havoc as in truly creative cultural accomplishment.

Lancour, Harold, comp., *American Art Auction Catalogues, 1785– 1942: A Union List*. New York, 1944. Pp. 377.
A descriptive list of auction catalogues of American art collections, arranged chronologically and thoroughly indexed by owners.

Larkin, Oliver W., *Art and Life in America*. New York, 1960. Pp. xvii, 559.
A revised and enlarged edition of a work originally published in 1949. One of the most successful attempts to telescope the published material on American art and architecture within one volume and relate it to contemporary developments.

Mendelowitz, Daniel M., *A History of American Art*. New York, 1960. Pp. ix, 662.
One of the most up-to-date historical surveys of the visual arts in the area which now constitutes the United States, from the arts of the Indians to the present. In addition to his competent chapters on painting, sculpture, and architecture, the author includes an impressive section on the household arts (furniture and the decorative arts).

Morisset, Gérard, *Coup d'œil sur les arts en Nouvelle-France*. Quebec, 1941. Pp. xi, 170.
This short survey deals mainly with architecture, sculpture, and painting; written by one of the most prolific writers on French Canadian arts.

Nye, Russel Blaine, *The Cultural Life of the New Nation, 1776–1830*
[New American Nation Series]. New York, 1960. Pp. xii, 324.
Chapters on art and architecture, in addition to religion, education,
literature, music, science, and the scientific approach.

Rogers, Meyric R., *American Interior Design: The Traditions and
Development of Domestic Design from Colonial Times to the
Present.* New York, 1947. Pp. 309.
An attempt to present an integrated picture of architecture, design,
furniture, and furnishings. The text is supplemented by 196 illustra-
tions plus 39 plates of rooms. There is also a useful glossary, bibli-
ography, and index.

Roy, Antoine, *Les lettres, les sciences et les arts au Canada sous le
régime français.* Paris, 1930. Pp. xvi, 292.
Half of this history of the cultural life of French Canada is devoted
to the architecture (civil, religious, military, and domestic), sculpture,
painting, engraving, music, and the decorative arts of the region.
Most of the textual narrative has been brought up to date in more
recent works, but the heavy annotation is full of useful references and
suggestions.

Tolles, Frederick B., " 'Of the Best Sort but Plain': The Quaker
Esthetic," *American Quarterly,* 11 (Winter 1959): 484–502.
A clear exposition of the relationship of Quakerism to the arts. The
essential spirit of Quakerism may have been anti-esthetic in its scorn
of the sensuous and merely ornamental, but there was some relation-
ship between the instincts of Quaker merchants and artisans and the
unfailing soundness of workmanship and sureness of line that char-
acterized the best Philadelphia craftsmanship in the eighteenth cen-
tury. This article was later incorporated into the author's *Quakers
and the Atlantic Culture* (1960) as a chapter.

Tracy, Berry B., and William H. Gerdts, *Classical America, 1818–
1845: An Exhibition at The Newark Museum.* Newark, 1963.
Pp. 212.
A superb catalogue of an exhibition of American decorative and
fine arts from the first half of the nineteenth century; choice objects
were lent from scores of public and private collections. Tracy's
chapters on the decorative arts (furniture, silver, ceramics, glass, wall-
paper and textiles, and lamps, stoves, and clocks) each begin with a
general historical essay before plunging into the catalogue descrip-
tions; he concludes with an admirable bibliography. Gerdts' section on
the fine arts, though shorter, is of high quality and also concludes
with a bibliography. The larger part of the 295 items in the catalogue
are illustrated. A model museum publication.

Wright, Louis B., *The Cultural Life of the American Colonies, 1607–1763* [New American Nation Series]. New York, 1957. Pp. xiv, 292.

A work of sweeping synthesis on the essential lineaments of a century and a half of American life, yet written with remarkable balance in the choice of materials and emphasis.

III. ARCHITECTURE

A. General Works

Andrews, Wayne, *Architecture, Ambition and Americans*. New York, 1955. Pp. xxv, 315.

An only partly successful attempt to combine a history of architecture with a history of taste. Also available in paperback.

Briggs, Martin S., *The Homes of the Pilgrim Fathers in England and America, 1620–1685*. London, 1932. Pp. xvi, 211.

An extremely useful comparative study which places early New England architecture (especially Essex Co., Massachusetts) in proper perspective with English antecedents. Contains numerous excellent line drawings.

Condit, Carl W., *American Building Art: The Nineteenth Century*. New York, 1960. Pp. xvii, 371.

A comprehensive history of the structural forms and building techniques used by architects and engineers in nineteenth-century America. The author, whose background is in the history of science, discusses with unusual competence the building technology of wood and iron framing, bridge trusses, suspension bridges, iron arch bridges, and concrete construction—all introduced and used in the United States before 1825. For illustrative purposes, he has appended in lengthy notes detailed analytical descriptions of particular works, giving dimensions, loads, stresses, and other quantitative material.

Dorsey, Stephen P., *Early English Churches in America, 1607–1807*. New York, 1952. Pp. xvi, 206.

Two centuries of Anglican church building; especially strong on early churches in Virginia.

Eberlein, Harold Donaldson, and Cortlandt Van Dyke Hubbard, *American Georgian Architecture*. Bloomington, Ind., 1952. Pp. xii, 56.

An historical and descriptive analysis, with a proper emphasis on such fine achievements as Independence Hall, the Wren Building at

the College of William and Mary, and the spire of the Old Baptist Church of Providence.

Hamlin, Talbot, *Greek Revival Architecture in America: Being an Account of Important Trends in American Architecture and American Life Prior to the War between the States.* London, 1944. Pp. xi, 439.

Hamlin brought thorough documentation and critical understanding to the writing of American architectural history, and probably more than any other individual brought about the significant alterations in that discipline in the quarter century before his death. *Greek Revival Architecture in America* was one of his great books. He concentrates on "architect's architecture," where stylistic elements and design are uppermost, and attempts to attribute the architects of once-anonymous buildings. Also available in paperback.

Historic American Buildings Survey: Catalog of the Measured Drawings and Photographs of the Survey in the Library of Congress, March 1, 1941. Washington, 1941. Pp. vii, 470.

A *Catalog Supplement* published in 1959 and an updated listing for New Hampshire in the October 1963 issue of *Historical New Hampshire* (the first of a series of updated state lists) make the *Survey* increasingly useful.

Hitchcock, Henry-Russell, *American Architectural Books: A List of Books, Portfolios, and Pamphlets on Architecture and Related Subjects Published in America before 1895.* 2d edn., Minneapolis, 1962. Pp. xii, 130.

First published in 1946. A bibliography of architectural books published in America between the Revolution and the end of the nineteenth century. Arranged alphabetically by author and indexed by subject. The first title published in America was *The British Architect* (1775), a Philadelphia edition of a work by the English carpenter-builder, Abraham Swan. This book in addition to the other earliest American imprints were of the "Builders' Guide" type—plates of the orders and plates of structural and ornamental detail.

Isham, Norman Morrison, *Early American Houses.* The Walpole Society, 1928. Pp. 61. 33 plates.

Excellent little book on architectural nomenclature, with numerous architect's drawings of framing details. But Isham's elaborate "theory of growth" of New England houses by the addition of rooms and lean-tos has since been proven mistaken by Anthony Garvan.

Isham, Norman Morrison, *A Glossary of Colonial Architectural Terms.* The Walpole Society, 1939. Pp. 37.

A glossary of architectural terms, illustrated with drawings, arranged alphabetically.

Kettell, Russell Hawes, ed., *Early American Rooms: A Consideration of the Changes in Style between the Arrival of the Mayflower and the Civil War in the Regions Originally Settled by the English and the Dutch.* Portland, Maine, 1936. Pp. xvii, 200.
A collection of twelve essays, each by a different author, each on a period room built sometime between the seventeenth and the middle of the nineteenth centuries. All are between Massachusetts and Virginia and all are open to the public. This book is important on many counts, but particularly as the most elaborately reasoned out apologia for the "Period Room" and supplier of the *raison d'être* for the early American museums and restorations as we know them today.

Kimball, Fiske, "Architecture in the History of the Colonies and of the Republic," *American Historical Review*, 27 (Oct. 1921): 47–57.
A significantly early, informed challenge to professional historians to incorporate the artistic aspects of American history, particularly architectural history, into their writings. The article was full of seminal ideas and new concepts for the time, many of which have received further elaboration at the hands of subsequent scholars.

Kimball, Fiske, *Domestic Architecture of the American Colonies and of the Early Republic.* New York, 1922. Pp. xx, 314.
A survey that is, though dated, still a classic on American domestic architecture from the early seventeenth century, through the eighteenth, and into the early nineteenth century.

Morrison, Hugh, *Early American Architecture.* New York, 1952. Pp. xiv, 619.
The best and most comprehensive one-volume treatment of early American architecture; the book is nearly evenly divided between Colonial architecture (seventeenth-century American building) and Georgian architecture (American building between 1700 and 1780).

Park, Helen, "A List of Architectural Books Available in America before the Revolution," *Journal of the Society of Architectural Historians*, 20 (Oct. 1961): 115–30.
A highly significant study documenting the availability and influence of design books in colonial America.

Rose, Harold Wickliffe, *The Colonial Houses of Worship in America, Built in English Colonies before the Republic, 1607–1789, and Still Standing.* New York, 1964. Pp. xiv, 574.
The author records in text and photographs 345 colonial houses of worship built in the English colonies before 1789 that are still extant; this number includes churches, chapels, meetinghouses, manor and Mass houses, cloisters, halls, and synagogues.

Roos, Frank J., Jr., *Writings on Early American Architecture.* Columbus, Ohio, 1943. Pp. viii, 271.

Bibliography of 2,700 titles on American architecture (before 1860), with cross-references to subject, style, author, and geographical location, all thoroughly indexed.

Shurtleff, Harold R., *The Log Cabin Myth: A Study of the Early Dwellings of the English Colonists in North America.* Edited with an Introduction by Samuel Eliot Morison, Cambridge, 1939. Pp. xxi, 243.
With conclusive documentation Shurtleff has demolished the popular belief that the early English settlers chose as their type of dwelling the log cabin that was later so conspicuous and typical a feature of the North American frontier. Rather, after building temporary structures, they built in the traditional English styles they had known at home: framed wooden houses, covered with clapboard, roofed with thatch or cedar shingle, and filled between outer wall and interior sheathing with wattle-and-daub, nogging, or plain clay daubing.

Sinnott, Edmund W., *Meetinghouse & Church in Early New England.* New York, Toronto, London, 1963. Pp. 243.
Excellent photographs and the check lists by state of meetinghouses and churches built by 1830 and still standing help compensate for an uninspired text.

Waterman, Thomas Tileston, *The Dwellings of Colonial America.* Chapel Hill, 1950. Pp. 312.
An architectural survey of the great houses of pre-Revolutionary America, particularly of southern domestic architecture.

B. Architects

1. WILLIAM BUCKLAND

Beirne, Rosamond Randall, and John Henry Scarff, *William Buckland, 1734–1774: Architect of Virginia and Maryland.* Baltimore, 1958. Pp. xvi, 176.
Buckland, who was born in England and emigrated to America in 1755, came to architecture as a trained craftsman—a joiner. He worked in Virginia and Maryland and designed, among other things, the woodwork at Gunston Hall and the Hammond-Harwood house at Annapolis.

2. CHARLES BULFINCH

Brown, Frank Chouteau, "The Joseph Barrell Estate, Somerville, Massachusetts, Charles Bulfinch's First Country House," *Old-Time New England,* 38 (Jan. 1948): 53–62.

An account of the design and construction of Bulfinch's first commission for a complete country house—the mansion built for the Boston merchant, Joseph Barrell, in Charlestown, 1792.

Bulfinch, Ellen Susan, *The Life and Letters of Charles Bulfinch, Architect, with Other Family Papers*. Boston and New York, 1896. Pp. xiv, 323.
A valuable collection of letters to and from Bulfinch, mortised together with an affectionate biography, edited and written by his granddaughter. Unfortunately, many of the letters are excised and she has made few attempts to date drafts.

Cummings, Abbott Lowell, "Charles Bulfinch and Boston's Vanishing West End," *Old-Time New England*, 52 (Oct.–Dec. 1961): 31–49.
An analysis of Bulfinch's buildings in a section of Boston that was threatened and since largely demolished.

Kirker, Harold and James, *Bulfinch's Boston, 1787–1817*. New York, 1964. Pp. ix, 305. 24 plates.
A sympathetic and competent biography of Charles Bulfinch (1763–1844) during his years as the leading architect and civic leader of Boston. The book explains the way in which he imposed his Georgian style and ideas on the city of Boston for the thirty years following his return from the Grand Tour in 1787. As architect he drew up and executed the plans for the Massachusetts State House and the Beacon Hill area; he planned the first theater and completely redesigned the wharf area. As civic leader he was a major force in Boston politics, society, reform, education, and town planning. Harold Kirker has published subsequently a newly discovered elevation and plan of "Bulfinch's Design for the Massachusetts State House" from the Stokes Collection in *Old-Time New England*, 55 (Fall 1964): 43–46.

Place, Charles A., *Charles Bulfinch, Architect and Citizen*. Boston and New York, 1925. Pp. xv, 295.
An old yet still serviceable biography of Bulfinch, combining his civic and professional careers. The book begins with his early years designing churches; his maturity in the state houses of Connecticut and Massachusetts; his pre-War of 1812 residences; his commercial, educational, and religious buildings between 1812 and 1817; and finally his last dozen years spent in Washington after 1817 working on federal buildings and the National Capitol.

3. HENRY CANER

Seymour, George Dudley, "Henry Caner, 1680–1731, Master Carpenter, Builder of the First Yale College Building, 1718, and of the

Rector's House, 1722," *Old-Time New England*, 15 (Jan. 1925): 99–124.

4. MAXIMILIAN GODEFROY

Davison, Carolina V., "Maximilian and Eliza Godefroy," *Maryland Historical Magazine*, 29 (March 1934): 1–20.

Davison, Carolina V., ed., "Maximilian Godefroy," *Maryland Historical Magazine*, 29 (Sept. 1934): 175–212.

The first article is a summary of Godefroy's architectural achievements in America and a brief statement of the literary production of Eliza Godefroy. The second contains an autobiographical account of his life written much later, probably in the 1830's. The French text is published with a translation by Gilbert Chinard, who collaborated with Miss Davison in seeking information from France. Godefroy was a French architect who worked in Baltimore, Washington, Philadelphia, and Richmond between 1805 and 1819. Among his works is the surviving Chapel of Saint Mary's Seminary in Baltimore—an early example of the Gothic style in the United States (1806).

Quynn, Dorothy Mackay, "Maximilian and Eliza Godefroy," *Maryland Historical Magazine*, 52 (March 1957): 1–34.

A revision and up-dating of the Davison articles through an investigation of the French sources. Mrs. Quynn's research seems to indicate that Godefroy claimed credit for more than he actually did.

5. PETER HARRISON

Bridenbaugh, Carl, *Peter Harrison, First American Architect*. Chapel Hill, 1949. Pp. xi, 195.

A complete biographical portrait of the most distinguished architect of the colonies. Bridenbaugh gives a thorough analysis of Harrison's architectural monuments, designed during the fifteen years of his activity (1748–1763), and points out the architect's adoption of the Palladian academicism of the Early Georgian period in England, a complete classical temple form, and the full-height classic portico for churches. Bridenbaugh brought the book up to date with new discoveries in "Peter Harrison Addendum," *Journal of the Society of Architectural Historians*, 18 (Dec. 1959): 158–59.

6. THOMAS JEFFERSON

Bear, James A., Jr., *Old Pictures of Monticello, An Essay in Historical Iconography*. Charlottesville, 1957. Pp. 32.

A chronological reproduction of views of Monticello from Jefferson's first sketch, *circa* 1770, to the present, with descriptive notes by the Curator of Monticello.

Berman, Eleanor Davidson, *Thomas Jefferson Among the Arts.* New York, 1947. Pp. xviii, 305.
An attempt to survey the esthetic views and tastes of Thomas Jefferson on the philosophy of art, painting, sculpture, architecture, gardening, music, rhetoric, and literature. Attention is given to the formative sources that shaped the framework of his criticism.

Kimball, Fiske, *Thomas Jefferson, Architect.* Boston, 1916. Pp. vii, 205, plates, xi.
A magnificent folio volume containing the Jefferson plans collected by Thomas Jefferson Coolidge, Jr. (now in the Massachusetts Historical Society) with an essay and notes by Fiske Kimball.

Lambeth, William Alexander, and Warren H. Manning, *Thomas Jefferson, As an Architect and a Designer of Landscapes.* Boston and New York, 1913. Pp. x, 122. 23 plates.
An analysis of Jefferson's resourcefulness and imagination as an architect at Monticello and in the University of Virginia buildings, with long printed extracts from his correspondence.

Nichols, Frederick Doveton, *Thomas Jefferson's Architectural Drawings.* 2d edn., Boston and Charlottesville, 1961. Pp. 46. 30 plates.
A digested and updated version of Fiske Kimball's *Thomas Jefferson, Architect,* based on Jefferson's architectural drawings in the Massachusetts Historical Society. The foreword is a succinct treatise on Jefferson the architect. The first edition was prepared as a picture book in connection with a Massachusetts Historical Society exhibition; to the second Mr. Nichols added a complete list of Jefferson's architectural drawings.

O'Neal, William B., comp., *A Checklist of Writings on Thomas Jefferson as an Architect.* [Charlottesville,] 1959. Pp. 18.
As early as 1828 there was a comparatively full architectural description of the University of Virginia in print; and from 1911 on there is hardly a year without at least one publication in which Jefferson's architecture is mentioned. An important publication of the Bibliographical Society of the University of Virginia.

O'Neal, William B., *Jefferson's Buildings at the University of Virginia, The Rotunda.* Charlottesville, 1960. Pp. 62. 22 plates.
The first of three proposed volumes on the architecture of the University of Virginia, the finest group of early college buildings in the country. The other two will be devoted to the pavilions and the ground plans. This new little study adds little to what Fiske Kimball had to say about the Rotunda in his *Thomas Jefferson, Architect,* except that

the author has added a section of relevant documents, many of them heretofore unpublished.

O'Neal, William B., *Jefferson's Fine Arts Library for the University of Virginia.* Charlottesville, 1956. Pp. 53.
A full bibliographical annotated listing or reconstruction of the fine arts books Jefferson selected and arranged for the purchase of at the University of Virginia. An appendix lists those books now in the University Library, remaining from or replacing books from the original fine arts collection; using this list the librarians are making an effort to replace all books in the original group that have not survived.

Truett, Randle Bond, *Monticello, Home of Thomas Jefferson.* New York, 1957. Pp. 72.
A pictorial guide to Monticello. Since 1955 the renovation of the mansion has been under the direction of Milton Grigg; his schematic drawing of the floor plan around 1800 is one of the most interesting illustrations in the book.

7. BENJAMIN HENRY LATROBE

Hamlin, Talbot, *Benjamin Henry Latrobe.* New York, 1955. Pp. xxxvi, 633.
Hamlin's definitive life of Latrobe (1764–1820), who between 1796 and 1820 almost single-handedly established architecture as a profession in the United States, introduced the Greek and Gothic Revival styles, and designed some of America's finest public and private buildings.

8. SAMUEL MCINTIRE

Cousins, Frank, and Phil M. Riley, *The Wood-Carver of Salem: Samuel McIntire, His Life and Work.* Boston, 1916. Pp. xx, 168.
An excellent survey of the domestic and public architecture of McIntire, with the emphasis on his design and carving of doorways, porches, mantels, chimney pieces, and interior woodwork.

Kimball, Fiske, *Mr. Samuel McIntire, Carver, The Architect of Salem.* Portland, Maine, 1940. Pp. xiii, 157. 373 plates.
A definitive life and collection of illustrations of the architectural masterpieces, ornamental carving, and drawings of Samuel McIntire of Salem, who has become the most celebrated of the craftsmen-architects of America. The book was made possible by the superb McIntire Collection in the Essex Institute, Salem. Kimball did not treat the furniture attributed to McIntire here, reserving it for a separate volume which was never completed.

9. ROBERT MILLS

Gallagher, H. M. Pierce, *Robert Mills, Architect of the Washington Monument, 1781–1855.* New York, 1935. Pp. xxv, 233.

An excellent biography of Robert Mills, the first native-born architect regularly trained for the profession (under Hoban, Jefferson, and Latrobe). Between 1802 and 1855 he was engaged in constant and varied practice of his profession in Carolina, in Philadelphia, in Baltimore, and in Washington. More than fifty of his works are still surviving, including houses, churches, college buildings, prisons, hospitals, bridges, monuments, and government buildings of all sorts. It is by his monuments, particularly the great Washington column in Baltimore, that Mills is chiefly remembered.

10. WILLIAM SPRATS

Warren, William L., "The Domestic Architecture of William Sprats and Other Litchfield Joiners," *Old-Time New England,* 46 (Fall 1955): 36–51.

Warren, William L., "William Sprats and His Civil and Ecclesiastical Architecture in New England," *Old-Time New England,* 44 (Winter 1954): 65–78; 44 (Spring 1954): 103–114.

11. WILLIAM STRICKLAND

Gilchrist, Agnes Addison, *William Strickland, Architect and Engineer, 1788–1854.* Philadelphia, 1950. Pp. xvii, 145. 50 plates.

Biography of one of the most successful architects of the first half of the nineteenth century. He apprenticed to Latrobe in 1803. He is famous today for such designs as the Second Bank of the United States (1818–24), Philadelphia Exchange (1832–34), Providence Athenaeum (1836), and numerous other government and institutional commissions. Four years after her biography of Strickland was published, enough new material had come to light, particularly letters, for Agnes Addison Gilchrist to publish "Additions to William Strickland, Architect and Engineer, 1788–1854," as a Documentary Supplement to the *Journal of the Society of Architectural Historians,* 13 (Oct. 1954), 16 pp. including 28 plates.

C. French Canada and Maritime Provinces

Gowans, Alan, *Church Architecture in New France.* Toronto, 1955. Pp. xii, 162.

A carefully documented architectural history of churches erected in Canada under the French regime. (Of these few examples survive; therefore, the study is largely based on documentary evidence.) The book is divided into three major chronological periods: 1608–1665, the "Heroic Age" of parish churches in the craft tradition and the more academic churches built by the orders; 1665–1700, the "Age of Laval," when the first Bishop of New France transplanted in the colony advanced architectural ideas from Old France; and 1700–1760, the "Canadien" age, a period when churches were built in a completely indigenous style. The work concludes with a remarkably thorough *catalogue raisonné* listing the churches of New France from 1615 to 1760. (Published simultaneously in this country by Rutgers University Press.)

Gowans, Alan, *Looking at Architecture in Canada*. New York, 1959. Pp. 232. 137 plates.

A historical study of Canadian architecture which successfully encompasses both chronologically and geographically the breadth of this vast subject. The book has been divided into five sections beginning with "The Pioneer Background," followed by a chapter on "New France." Port Royal Habitation at Lower Granville, Nova Scotia, was built in 1605 and marks the beginning of the French tradition in North America. There follows a discussion of "British North American" architecture during the first decades of the nineteenth century which, paralleling the Greek Revival in the United States, dwells largely on British and French classicism, and correctly stresses the importance of English pattern books. Under the heading "The Victorian Age" the author presents a sensitive appreciation of the Victorian social background and its relationship to architecture; since the limits of the Victorian Age extend well into the twentieth century, the survey closes with a chapter entitled "Since 1930."

Gowans, Alan, "New England Architecture in Nova Scotia," *Art Quarterly*, 25 (Spring 1962): 6–33.

The author finds that the domestic architecture of Nova Scotia, built before the American Revolution, is in a distinctive style we recognize as characteristic of New England. In its simplicity, its straightforward construction, its natural use of materials, and its "organic" plans, it is frequently called the New England "plain style." But after the arrival of the Loyalists, through the War of 1812, there was a conscious rejection of this tradition and the official British classical style swept into Halifax. It represented everything the New England tradition was not: coldly precise, classically self-contained, and formally planned. The house-type that resulted in the nineteenth century was a creation of Nova Scotia—reminiscent of both traditions but identical with neither.

MacRae, Marion, and Anthony Adamson, *The Ancestral Roof—Domestic Architecture of Upper Canada, 1783–1867*. Toronto, 1963. Pp. 258. 203 plates.

A comprehensive sampling of the rich variety of nineteenth-century house-types in the Province of Ontario, or, as it was known before Confederation, Upper Canada. The authors have provided a useful schematic summary of the evolution of Ontario house-types in plan, elevation, and detail through drawings. Even though no great original school of architecture has ever arisen in Canada, it is surprising to find how soon there developed in Ontario distinctive regional variants of house-types originating elsewhere. The first houses of any pretension in Ontario were built by American Loyalist refugees in the Adamesque-Federal style, 1783–1812; this light, decorative, playful phase of the classical tradition soon took on a certain distinctive solidity. The British immigrants who arrived in large numbers after 1815 built in a variant of this style identified as Canadian Regency; it soon manifested a certain stolidity. For some inexplicable reason there is a total absence in this otherwise excellent book of any formal documentation.

Morisset, Gérard, *L'Architecture en Nouvelle-France*. Quebec, 1949. Pp. 150.

Like his *Coup d'œil sur les arts*, a distillation of a portion of the vast material collected by the author for the Inventaire des Œuvres d'Art de la Province de Quebec.

Morse, William Inglis, *The Land of the New Adventure (The Georgian Era in Nova Scotia)*. London, 1932. Pp. xviii, 158. 92 plates.

An architectural history of eighteenth-century churches and an analysis of "monumental art" or gravestones in Nova Scotia. The scores of collotype plates add to the importance of this volume.

Quebec, Historic Monuments Commission, *Old Manors, Old Houses*. Quebec, 1927. Pp. viii, 376.

A pictorial guide to Quebec's historic domestic architecture by Pierre-Georges Roy; the text is thin and woefully out of date. Published in French as *Vieux manoirs, vieilles maisons*.

Quebec, Historic Monuments Commission, *Les vieilles églises de la province de Québec*. Quebec, 1925. Pp. vii, 323.

Also compiled by Roy; his counterpart on old churches. An English edition has also been published.

Traquair, Ramsay, *The Old Architecture of Quebec*. Toronto, 1947. Pp. xix, 324.

An attempt of only limited success to bring together the essence of a lifetime of scholarship. Numerous individual studies by Traquair and various collaborators can be found in the *McGill University Publications*, Series XIII (Art and Architecture).

D. New England

1. GENERAL WORKS

Cummings, Abbott Lowell, *Architecture in Early New England*. Sturbridge, Mass., 1958. Pp. 30.
A short but highly informed survey of the distinctive features of construction and decoration of New England buildings, domestic and public, from the seventeenth century through the Greek Revival of the 1830's. An Old Sturbridge Village Booklet.

Donnelly, Marian Card, "New England Meetinghouses in the Seventeenth Century," *Old-Time New England*, 47 (Spring 1957): 85–99.
An imaginative article, based on the author's 1956 doctoral dissertation at Yale University, specifically placing the architecture of New England meetinghouses within the history of Protestant building traditions.

2. MAINE AND NEW HAMPSHIRE

Howells, John Mead, *The Architectural Heritage of the Piscataqua: Houses and Gardens of the Portsmouth District of Maine and New Hampshire*. New York, 1937. Pp. xxvi, 217.
An illustrated survey of the notable examples of eighteenth-century architecture in Portsmouth, N.H., and Kittery Point, Maine, in 301 plates. The pictorial record is of particular importance in cases like that of Sparhawk Hall (*ca.* 1740), which has been gutted of its panelling since Howell's photographs were published.

Speare, Eva A., *Colonial Meeting-Houses of New Hampshire, Compared with Their Contemporaries in New England*. Daughters of Colonial Wars, State of New Hampshire, 1938. Pp. xv, 238.
A digressive and largely uncritical tour of New Hampshire's meetinghouses, but probably a fairly comprehensive treatment of the subject with numerous photographs that are informative.

3. VERMONT

Congdon, Herbert Wheaton, *Early American Homes for Today, A Treasury of Decorative Details and Restoration Procedures.* Rutland, Vt., 1963. Pp. xi, 236.
Useful photographs of early Vermont domestic architecture.

Congdon, Herbert Wheaton, *Old Vermont Houses: The Architecture of a Resourceful People.* Brattleboro, 1940. Pp. 190.
Congdon traces Vermont's architecture from its earliest houses up to 1850 by subject: wooden houses, brick houses, stone houses, a court house and some taverns, doorways, and meetinghouses. There are 124 plates illustrated, which have been conveniently arranged under an alphabetical listing of the counties at the front. A "new edition" was published in New York in 1946 (Pp. xiv, 192).

4. MASSACHUSETTS

Connally, Ernest Allen, "The Cape Cod House: an Introductory Study," *Journal of the Society of Architectural Historians*, 19 (May 1960): 47–56.
The result of a study for the Historic American Buildings Survey. The only thorough study of the subject.

Coolidge, John, "Hingham Builds a Meetinghouse," *New England Quarterly*, 34 (Dec. 1961): 435–461.
A brilliant study of the Old Ship Church in Hingham—the unique survivor of seventeenth-century New England meetinghouses. Coolidge gathers together everything known about the people who built the church and their choices in the plan and form; he concludes that the evidence proves how faithfully New Englanders reproduced a known international type of building for dissenting Protestants.

Coolidge, John, *Mill and Mansion: A Study of Architecture and Society in Lowell, Massachusetts, 1820–1865.* New York, 1942. Pp. xi, 261.
A detailed study of the first Utopian community devoted solely to the exigencies of industry. Lowell on the Merrimack River, as chronicled by the author, is illustrative of the architectural impact of the infant textile industry on New England: new towns were founded on new sites where water power existed ready to be harnessed. In addition to his able delineation of the industrial and social patterns, Coolidge deftly traces the architectural evolution of the mill building, and its concomitant form of industrial housing, through the Federal, the Greek, and Gothic Revival styles, and on into the maze of

stylistic Romanticism which eventually penetrated this stronghold of puritanical paternalism. Published in the series of Columbia Studies in American Culture.

Cousins, Frank, and Phil M. Riley, *The Colonial Architecture of Salem.* Boston, 1919. Pp. xxiii, 282.
An analysis of four periods of Salem architecture covering the years 1628 to 1828: (1) the gable and peaked-roof house; (2) the lean-to house; (3) the gambrel-roof house; and (4) the square three-story house in either brick or wood. Elements of design, ornamentation, and construction peculiar to Salem are discussed and illustrated with 127 plates.

Cummings, Abbott Lowell, "The Foster-Hutchinson House," *Old-Time New England*, 54 (Winter 1964): 59–76.
A fully documented history of the Foster-Hutchinson House, built in Boston in 1689–1692, a house important for its imposing architectural qualities as the first developed example of provincial Palladianism in New England. It was demolished in 1833.

Cummings, Abbott Lowell, "The Old Feather Store in Boston," *Old-Time New England*, 48 (Spring 1958): 85–104.
A complete iconographic study of a single building, in this case, a famous Boston landmark dating from the seventeenth century.

Cummings, Abbott Lowell, "The Parson Barnard House, Formerly Known as the Bradstreet House in North Andover, Mass.," *Old-Time New England*, 47 (Oct.–Dec. 1956): 29–40.
An excellent example of the use of documents in disproving local myths.

Cummings, Abbott Lowell, "The 'Scotch'-Boardman House, A Fresh Appraisal," *Old-Time New England*, 43 (Jan.–Mar. 1953): 57–73; 43 (Apr.–June 1953): 91–102.
Illustrative of the manner by which an historian goes about researching a house from court records.

Feld, Stuart Paul, "St. Michael's Church, Marblehead, Massachusetts, 1714," *Old-Time New England*, 52 (Apr.–June 1962): 91–113; 53 (Oct.–Dec. 1962): 31–48.
In addition to documenting the original features of the building, changes, and additions, the author relates its general character to traditional ecclesiastical architecture.

Foley, Suzanne, "Christ Church, Boston," *Old-Time New England*, 51 (Jan.–Mar. 1961): 67–85.
A model architectural study of a church building around which a great deal of sentiment and myth has grown.

Garrett, Wendell D., *Apthorp House, 1760–1960*. Cambridge, 1960. Pp. xviii, 100.
A study of a Cambridge house, possibly designed by Peter Harrison, which stresses historical and cultural materials as well as architectural.

Hitchings, Sinclair H., and Catherine H. Farlow, *A New Guide to the Massachusetts State House*. Boston, 1964. Pp. 108.
A full social and architectural history of Bulfinch's greatest monument, the Massachusetts State House, built on Beacon Hill between 1795 and 1798. Most of the important views of the building (beginning with an 1805 water color and extending through a number of unique photographs taken early in this century) are reproduced. A number of contemporary photographs of architectural details and portraits of past state officials are also included. The "biography" of this important architectural landmark concludes with a reprinting from the *Columbian Centinel* of the description of the structure at its dedication in January 1798.

Howells, John Mead, *The Architectural Heritage of the Merrimack*. New York, 1941. Pp. xxiii, 229.
A pictorial survey of the early houses and gardens in the valley of the Merrimack River, which winds for a hundred miles from its source in New Hampshire near the towns of Tilton and Franklin, Boscawen and Penacook, down to Newburyport in Massachusetts. The volume stresses the architecture of Newburyport, Newbury, Amesbury, Georgetown, Old Town, and Haverhill in Massachusetts, and Concord in New Hampshire. There are 302 plates of illustrations.

Kilham, Walter H., *Boston After Bulfinch: An Account of Its Architecture, 1800–1900*. Cambridge, 1946. Pp. xv, 114, xxxii.
Discusses the work of Bulfinch, Benjamin, Banner, McIntire, Parris, and Willard for the pre-1826 period.

Morison, Samuel Eliot, "A Conjectural Restoration of the 'Old College' at Harvard," *Old-Time New England*, 23 (Apr. 1933): 131–58.
Detailed comparative discussion of early college buildings in England and America with plans and pictures.

5. RHODE ISLAND

Cady, John Hutchins, *The Civic and Architectural Development of Providence, 1636–1950*. Providence, 1957. Pp. 320.
A topographical history of Providence with lesser emphasis on the architecture of specific buildings.

Downing, Antoinette F., and Vincent J. Scully, Jr., *The Architectural Heritage of Newport, Rhode Island, 1640–1915.* Cambridge, 1952. Pp. x, 241. 230 plates.

A model of architectural history of an American town; monumental folio in size, sumptuously illustrated. The purpose of the book was to appeal for an enlightened and informed preservation of the incredibly rich architectural remains of Newport.

Downing, Antoinette Forrester, *Early Homes of Rhode Island.* Richmond, Va., 1937. Pp. xviii, 480.

Much in the first half of this book has since been superseded by the author's preceding book on Newport; but the second half, which is particularly strong on Providence architecture from the middle of the eighteenth century, is of great importance. The text is supported with 209 plates of photographs and 80 plates of drawings.

6. CONNECTICUT

Garvan, Anthony N. B., *Architecture and Town Planning in Colonial Connecticut.* New Haven, 1951. Pp. xiv, 166.

Garvan introduces innovation in architectural writing by first discussing Connecticut people of the seventeenth century: the national stock was pure English, prevailingly from the southeastern and northwestern counties. The author is chiefly concerned with the English and continental character of colonial dwellings and with the typical nucleated village in which these frontier shelters were placed. In the concept of house evolution he rejects the "theory of growth" and assumption that all types of colonial houses developed from a single typical model; rather, from its founding, Connecticut had a rich variety of architecture built by colonists derivative from examples they had known in England and Ulster.

Keith, Elmer D., and William L. Warren, "Peter Banner, A Builder for Yale College," *Old-Time New England*, 45 (Spring 1955): 93–102; 47 (Fall 1956): 49–53; 49 (Spring 1959): 104–10; 53 (Spring 1963): 102–9.

A detailed study of the architectural achievements of Banner in the President's House, Berkeley Hall, The Lyceum, and miscellaneous houses in New Haven.

Kelly, J. Frederick, *Early Connecticut Meetinghouses.* 2 vols., New York, 1948. Pp. xxi, 332; xiii, 360.

Like the author's following work this is an exhaustive study of both existing church buildings (87 in number) and documentary sources. Excellent photographs and line drawings add to its usefulness.

Kelly, J. Frederick, *The Early Domestic Architecture of Connecticut.* New Haven, 1924. Pp. xx, 210.
 Kelly's book is afflicted with a crude Darwinism that dominates most early studies of American architectural history: the hypothesis that from humble beginnings house style grew by accretion and additions from a single-room, end-chimney house into a two-room plan with central chimney, and finally incorporated the lean-to into its floor plan. This assumption has been proven unjustified by Garvan. Yet Kelly's work still remains the best descriptive analysis of framing techniques, architectural nomenclature, building materials, and the variations in the joinery of the cornice, panelling, mantels, cupboards, stairs, and mouldings. All of his successors in this field have drawn on his 242 detailed drawings and 48 plates of illustrations of Connecticut domestic architecture. Forty years after it was published, this volume still remains one of the great books in early American architecture. Also available in paperback.

E. Middle States

1. NEW YORK

Eberlein, Harold Donaldson, *The Manors and Historic Homes of the Hudson Valley.* Philadelphia and London, 1924. Pp. xvii, 328.
 This book, like all of those by Eberlein, suffers from imprecision as social and architectural history; yet again and again the author's books fill a need not yet met by updated, more scholarly studies. Eberlein surveys domestic architecture and ranks houses by their association with great personages and historic events, by their antiquity, and by their size or scale. In this volume he studies about 45 seventeenth- and eighteenth-century houses on the shores of the Hudson from New York to Albany, excluding those within the boundaries of New Jersey and those on Long Island and Staten Island.

Eberlein, Harold Donaldson, *Manor Houses and Historic Homes of Long Island and Staten Island.* Philadelphia and London, 1928. Pp. xi, 318.
 A sequel study to Eberlein's Hudson Valley book, investigating the domestic architecture of the insular portion of southeastern New York —33 houses on Long Island and 8 on Staten Island—built prior to 1800. There are 75 illustrations.

Reynolds, Helen Wilkinson, *Dutch Houses in the Hudson Valley Before 1776.* New York, 1929. Pp. 467.
 A publication of the Holland Society of New York with material arranged by county and generously illustrated.

2. NEW JERSEY

Bailey, Rosalie Fellows, *Pre-Revolutionary Dutch Houses and Families in Northern New Jersey and Southern New York*. New York, 1936. Pp. 612.
A companion volume to Reynolds's *Dutch Houses in the Hudson Valley* with a similar arrangement of material.

Bill, Alfred Hoyt, *A House Called Morven: Its Role in American History, 1701–1954*. Princeton, 1954. Pp. xi, 206.
Princeton house built *ca.* 1701 by Richard Stockton, a Quaker, and occupied by generations of Stocktons, including Elias Boudinot when the Continental Congress met in Princeton in 1783 and Richard F. Stockton who played a leading role in the conquest of California. The house is now owned by the State of New Jersey. George B. Tatum has written an excellent chapter on the architecture of the house.

Gowans, Alan, *Architecture in New Jersey: A Record of American Civilization* [The New Jersey Historical Series, Vol. 6]. Princeton, 1964. Pp. xiii, 161.
A short but highly informed discussion of three hundred years of New Jersey architecture divided into four periods: Medieval, Classical, Victorian, and Twentieth-Century. By a "Medieval" building tradition, Gowans means seventeenth-century houses with a contiguous plan, frankly exposed materials, and haphazard fenestration expressing the absence of a systematic interior plan. During this period at least three groups of settlers introduced their distinctive national traditions of folk building into New Jersey: the Swedes (patterned brickwork of glazed headers against plain stretchers), New Englanders (frame and clapboard wooden houses), and New Netherlanders (long, low, stone or shingled walls and the roof sweeping far out at the eaves to form a porch). In the eighteenth-century buildings of the state, he demonstrates their "Classical" characteristics: natural patterns and textures of their materials are concealed, and overall symmetry and a new sense of proportion is crisply defined and precisely coordinated. The author makes no claims of greatness or originality in New Jersey architecture, but rather an openness to diverse influences from all sides representing the changing tastes and permanent values of American life.

Greiff, Constance, and Mary Gibbons, "The Changing Face of Princeton," *The Princeton University Library Chronicle*, 25 (Spring 1964): 184–208.
A prize example of local architectural history. This study covers the buildings of Princeton, New Jersey, over almost three hundred years. Illustrated with sixteen plates.

Savage, Henry Lyttleton, ed., *Nassau Hall, 1756–1956*. Princeton, 1956. Pp. ix, 188.
A collection of essays by six scholars on Nassau Hall as originally built, its later transformations, uses, and iconography.

3. PENNSYLVANIA

Brumbaugh, G. Edwin, *Colonial Architecture of the Pennsylvania Germans* [Pennsylvania German Society, *Proceedings*, XLI]. Lancaster, 1933. Pp. iii, 60. 105 plates.
Brumbaugh emphasizes the European background and sources of Pennsylvania German architecture. The illustrations are accompanied by useful and instructive captions.

Cousins, Frank, and Phil M. Riley, *The Colonial Architecture of Philadelphia*. Boston, 1920. Pp. xix, 248.
A discussion of the regional characteristics of greater Philadelphia Georgian architecture, from the building materials and external finish (brick, ledge stone, plastered stone, and hewn stone) to the design and joinery of doorways and porches, windows and shutters, halls and staircases, mantles and chimney pieces.

Dickson, Harold E., *A Hundred Pennsylvania Buildings*. State College, Pa., 1954. Pp. 128.
One of the better surveys of regional architecture, from the Swedish log house, through intermediate stages, down to the present.

Dornbusch, Charles H., *Pennsylvania German Barns* [The Pennsylvania German Folklore Society, Vol. 21]. Allentown, 1958. Pp. xxiv, 312.
A valuable work on the architecture of barns in Pennsylvania, begun by Dornbusch and completed by John K. Heyl. There are 150 pages of illustrations.

Historic Philadelphia, from the Founding until the Early Nineteenth Century: Papers Dealing with Its People and Buildings, with an Illustrative Map [American Philosophical Society, *Transactions*, XLIII, Part 1]. Philadelphia, 1953. Pp. 331.
An architectural survey written soon after the transfer from the City of Philadelphia to the National Park Service in 1951 of Independence Hall and the buildings and Square that surround it. This volume grew out of the planning and work towards that great restoration project. Here are articles devoted to the Independence Hall Group, Philosophical Hall, Philadelphia Exchange, Carpenters' Hall, Library Hall, and the Pennsylvania Hospital.

Massey, James C., ed., *Two Centuries of Philadelphia Architectural Drawings: Catalogue of the Exhibit Held at the Philadelphia Museum of Art by the Society of Architectural Historians.* Philadelphia, 1964. Pp. vi, 112.
A catalogue of 109 architectural drawings that have survived in institutions and private collections, largely by deceased Philadelphia architects of buildings in the Philadelphia area. However, some drawings by local architects working elsewhere, and conversely, by out of town architects working in Philadelphia, have been included. Illustrated with only twelve plates.

Murtagh, William John, "The Philadelphia Row House," *Journal of the Society of Architectural Historians*, 16 (Dec. 1957): 8–13.
Houses are described in terms of four basic types, and extant examples are examined; representative plans and photographs are included.

Tatum, George B., *Penn's Great Town, 250 Years of Philadelphia Architecture Illustrated in Prints and Drawings.* Philadelphia, 1961. Pp. 352. 145 plates.
Scores of prints and drawings illustrate the growth, development, and spread of the city's physical body over 250 years through successive seas of styles. The text illuminates how Philadelphia has become, as much as any city can, a microcosm of architectural happenings for almost three hundred years.

Tinkcom, Harry M., Margaret B. Tinkcom, and Grant Miles Simon, *Historic Germantown, From the Founding to the Early Part of the Nineteenth Century: A Survey of the German Township* [American Philosophical Society, *Memoirs*, Vol. 39]. Philadelphia, 1955. Pp. vii, 154.
An excellent study divided into two parts: "The History" by the Tinkcoms, and "The Architecture" by Simon. A survey has been made of eighty-five buildings because of either their historical associations or architectural interest. Dimensioned floor plans, photographic illustrations, and a description of each building as it exists today, with comments on its state of preservation, have been provided. The Tinkcoms have included an extensive bibliography.

Wainwright, Nicholas B., *Colonial Grandeur in Philadelphia: The House and Furniture of General John Cadwalader.* Philadelphia, 1964. Pp. xii, 169.
An authoritative record of how a great Philadelphia town house was furnished and decorated in pre-Revolutionary times. This study is based on the bills of carpenters and cabinetmakers, recently discovered, for General John Cadwalader's residence, said in the 1770's to

have been the grandest and most magnificently furnished in the city. The author has facsimiled and illustrated receipts and inventories of the house, family portraits, architectural details of other contemporary Philadelphia mansions, and a number of pieces of Philadelphia Chippendale furniture once owned by the Cadwalader family.

4. DELAWARE

Sweeney, John A. H., *Grandeur on the Appoquinimink; the House of William Corbit at Odessa, Delaware*. Newark, 1959. Pp. xiv, 146.
An analysis of an unusually well-documented house as well as a study of William Corbit and the town of Odessa.

5. MARYLAND

Hammond, John Martin, *Colonial Mansions of Maryland and Delaware*. Philadelphia and London, 1914. Pp. xiii, 304.
The story of twenty-nine houses in Maryland and eight in Delaware, built between 1735 and 1800, told largely in terms of the families (rarely *a* family) who have occupied them. The book being fifty years old, the seventy-five illustrations themselves are of great interest and some rarity now.

Howland, Richard H., and Eleanor P. Spencer, *The Architecture of Baltimore: A Pictorial History*. Baltimore, 1953. Pp. xx, 149.
Sponsored by the Peale Museum of Baltimore, this book covers the architecture of Baltimore from its beginnings in the eighteenth century down to the early part of this century. It is concerned chiefly with buildings of commerce and industry, town and country houses of the leaders of trade and manufacture, and churches built by that wealth.

Radoff, Morris L., *Buildings of the State of Maryland at Annapolis*. Annapolis, 1954. Pp. xii, 140.
Valuable contribution to the documentation of the erection, the builders, and business methods employed in constructing the public buildings of Annapolis.

6. WASHINGTON, D.C.

Fairman, Charles E., *Art and Artists of the Capitol of the United States of America*. Washington, 1927. Pp. xiii, 526.
A heavily documented account of the Capitol during its construction and at every stage of its history.

Frary, I. T., *They Built the Capitol*. Richmond, 1940. Pp. xvi, 324.
A popular, though not sufficiently detailed, study of the extensions
to the Capitol, told largely in terms of short biographies of the
succession of architects who have worked on the building. Illustrated
with nearly a hundred plates. A concluding fifty-page annotated
"Chronology" is one of the most valuable features of the book.

United States Capitol Historical Society, *We, the People: The Story
of the United States Capitol, Its Past and Its Promise*. Washing-
ton, 1963. Pp. 145.
A well-illustrated volume that serves as a companion to the White
House *Guide* published the previous year.

White House Historical Association, *The White House, An Historic
Guide*. Washington, 1962. Pp. 130.
An historical account of the architecture, the furnishings, and the
occupants of America's most famous dwelling, with text written by
Mrs. John N. Pearce.

F. Southern States

1. GENERAL WORKS

Forman, Henry Chandlee, *The Architecture of the Old South: The
Medieval Style, 1585–1850*. Cambridge, 1948. Pp. 203.
Medieval (Gothic) construction methods dominated building in
the continental colonies from Maryland to Georgia and in the Ber-
mudas, from their first settlement to the end of the seventeenth
century. The author describes five chief types of construction used
during the ascendancy of the medieval style in the Southern colonies:
the palisade, building with puncheons, the use of crucks, the use of
vertical posts some distance apart and filling with wattle-and-daub
or bricks, and finally the use of brick walls. These methods, the
author argues, continued to influence strongly building in the Geor-
gian style.

2. VIRGINIA

Brock, Henry Irving, *Colonial Churches in Virginia*. Richmond, 1930.
Pp. x, 94.
Good photographs with rather general architectural and historical
descriptions of each church.

Claiborne, Herbert A., *Comments on Virginia Brickwork before
1800*. Portland, Maine, 1957. Pp. 47.

A compendium of field notes on Virginia brick usage: brick sizes, the various types of bond, the prevalence or absence of glazed headers, and the uses made of rubbed brick for arches, quoins, water tables, and belt courses.

Cotter, John L., *Archeological Excavations at Jamestown Colonial National Historical Park and Jamestown National Historic Site, Virginia.* Washington, D.C., 1958. Pp. iii, 299.
This report (a major supplement to *New Discoveries at Jamestown,* published in 1957 by Cotter and J. Paul Hudson) presents new data on the several churches and burial grounds, the country houses, more modest dwellings, and other buildings. The work deals with architectural styles and construction methods followed, tracing localized developments during the seventeenth century, and pointing out historic changes.

Lancaster, Robert A., Jr., *Historic Virginia Homes and Churches.* Philadelphia and London, 1915. Pp. xviii, 527.
An illustrated architectural survey that moves chapter by chapter across the state: "Jamestown, Williamsburg, Yorktown," "Hampton Roads and the Lower James," "Richmond, Manchester and the Upper James," "Gloucester and the York River Country," "The Rappahannock and Potomac," "Piedmont and the South Side," "Beyond the Mountains," and "The Eastern Shore." What is of particular interest to the historian in this book are the 316 illustrations of the interiors and exteriors of eighteenth-century Virginia houses and churches as they must have looked through the late nineteenth century and early into this one before the age of restoration and reconstruction.

Noël Hume, Ivor, *Here Lies Virginia: An Archaeologist's View of Colonial Life and History.* New York, 1963. Pp. xx, 317.
A work in which the chief archaeologist for Colonial Williamsburg combines the techniques of archaeology and recorded history. He devotes considerable detail to the crafts, particularly pottery making, which he finds to have been much more extensive than presumed. Here archaeologists have dispelled such old ideas that Virginia homes were bricked with ballast from inbound tobacco ships, and that great quantities of Virginia-made furniture could have survived to become family heirlooms.

Rawlings, James Scott, *Virginia's Colonial Churches: An Architectural Guide Together with Their Surviving Books, Silver, & Furnishings.* Richmond, 1963. Pp. xi, 286.
A sound architectural survey of forty-eight Virginia churches, dating from 1647 to 1776, with a glossary of architectural terms and drawings of architectural details. Unfortunately, only five

churches are illustrated, and there are no scale drawings of the churches.

Sale, Edith Tunis, *Interiors of Virginia Houses of Colonial Times: From the Beginnings of Virginia to the Revolution.* Richmond, 1927. Pp. xxiii, 503.
The text of this book is nothing short of sentimental bilge, but it is filled with an extraordinary number of informative photographs of the interiors of the more than forty houses under discussion, in addition to a floor plan for nearly every one. The work is arranged as a guide book, with the information on the houses grouped on one of the nine "Trails," "Highways," or "Roads" given.

Scott, Mary Wingfield, *Houses of Old Richmond.* Richmond, 1941. Pp. xii, 332.
A kind of architectural census of Richmond's (incorporated in 1742 and made the state capital in 1779) ante-bellum houses, published by the Valentine Museum. The author's descriptions of the 40 extant houses built prior to 1819 are heavily documented from county deed books, land books, will books, insurance records (which include small scale drawings), and account books. This is a magnificent example of architectural history supported, researched, and written on the local level.

Waterman, Thomas Tileston, and John A. Barrows, *Domestic Colonial Architecture of Tidewater Virginia.* New York and London, 1932. Pp. xvii, 191.
The following fifteen pre-Revolutionary Virginia houses are given good pictorial and descriptive analysis: Adam Thoroughgood House, Greenspring, Bacon's Castle, Fairfield, Ampthill, President's House (College of William and Mary), Stratford, Westover, Rosewell, Carter's Grove, Cleve, Wilton, Mount Airy, Blandfield, and Menokin. The authors have appended helpful schematic drawings of "Details of Profiles" (e.g., architraves, dado caps, pilaster bases, string courses, etc.) and comparative "Outline Plans" on all of the houses.

Waterman, Thomas Tileston, *The Mansions of Virginia, 1706–1776.* Chapel Hill, 1945. Pp. 456.
An ambitious, comprehensive survey, with photographs and drawings, of the domestic architecture of the Virginia tobacco country of the eighteenth century (e.g., Westover, Stratford, Mount Airy, Rosewell, Marmion, Shirley, Mount Vernon, and the Governor's Palace). The book suffers from thin documentation and the author's questionable attribution of the Governor's Palace to Sir Christopher Wren.

Whiffen, Marcus, "The Early County Courthouses of Virginia," *Journal of the Society of Architectural Historians*, 18 (March 1959): 2–10.
A survey of the architectural development of Virginia courthouses, from the time they were built in the form of an ordinary house down to the time when they assumed the standard forms of Romantic Classicism.

Whiffen, Marcus, *The Eighteenth-Century Houses of Williamsburg: A Study of Architecture and Building in the Colonial Capital of Virginia.* New York, 1960. Pp. xx, 234.
Second volume in the Williamsburg Architectural Studies. This book is architectural history in the best sense and treats Williamsburg houses that have survived from the eighteenth century. The first part of the study surveys building material, the various building crafts and craftsmen, the general design of the houses built, and the construction and detail of the houses. The second part is a pictorial survey.

Whiffen, Marcus, *The Public Buildings of Williamsburg, Colonial Capital of Virginia.* Williamsburg, 1958. Pp. xvi, 269.
An outstanding work of architectural scholarship; the author shows how the College of William and Mary and the Capitol were the first examples of new building types in the colonies; how the Governor's Palace set a new standard for the larger plantations; how Bruton Parish Church was the first cruciform church plan in Virginia; how the Magazine was regarded as a model structure; how the Courthouse of 1770 was the ancestor of the porticoed courthouse of Virginia; and how the Public Hospital was important to medical architecture.

3. NORTH CAROLINA

Dill, Alonzo Thomas, *Governor Tryon and His Palace.* Chapel Hill, 1955. Pp. xiii, 304.
Part of this book on the life and times of North Carolina's colonial governor William Tryon is on the palace he built between 1767 and 1770 in New Bern, apparently designed by the English architect John Hawks who accompanied Tryon to his first American post in 1764.

Johnston, Frances Benjamin, and Thomas Tileston Waterman, *The Early Architecture of North Carolina, A Pictorial Survey with an Architectural History.* Chapel Hill, 1941. Pp. xxiii, 290.

A collaboration between a distinguished photographer, supported by the Carnegie Corporation of New York, and an historically minded architect, resulting in a small folio pictorial survey, interspersed with brief chapters of architectural comment, illustrated by ground plans.

4. SOUTH CAROLINA

Leiding, Harriette Kershaw, *Historic Houses of South Carolina.* Philadelphia and London, 1921. Pp. xvii, 318.
Heavily anecdotal, but still important for the 100 illustrations and the encyclopedic information on the occupants of these ante-bellum houses.

Ravenel, Beatrice St. Julien, *Architects of Charleston.* Charleston, 1945. Pp. xvi, 329.
Biographical account of architects working in Charleston, illustrated by examples of their buildings, published by the Carolina Art Association.

Smith, Alice R. Huger, and D. E. Huger Smith, *The Dwelling Houses of Charleston, South Carolina.* Philadelphia and London, 1917. Pp. 387.
Neither good architectural history nor good social history, but in the authors' attempt to move through chronological periods of domestic architecture by focusing on streets and districts, a great deal of important information has been recorded. Over 100 illustrations.

Stoney, Samuel Gaillard, *Plantations of the Carolina Low Country*, 3d edn., Charleston, 1955. Pp. 247.
An historical sketch of the country and the people, with photographs taken in 1928 by Ben Judah Lubschez and in 1938 by Frances Benjamin Johnston, with plans and elevations by the editors, Albert Simons and Samuel Lapham, Jr., and other architects. First published in 1938 by the Carolina Art Association; similar in format to the Johnston-Waterman volume on North Carolina and the Nichols-Johnston volume on Georgia.

Stoney, Samuel Gaillard, *This is Charleston, A Survey of the Architectural Heritage of a Unique American City.* Charleston, 1960. Pp. x, 137.
A pictorial survey and classification, first published in 1944 by the Carolina Art Association, with a view to encouraging historic preservation, revised and republished in 1960, with the notation "GONE" against certain buildings.

5. GEORGIA

Davidson, William H., *Pine Log and Greek Revival: Houses and People of Three Counties in Georgia and Alabama*. Alexander City, Ala., 1964. Pp. vii, 396.
A pictorial and historical survey of ante-bellum and post-bellum houses in the area around West Point, Georgia (portions of Troup County and Harris County in Georgia and Chambers County in Alabama). The book demonstrates the rigid architectural conservatism of a rural region where most houses were built by carpenter-builder-contractor teams, aided by an itinerant architect only occasionally. Once a successful plan was found to be workable and popular, it was assiduously repeated for generations. A publication of the Chattahoochee Valley Historical Society.

Nichols, Frederick Doveton, *The Early Architecture of Georgia* [with A Pictorial Survey by Frances Benjamin Johnston]. Chapel Hill, 1957. Pp. xvi, 292.
Sections on town planning, domestic building in the coastal area, domestic building in the Piedmont, and public buildings. Strong on the neoclassical architecture of the early nineteenth century; a solid account on the beautifully planned houses by William Jay at Savannah.

6. FLORIDA

Gjessing, Frederik C., and others, "Evolution of the Oldest House, Written for the St. Augustine Historical Society," *Notes in Anthropology* [Florida State University], 7 (1962). Pp. 129.
A careful cooperative archaeological study of a building frequently touted for tourists as a sixteenth-century survival, with detailed reports of excavations, and drawings showing the evolution of the present building, through the eighteenth and nineteenth centuries, from a one-story, one-room-deep house to its present form. A valuable example of the manner in which archaeology can demolish romantic day-dreaming.

7. KENTUCKY

Newcomb, Rexford, *Architecture in Old Kentucky*. Urbana, 1953. Pp. ix, 185. 70 plates.
Replaces the author's earlier, less successful *Old Kentucky Architecture* (New York, 1940). He compares with keen insight architec-

tural developments in Kentucky to parent achievements in Virginia, Maryland, and Pennsylvania. Covering the period 1800–1860, he analyzes the chronological lag in Kentucky styles and the shrinkage of that lag until 1825, when provincialism disappeared all but in minor details. Newcomb relates his conclusions on architectural matters admirably to Kentucky's social history.

G. Old Northwest

Buley, R. Carlyle, *The Old Northwest, Pioneer Period, 1815–1840.* 2 vols., Indianapolis, 1950. Pp. xiii, 632; viii, 686.

A masterful and mammoth regional history published by the Indiana Historical Society in which the author has most successfully incorporated a section on local architecture and the household arts in a chapter on "Pioneer Life—the Material Side" (1:138–239), and a shorter section on painting and sculpture in a later chapter on "Literature—Science—Reform" (2:576–80).

Burns, Lee, "Early Architects and Builders of Indiana," *Indiana Historical Society Publications*, 11 (1935): 179–215.

Some account of the general use of architectural design books by trained carpenters and builders, but surprisingly little biographical information on Indiana architects and even less information on their buildings.

Drury, John, *Historic Midwest Houses.* Minneapolis, 1947. Pp. x, 246.

An only partially successful attempt to give "biographical treatment" to old houses west of the Appalachian Mountains, important for historical association rather than architectural importance. Organized by states. Only a small number of the houses, of course, were built in the first quarter of the nineteenth century.

Frary, I. T., *Early Homes of Ohio.* Richmond, Va., 1936. Pp. xviii, 336. 196 plates.

A diffuse book, yet it is filled with a great deal of useful information. There are biographical sketches of early Ohio builders and carpenters, a section on six of the more academically designed houses built in the first half of the nineteenth century, one on public buildings (churches, courthouses, and taverns), an amusing chapter on "The Vernacular" (clumsy attempts of untrained carpenters to work out the problems of construction and the details of design), another on architectural construction and details, and a final chapter on the architectural heritage of four historic towns in the old Western Reserve in northern Ohio (Canfield, Norwalk, Milan, and Jefferson).

Newcomb, Rexford, *Architecture of the Old Northwest Territory: A Study of Early Architecture in Ohio, Indiana, Illinois, Michigan, Wisconsin, & Part of Minnesota.* Chicago, 1950. Pp. xvii, 176. 96 plates.

An extraordinary architectural study of a region, covering in date from the mid-eighteenth century French courthouse in Cahokia to the sophisticated buildings of the 1850's, and covering in space from the the Alleghenies to the Mississippi and from the Ohio River to the Great Lakes. In the text Newcomb sets forth the historical background of each state and gives descriptions and dates of a tremendous number of architectural examples, together with references to a vast body of source material.

Peat, Wilbur D., *Indiana Houses of the Nineteenth Century.* Indianapolis, 1962. Pp. xiv, 195. 193 plates.

A descriptive catalogue of nearly two hundred historically and architecturally important, extant houses in Indiana, published by the Indiana Historical Society. The book is divided by period styles, the earliest chapters on the "Federal Mode" and "Neo-Classic Mode" being the most important for this bibliography.

Peterson, Charles E., "Notes on Old Cahokia," *The French American Review,* 1 (July–Sept. 1948): 184–225.

Cahokia, Illinois, was a French settlement established at the end of the seventeenth century, and today lies in the "American Bottoms" a mile east of the Mississippi River and opposite South St. Louis. Peterson, who has worked most thoroughly the field of French architecture in the Mississippi Valley, has written a superb architectural history of a settlement, covering two and a half centuries of its existence. He studies the architectural landmarks by periods: the Founding (1699–1717); the Louisiana Period (1718–65); British Occupation (1765–77); and the Early American Period (after 1777). A model essay growing out of two National Park Service reports.

Tallmadge, Thomas E., *Architecture in Old Chicago.* Chicago, 1941. Pp. xiii, 218.

In his first chapter, "The Birth of a City," Tallmadge carries the story of Chicago's early architecture down to 1830, dealing in the main with Fort Dearborn (the first fort built in 1803 and destroyed in 1812; the second built in 1816).

H. Spanish Southwest

Baer, Kurt, *Architecture of the California Missions.* Berkeley and Los Angeles, 1958. Pp. xvi, 196.

An important architectural survey of California mission churches, most of which were built during the renaissance of the neoclassic style in the early part of the nineteenth century. An explanatory chapter comprehensively treats the outstanding characteristics of the missions: the mission plan (with religious, residential, and work areas), arcades, belfries, the espadaña (the terraced, curved, and decorated façade of a church), the campanario (terraced bell towers), towers, the church nave, the choir, and sculptural decorations.

Baer, Kurt, *Painting and Sculpture at Mission Santa Barbara*. Washington, 1955. Pp. xx, 244.
Largely a catalogue of the paintings and sculpture at the mission with 151 illustrations but also contains an architectural and historical account.

Baird, Joseph Armstrong, Jr., *Time's Wondrous Changes: San Francisco Architecture, 1776–1915*. San Francisco, 1962. Pp. viii, 67. 44 plates.
The first chapter, "1776–1846, Prelude: The Spanish-Mexican Era," is short but well-written, and tells the little that is known of this early period of San Francisco's architecture. A publication of the California Historical Society.

Cali, François, *L'Art des Conquistadors* [photographies de Claude Arthaud et François Hebert-Stevens]. Paris, 1960. Pp. 297. 181 plates.
An imaginative survey of the architecture of conquest and the painting and sculpture of the conquerors in New Spain from the beginning of the sixteenth through the eighteenth centuries. The distinction is drawn between the building traditions of the "conquistadores a lo divino" and the "conquistadors de l'or." The spiritual conquest was as important as the military and commercial by the Spaniards in their systematic destruction of the pre-Columbian civilization. The pervasive thesis of the author is that the importation of "le baroque" into colonial America resulted in an evolution of an art style of rare originality: American baroque became more baroque than its Spanish parent. Innovation, particularly in architecture, was of equal if not more importance than imitation.

Domínguez, Fray Francisco Atanasio, *The Missions of New Mexico, 1776, A Description*. Translated and annotated by Eleanor B. Adams and Fray Angelico Chavez. Albuquerque, 1956. Pp. xxi, 387.
A meticulously annotated and beautifully printed edition of Fray Francisco Atanasio Domínguez's (1740–1805?) description of the conditions he found in New Mexico in 1776. He had been in-

structed as a canonical visitor to make a complete, detailed report on the spiritual and economic status of the New Mexico missions, and this entailed the gathering of much architectural data as well. The original manuscript report found its way into the National Library of Mexico, where it was discovered in 1928 among bundles of unsorted papers.

Kirker, Harold, *California's Architectural Frontier: Style and Tradition in the Nineteenth Century*. San Marino, 1960. Pp. xiv, 224. 64 plates.

Even though the pastel-tinted hacienda of legend and other forms of romantic Spanish architecture were perpetrated in California at the end of the nineteenth century, the development of the state's architecture earlier in the century was colonial. Each immigrant group (Russian, Spanish-Mexican, American, and European) brought its own society's architectural heritage (crude adobe, Yankee clapboard, Romanesque and Gothic edifices, etc.). All these architectural styles merged on California's cosmopolitan frontier. The first chapter, "The Adobe Builders," deals with the pre-1826 period.

Kubler, George, and Martin Soria, *Art and Architecture in Spain and Portugal and Their American Dominions, 1500 to 1800*. Baltimore, 1959. Pp. xxviii, 445. 192 plates.

One of the most impressive volumes in the Pelican History of Art series; it deals with the development of all the major arts (architecture, sculpture, and painting) in the two Iberian nations and their projection in Latin America throughout three centuries (1500–1800). Kubler's section on the colonial architecture of Spanish America is the most comprehensive account published on the subject, with the exception of Diego Angulo Iñiguez's huge three-volume *Historia del arte hispano-americano*. Soria's sections on sculpture and painting both deal at some length with the Spanish American part of the story. He offers a huge panorama which in many cases is corollary to the architecture. This is especially true of the sculpture, much of which consists of wood-carved altar-pieces, pulpits, and choirstalls, that are part of the furnishings of the churches.

Kubler, George, *The Religious Architecture of New Mexico in the Colonial Period and since the American Occupation*. Colorado Springs, 1940. Pp. xxi, 159 [12 pages of index]. 219 plates and drawings.

A thorough analysis of the architectural history of churches in New Mexico, 1600–1846. Kubler explains in detail the emplacement, materials, plan, structure, architectural mass, decoration, fenestration, and secondary constructions (chapels, baptistries, sacristies, etc.) of these monuments. He found that, once defined, the early formulas

of construction and design over this historic period varied little from a frozen and immobile type; sluggish fashions and technical conservatism characterized colonial New Mexico in their construction of monumental buildings, as one would expect in a frontier society. A publication of the Taylor Museum of the Colorado Springs Fine Arts Center.

Newcomb, Rexford, *The Old Mission Churches and Historic Houses of California: Their History, Architecture, Art and Lore.* Philadelphia and London, 1925. Pp. xvii, 379.
An early book of a distinguished architectural historian, but by current standards its textual content on architectural development and style seems superficial and unsophisticated. The subject fortunately has been recently updated by equally distinguished scholars. This book is one of a whole shelf of works published by J. B. Lippincott Company in the 1920's on regional architecture.

Sanford, Trent Elwood, *The Architecture of the Southwest: Indian, Spanish, American.* New York, 1950. Pp. xii, 312. 64 plates.
A competent history of building styles in the Greater Southwest of the United States, the Mexican states of Chihuahua and Sonora, and the territory of Baja California through the major chronological periods of the region: Indian, 100 B.C.—A.D. 1540; Spanish, 1540–1821; Mexican, 1821–46; and American, 1846 to the present. The book does, however, suffer from faulty organization and terminology and from a lack of documentation.

Smith, Frances Rand, *The Architectural History of Mission San Carlos Borromeo, California.* Berkeley, 1921. Pp. 81.
A historical account followed by an architectural study with plans, elevations, and drawings and photographs of details.

IV. TOPOGRAPHY

Bail, Hamilton Vaughan, *Views of Harvard: A Pictorial Record to 1860.* Cambridge, 1949. Pp. xviii, 264.
Sixty-six views of Harvard College reproduced from paintings, engravings, woodcuts, daguerreotypes, and lithographs accompanied with scholarly descriptions of them and their provenance by Bail. A learned blending of the history of education, iconography, and American architecture.

Bannister, Turpin C., "Oglethorpe's Sources for the Savannah Plan," *Journal of the Society of Architectural Historians,* 20 (May 1961): 47–62.

The author systematically disproves previous theories and presents a convincing account of the relationship of Oglethorpe's plan to a military camp, specifically to Robert Barrett's *The Theorike and Practike of Modern Warres* (1598).

Fraser, Charles, *A Charleston Sketchbook, 1796–1806: Forty Water- color Drawings of the City and the Surrounding Country, Including Plantations and Parish Churches*. Introduction and Notes by Alice R. Huger Smith, Charleston, 1940. Pp. xix, 40.
A collection of 40 watercolors from Charles Fraser's Sketchbook, now in the Carolina Art Association.

Green, Constance McLaughlin, *Washington: Village and Capital, 1800–1878*. Princeton, 1962. Pp. xix, 445.
The first of a two-volume work; strong on early city planning and urban aesthetics; over fifty illustrations.

Kite, Elizabeth S., *L'Enfant and Washington, 1791–1792* [Institut Français de Washington, Historical Documents, cahier III]. Balti- more, 1929. Pp. xi, 182.
Includes an introduction by J. J. Jusserand as well as documents relating to the planning of Washington.

Kouwenhoven, John A., *The Columbia Historical Portrait of New York: An Essay in Graphic History in Honor of the Tricentennial of New York City and the Bicentennial of Columbia University*. Garden City, 1953. Pp. 550.
Contains material not in Stokes and revises his work.

McClintock, Gilbert S., *Valley Views of Northeastern Pennsylvania, Reproductions of Early Prints and Paintings of the Wyoming and Other Valleys of the Susquehanna, Lehigh, Delaware and Lacka- wanna Rivers Together with a Descriptive List of the Plates*. Wilkes-Barre, 1948. Pp. 45. 104 plates.
Published by the Wyoming Historical and Geological Society.

Mills, Paul, ed., *Early Paintings of California in the Robert B. Honeyman Jr. Collection*. Oakland, 1956. Pp. 48.
Catalogue of an exhibition of a private collection sponsored by the Archives of California Art at the Oakland Art Museum, arranged chronologically, largely covering the nineteenth century: the age of exploration, the mission period, the Gold Rush, and the discovery of the great monuments of California landscape.

Spendlove, F. St. George, *The Face of Early Canada*. Toronto, 1958. Pp. xxi, 162. 122 plates.
A thorough exploration (part narrative history and part catalogue) of sketches and prints of historical Canadian views; the book begins

with the year 1556 and the publication by Ramusio of a fanciful plan of Hochelaga based upon Jacques Cartier's narrative and ends in 1867, the year of Confederation. Mr. F. St. George Spendlove, curator of the Canadiana Collections of The Royal Ontario Museum, has brought together an impressive selection of drawings in pencil, ink, and sepia, water colors, wash drawings, engravings, and lithographs which record the growth of settlement, the birth of towns, the appearance of fort and government house, church and school, city hall and army barracks, law courts, wharves, and warehouses. The textual commentary is arranged first by a collective treatment of the earliest views (i.e., those before 1770), then a section of short biographies of artists working before the War of 1812 (e.g., Thomas Davies, James Peachey, J. F. W. Des Barres and *The Atlantic Neptune,* George B. Fisher, and George Heriot), and finally topographical views by geographic locality.

Stokes, I. N. Phelps, *The Iconography of Manhattan Island, 1498– 1909.* 6 vols., New York, 1915–1928. [vol. 1:] Pp. lii, 473; [vol. 2:] xxii, 452; [vol. 3:] xxviii, 478–1026; [vol. 4:] xxii, 986; [vol. 5:] xxviii, 987–2078; and [vol. 6:] xviii, 677.
The contents of these six volumes are as follows: (1) the history and development of Manhattan, 1524–1811, with plates and descriptions of plates; (2) cartography of the island; (3) its history and development, 1812–1909; (4) an arrangement of all the available sources on its history and development (e.g., charters, records, letters, etc.) in chronological order for the years 1565–1776; (5) the same for the period 1776–1909; and (6) chronology, addenda, original grants and farms, bibliography, and index.

Thomas Jefferson and the National Capital: Containing Notes and Correspondence Exchanged between Jefferson, Washington, L'Enfant, Ellicott, Hallett, Thornton, Latrobe, the Commissioners, and Others, Relating to the Founding, Surveying, Planning, Designing, Constructing, and Administering of the City of Washington, 1783–1818. Ed. Saul K. Padover, Washington, D.C., 1946. Pp. xxxvi, 522.
A collection of correspondence, largely to and from Jefferson gleaned from numerous sources, on the locating, planning, and building of the City of Washington. The story is largely Jefferson's, laying the foundations for the city's greatness and providing, above all, for its enduring beauty. Well illustrated, but the editor has supplied almost no editorial comment and no index.

Tunnard, Christopher, and Henry Hope Reed, *American Skyline: The Growth and Form of Our Cities and Towns.* Boston, 1955. Pp. xviii, 302.

The first two chapters of this discursive, though provocative, book cover the subject of American town plans and the configurations of building styles down to 1826. The authors trace the various stages in the evolution of the clearing in "The First Communities"; they explain the use of open space in "Courthouse Square and 'Village' Green"; and they point out the beginnings of suburban sprawl in "State Capital and College Town."

Van Nostrand, Jeanne, and Edith M. Coulter, *California Pictorial: A History in Contemporary Pictures, 1786–1859*. Berkeley and Los Angeles, 1948. Pp. ix, 161.
Sixty-nine plates (eight for the pre-1826 period) with descriptive notes, biographical information on the artists, and a historical account placing the picture in its proper setting.

Whitehill, Walter Muir, *Boston, A Topographical History*. Cambridge, 1959. Pp. xxix, 244.
A model study of the changing profile of a city: Mr. Whitehill traces the topographical development of Boston from the seventeenth century when it was a hilly peninsula, almost completely surrounded by water, down to the present—the leveling of hills and filling of bays, the construction of bridges and wharves, the building of houses and markets, the planning of Back Bay, and the laying of railroad tracks. Documented graphically with 116 plates of old maps, wood engravings, copper engravings, paintings, lithographs, architects' drawings, and photographs.

V. PAINTING

A. General Works

Barker, Virgil, *American Painting, History and Interpretation*. New York, 1950. Pp. xxvii, 717.
An indispensable survey of American art to the year 1880; Barker traces the development of American painting from the time when artists were almost exclusively preoccupied with portrait painting, through the period when they branched out into the painting of landscapes, still-life subjects, and panoramas. Largely concerned with the social backgrounds rather than style or "nationality" in American art.

Bayley, Frank W., *Five Colonial Artists of New England: Joseph Badger, Joseph Blackburn, John Singleton Copley, Robert Feke, John Smibert*. Boston, 1929. Pp. vi, 448.

A pioneering work at the time of its publication, but should be used with caution now. Recent scholarship on these five artists has revealed that many of Bayley's attributions of artists and subjects were faulty.

Belknap, Waldron Phoenix, Jr., *American Colonial Painting: Materials for a History*. Ed. Charles Coleman Sellers, Cambridge, 1959. Pp. xxii, 378.
A posthumous printing of articles and research notes of Belknap on eighteenth-century American portraits, especially the career of Robert Feke and portrait subjects from New York State (the de Peyster family in particular). Of great importance was Belknap's discovery of English mezzotint sources for the poses, props, and backgrounds in hundreds of early American portraits.

Bizardel, Yvon, *American Painters in Paris*, trans. by Richard Howard. New York, 1960. Pp. 177.
An imaginative study of the influence of Paris on a number of American artists (e.g., West, Copley, Trumbull, Mather Brown, Patience and Joseph Wright, Peale, Vanderlyn, Fulton, etc.) who either lived or traveled extensively in France. Especially valuable for relating these artists to the European scene and contemporary trends in painting. The book lacks a table of contents, chapter headings, footnotes, and a bibliography.

Bolton, Charles Knowles, *The Founders: Portraits of Persons Born Abroad Who Came to the Colonies in North America Before the Year 1701, with an Introduction, Biographical Outlines, and Comments on the Portraits*. 3 vols., Boston, 1919–1926. Pp. vii, 1–335; vii, 339–690; xix, 691–1103.
First two volumes arranged by colonies; third volume lists additions and corrections; an uncritical piece of antiquarianism that must be used with caution, but that nevertheless provides useful leads.

Bolton, Theodore, *Early American Portrait Draughtsmen in Crayons*. New York, 1923. Pp. xii, 111.
A biographical dictionary of American artists of portrait drawings in colored crayons, including John Singleton Copley, Joseph Blackburn, John Johnston, Benjamin Blyth, Edward Malbone, James Sharples, and Saint-Mémin.

Bolton, Theodore, *Early American Portrait Painters in Miniature*. New York, 1921. Pp. x, 180.
A biographical dictionary of early American miniature painters, arranged alphabetically.

Buhler, Kathryn C., Barbara N. Parker, and John M. Phillips, *The Waldron Phoenix Belknap, Jr. Collection of Portraits and Silver,*

with a Note on the Discoveries of Waldron Phoenix Belknap, Jr. Concerning the Influence of the English Mezzotint on Colonial Painting. Cambridge, 1955. Pp. ix, 177.

Largely concerned with the Belknap Collection at the New-York Historical Society but includes Belknap's notes on New York goldsmiths and silversmiths and a chapter on his comparisons of English mezzotints and American paintings.

Burroughs, Alan, *Limners and Likenesses: Three Centuries of American Painting.* Cambridge, 1936. Pp. ix, 246.

An interpretative, balanced survey stressing the nationalism and independence of American art even before there was a nation.

Clark, Edna Maria, *Ohio Art and Artists.* Richmond, 1932. Pp. xiii, 509.

Includes architecture. The brief treatment here of the pre-1826 period indicates the great need for more work in this area.

Dresser, Louisa, *XVIIth Century Painting in New England, A Catalogue of an Exhibition Held at the Worcester Art Museum in Collaboration with the American Antiquarian Society, July and August 1934, with a Laboratory Report by Alan Burroughs.* Worcester, 1935. Pp. 187.

Prepared after the exhibition, the catalogue contains an essay on the rise and development of art in the Massachusetts Bay Colony before 1700 and raises questions about the attributions of subjects.

Flexner, James Thomas, *America's Old Masters: First Artists of the New World.* New York, 1939. Pp. 332.

Flexner has written biographical essays on Benjamin West, John Singleton Copley, Charles Willson Peale, and Gilbert Stuart in an attempt to answer the question, how did late eighteenth-century America produce such a school of great painters? As he points out, this group "enjoyed a greater European acclaim than was to come to any other American artists for at least a century." For the author this is "the strangest development in all Colonial America": each artist grew up isolated from one another; each began to draw in an environment hostile to drawing; each was trained by an incompetent craftsman; and finally each managed to travel to the galleries of the Old World.

Flexner, James Thomas, *American Painting: First Flowers of Our Wilderness.* Boston, 1947. Pp. xxii, 368.

A good assemblage of illustrations of paintings, mostly portraits, produced in America down to 1775. The text, written in an extravagantly popular style, is marred by exaggeration and overstatement with the author's claims for paintings as the best documents of social history and for the accomplishments of American artists.

Flexner, James Thomas, *American Painting: The Light of Distant Skies, 1760–1835*. New York, 1954. Pp. xiii, 306.

The continuing volume to *First Flowers*, but a more balanced narrative than its predecessor and more effectively arranged (particularly grouping the illustrations in a separate section). These are pioneering rather than final studies of the history of American painting.

Groce, George C., and David H. Wallace, *The New-York Historical Society's Dictionary of Artists in America, 1564–1860*. New Haven, 1957. Pp. xxvii, 759.

A comprehensive, accurate biographical dictionary of over 10,000 artists active in America prior to 1860. Entries give pertinent biographical data and cite sources—books, periodicals, exhibition records, city and business directories, census records, newspapers, and signed objects.

Hagen, Oskar, *The Birth of the American Tradition in Art*. New York and London, 1940. Pp. xvii, 159.

A book full of interest if only for its tendency to overstatement. The author stretches the "frontier fallacy" to its limit. He derides West's and Copley's British work; he mocks Stuart's paintings after the artist returned to America in 1793, because they "were the first examples of that fashionable manner in the New World." For Hagen, incompetence is the real measure of native American quality in painting. Earl is praised for being a "cumbersome designer and a quaint narrator of details"; Peale's portraits are praised for being "drier" and Trumbull's for being "colder" than Stuart's. He reserves his highest praise for Earl, because "he repudiated the manner he had been taught in England."

Lane, William Coolidge, and Nina E. Browne, *A.L.A. Portrait Index: Index to Portraits Contained in Printed Books and Periodicals*. Washington, D.C., 1906. Pp. lxxv, 1601.

Indexed by subject.

Lee, Cuthbert, *Early American Portrait Painters: The Fourteen Principal Earliest Native-Born Painters*. New Haven, 1929. Pp. xii, 350.

An attempt to judge in the conventional terms of art history the quality of fourteen pre-Revolutionary native-born American painters working between 1725 and 1825, now recognized by the inclusion of their works in art museums (Gilbert Stuart, John Singleton Copley, Benjamin West, Charles Willson Peale, John Trumbull, Edward Greene Malbone, Robert Feke, Joseph Badger, Ralph Earl, Joseph Wright, Matthew Pratt, James Peale, Mather Brown, and Robert Fulton).

London, Hannah R., *Miniatures of Early American Jews*. Springfield,
1953. Pp. x, 154.
A valuable pictorial record of miniatures of American Jews painted
into the early nineteenth century, with information on American
miniaturists.

McCoubrey, John W., *American Tradition in Painting*. New York,
1963. Pp. 128.
A highly conceptualized and closely reasoned answer to the
question, "What is distinctively American about American painting?"
The author argues that realism or a profound rightness, even in the
most untutored efforts of our painters, is the most consistent and
obvious characteristic of our painting. The accuracy with which our
artists have observed American scenery and objects has enabled them
to reject those traditional skills which have been at the heart of the
European tradition. A particularly thoughtful first chapter on "The
Colonial Portrait."

McInnes, Graham, *Canadian Art*. Toronto, 1950. Pp. x, 140.
A thin book that only briefly outlines in its first several chapters
the growth, flowering, and eventual decay of a highly individual
Canadian style in art in the period 1760–1850. Of greatest im-
portance in this era were the topographers doing landscapes in wash
and line that were eventually lithographed or engraved and sold as a
series.

Morisset, Gérard, *Les arts au Canada Français; peintres et tableaux*.
2 vols., Quebec, 1936–37. Pp. xi, 267; 178.
Devoted largely to individual painters (e.g., Frère Luc) or, schools
of artists (e.g., the cloister of Ursuline nuns) in French Canada. No
illustrations and little documentation.

National Society of Colonial Dames of America in the State of Dela-
ware, *Portraits in Delaware, 1700–1850*. Wilmington, 1951.
Pp. 176.
A check list of almost three hundred portraits, listed alphabetically
by subject, within divisions based on location among towns. Thirty-
six portraits are reproduced.

Neuhaus, Eugen, *The History & Ideals of American Art*. Stanford
University, 1931. Pp. xv, 444.
Considering its date of publication, this book is still a better-than-
average compendium of American painting. In its early chapters the
author places great stress on "the outside influences which shaped
[American art's] course from its meager beginnings in the New
England States," meaning largely the English influence.

Peat, Wilbur D., *Pioneer Painters of Indiana*. Indianapolis, 1954.
Pp. xix, 254. 84 plates.

The account begins with early nineteenth-century Indiana artists working in Fort Wayne, Vincennes, New Harmony, and Richmond. The author concludes with a "Roster" of painters active in the state from 1800 to 1885.

Richardson, Edgar P., *American Romantic Painting*. New York, 1944. Pp. 50. 236 plates.
A pictorial catalogue with an introduction on a tradition that began around 1800 with Washington Allston.

Richardson, Edgar P., *Painting in America*. New York, 1956. Pp. xii, 447.
Unquestionably the best conspectus of American painting, a tradition which is viewed both as an art and a craft within the perspective of Western art. Richardson carefully follows the first migration of drawing and painting to America, the transplanting of painting skills from the Old to the New World, the changes in the direction of imaginative interests, the evolution of the language of painting, the interaction of American developments with those in other parts of the world, and the talents and fortunes of many gifted individuals.

Rossiter, Henry P., *M. & M. Karolik Collection of American Water Colors & Drawings, 1800–1875*. 2 vols., Boston, 1962. Pp. 337; 352.
The three thousand objects in the M. and M. Karolik Collection of American Water Colors and Drawings, 1800–1875, include academic drawings, folk art, and Civil War sketches. There are also a modest number of prints and sculptures. In these two handsomely printed volumes there are 1,465 entries (of which almost a third are illustrated), providing a survey of the subject second only to that afforded by the collection itself. Extensive documentation, biographical notices of the artists represented, indexes, and a commentary by the collector add to the importance of this publication. Published by the Museum of Fine Arts, Boston.

Rutledge, Anna Wells, *Artists in the Life of Charleston, Through Colony to Nation, from Restoration to Reconstruction*. Philadelphia, 1949. Pp. 159.
A superbly documented chronological essay which introduces hundreds of artists—painters, carvers, engravers, scene painters, miniaturists, drawing masters, daguerreotypists, and other practitioners of the arts—in terms of a single community and adroitly integrates their work with the development of Charleston life and culture.

Weddell, Alexander W., ed., *Virginia Historical Portraiture, 1585–1830*. Richmond, 1930. Pp. xxxi, 556.
Illustrates 198 portraits and supplies biographical sketches of the subjects and the artists.

Wehle, Harry B., *American Miniatures, 1730–1850*. Garden City, 1927. Pp. xxv, 127.
A thorough, descriptive account, divided regionally into chapters on miniatures and miniaturists, covering the eighteenth and nineteenth centuries. A useful "Biographical Dictionary of the Artists" compiled by Theodore Bolton has been added.

B. Painters

1. WASHINGTON ALLSTON

Richardson, Edgar Preston, *Washington Allston: A Study of the Romantic Artist in America*. Chicago, 1948. Pp. ix, 234. 59 plates.
The full biography of Washington Allston (1779–1843), with a catalogue of his existing and recorded paintings, numbering 197 items. Richardson includes helpful "biographical summaries" between chapters, in the form of chronological itineraries.

2. EZRA AMES

Bolton, Theodore, and Irwin F. Cortelyou, *Ezra Ames of Albany: Portrait Painter, Craftsman, Royal Arch Mason, Banker, 1768–1836*. New York, 1955. Pp. xix, 398.
Ames was an artist who developed slowly, but after moving to Albany in 1793 until his death in 1836 he painted easel portraiture, miniatures, silhouettes, landscapes, and still-lifes. In addition to a biographical essay, there is a comprehensive catalogue of his works running to 634 items.

3. JOSEPH BADGER

Park, Lawrence, "Joseph Badger of Boston, and His Portraits of Children," *Old-Time New England*, 13 (Jan. 1923): 99–109. Includes a check list.

Park, Lawrence, "Joseph Badger, 1708–1765, and a Descriptive List of Some of His Works," Massachusetts Historical Society, *Proceedings*, 51 (1918): 158–201.

4. JOSEPH BLACKBURN

Morgan, John Hill, and Henry Wilder Foote, "An Extension of Lawrence Park's Descriptive List of the Works of Joseph Black-

burn," American Antiquarian Society, *Proceedings*, 46 (April 1936): 15–81.

Morgan and Foote add 38 Blackburn portraits to Park's list—17 of which were painted in Bermuda. They also separately list the questionably attributed portraits.

Park, Lawrence, "Joseph Blackburn, A Colonial Portrait Painter, With a Descriptive List of His Works," American Antiquarian Society, *Proceedings*, 32 (Oct. 1922): 270–329.

An annotated check list of eighty-eight portraits painted by Blackburn, including extensive biographical material on the subjects.

5. JOHN COLES

Watkins, Walter Kendall, "John Coles, Heraldry Painter," *Old-Time New England*, 21 (Jan. 1931): 129–43.

Includes a check list compiled by Charles Knowles Bolton.

6. JOHN SINGLETON COPLEY

Amory, Martha Babcock, *The Domestic and Artistic Life of John Singleton Copley, R.A., With Notices of His Works.* . . . Boston, 1882. Pp. xii, 478.

A long, rambling work of fileopietism, yet packed with valuable letters—some *in extenso* and others obviously abridged and edited—of Copley to his wife while he was in Italy, and letters written between members of the family during his English years. The book is all the more valuable now, because most of these papers were recently burned by one of Copley's descendants "because they contained allusions which she considered undesirable to preserve." A few, which came down in another branch of the family, are in the Library of Congress.

Bayley, Frank W., *The Life and Works of John Singleton Copley.* Boston, 1915. Pp. 285.

Catalogue of Copley's portraits with the names of the owners, and the last known owners of unlocated ones.

Flexner, James T., *John Singleton Copley.* Boston, 1948. Pp. xv, 139. 33 plates.

A revised and enlarged version of the biography originally published in *America's Old Masters.*

Letters & Papers of John Singleton Copley and Henry Pelham, 1739– 1776, [Eds. Charles Francis Adams 2d, Guernsey Jones, and

Worthington Chauncey Ford], [Massachusetts Historical Society, *Collections*, vol. 71]. Boston, 1914. Pp. xxii, 384.

Collection of letters and documents found in the Public Record Office in London. The correspondence dates before Independence and throws valuable light on Copley and his early paintings, his impressions of the work of other painters, and comments on his methods of painting in his letters from France and Italy. A kind of documentary publication that is all too rare in the fine and decorative arts.

Parker, Barbara Neville, and Anne Bolling Wheeler, *John Singleton Copley, American Portraits in Oil, Pastel, and Miniature, with Biographical Sketches*. Boston, 1938. Pp. ix, 284. 130 plates.

The best book on Copley to date; his American paintings have been expertly catalogued and discussed. This comprehensive and scholarly work is typical of the quality of publications that have come out of the Museum of Fine Arts, Boston.

Perkins, Augustus Thorndike, *A Sketch of the Life and a List of Some of the Works of John Singleton Copley*. Boston, 1873. Pp. viii, 144.

Until Jules Prown's forthcoming definitive study of the life and complete catalogue of Copley's works is published, this dated study must suffice for the little-known period of the artist's English paintings. Perkins added a "Supplementary List" of 29 pages in 1875.

7. ANSON DICKINSON

Kidder, Mary Helen, ed., *List of Miniatures Painted by Anson Dickinson, 1803–1851*. Hartford, 1937. Pp. xvi, 75.

An edited list kept by the artist of the subject (usually given only by last name) and date of portraits he painted. The record is brief and the editor has done nothing to identify further the subjects or to discover the present location of any of the portraits.

8. PIERRE EUGÈNE DU SIMITIÈRE

Huth, Hans, "Pierre Eugène Du Simitière and the Beginnings of the American Historical Museum," *Pennsylvania Magazine of History and Biography*, 69 (Oct. 1945): 315–25.

An important chapter on early collecting and the beginnings of the museum movement in this country. There is, however, little that is new here that was not in the Potts article.

Potts, William John, "Du Simitière, Artist, Antiquary, and Naturalist, Projector of the First American Museum, with Some Extracts

from His Notebook," *Pennsylvania Magazine of History and Biography*, 13 (Oct. 1889): 341–75.

Pierre Eugène Du Simitière (1736–84) was a native of Geneva and settled in Philadelphia in 1766. His collection of artifacts became so famous that he opened it to the public as a museum in 1782. He designed a number of state seals (only a few of which were finally adopted), and his name has been most generally remembered for his portraits of heroes of the Revolution as engraved by various artists. Curiously, this is still the most extensive account of Du Simitière published.

9. RALPH EARL

Sawitzky, William, *Ralph Earl, 1751–1801*. New York and Worcester, 1945. Pp. [44].

An exhibition catalogue of a selection of fifty-three paintings by Ralph Earl shown at the Whitney Museum of American Art and the Worcester Art Museum in 1945–46.

10. ROBERT FEKE

Foote, Henry Wilder, *Robert Feke, Colonial Portrait Painter*. Cambridge, 1930. Pp. xix, 223.

Biography with catalogue of portraits.

11. JOHN GREENWOOD

Burroughs, Alan, *John Greenwood in America, 1745–1752: A Monograph with Notes and a Check List*. Andover, Mass., 1943. Pp. 87.

A study and check list growing out of an exhibition of Greenwood's portraits held at the Addison Gallery of American Art, Phillips Academy, in 1942. For a short span of seven years in the middle of the eighteenth century Greenwood painted portraits in Boston, Salem, and Portsmouth.

12. JOHN VALENTINE HAIDT

Howland, Garth A., "John Valentine Haidt, A Little Known Eighteenth Century Painter," *Pennsylvania History*, 8 (Oct. 1941): 304–13.

Haidt (1700–1780) is an unusual example of a transplanted, European-trained artist working in an established tradition in America, more or less *in vacuo*. He did portraits of his fellow Moravians and religious pictures for their chapels. Examples of his work are preserved at the Moravian Historical Society Museum in Nazareth, Pa., and in the Archives of the Moravian Church, Bethlehem, and other Moravian centers. Howland's study is unfortunately not illustrated.

13. JOHN WESLEY JARVIS

Dickson, Harold E., *John Wesley Jarvis, American Painter, 1780–1840, With a Checklist of His Work.* New York, 1949. Pp. xx, 476.
Biography and check list that ranks high in scholarship and completeness. Jarvis was an American portrait painter of the early nineteenth century standing in point of time between Gilbert Stuart and Thomas Sully. An impressive check list of 412 portraits in oil and miniature, sculptures, and engravings.

14. RICHARD JENNYS

Sherman, Frederic Fairchild, *Richard Jennys: New England Portrait Painter.* Springfield, Mass., 1941. Pp. 96.
A poorly organized cluster of former articles written by Sherman over a period of ten years which were occasioned by the discovery from time to time of Jennys portraits.

15. CHARLES BIRD KING

Ewers, John C., "Charles Bird King, Painter of Indian Visitors to the Nation's Capital," *Annual Report of the Board of Regents of the Smithsonian Institution . . . 1953*, Washington, 1954. Pp. 463–73. 8 plates.
Charles Bird King (1785–1862), between 1816 and 1862, maintained a studio in Washington, D.C., where he painted both portraits of socially and politically prominent persons and portraits of many members of Indian delegations when they came to the nation's capital. This brief essay gives more biographical information on King than that published anywhere else, and includes a check list of his Indian portraits.

16. EDWARD GREENE MALBONE

Tolman, Ruel Pardee, *The Life and Works of Edward Greene Malbone, 1777–1807*. New York, 1958. Pp. xxiii, 322.

Prominent miniaturist who died at twenty-nine after an active career of only a dozen years. Following the text of a biographical sketch, there is a facsimile of Malbone's important account book, list of possible clients' names from the account book, descriptive list of known works by Malbone accompanied with many reproductions, a check list of misattributed miniatures, and a brief chronology of the artist's life.

17. REUBEN MOULTHROP

Sawitzky, Susan, ed., "Portraits by Reuben Moulthrop, A Checklist by William Sawitzky," *New-York Historical Society Quarterly*, 39 (Oct. 1955): 385–404.

An illustrated and detailed check list of 47 portraits by the relatively unknown Reuben Moulthrop (1763–1814) of East Haven and New Haven, Connecticut.

18. CHARLES WILLSON PEALE

Sellers, Charles Coleman, *Charles Willson Peale*. Volume 1: *Early Life (1741–1790)*. Volume 2: *Later Life (1790–1827)*. 2 vols., Philadelphia, 1947. Pp. xiv, 293; xii, 468.

This mammoth biography still stands as one of the major achievements in the bibliography of American fine arts. Sellers set himself the enormous task not only of distilling the 1600 letters, 23 diaries, and unpublished autobiography of Peale, but also of choosing a subject who was not only a painter, but philosopher, inventor, naturalist, educator, farmer, and above all devoted family man.

Sellers, Charles Coleman, *Portraits and Miniatures by Charles Willson Peale* [American Philosophical Society, *Transactions*, XLII, Part 1]. Philadelphia, 1952. Pp. 369.

The definitive catalogue of 1046 portraits in oil and miniature by Peale. The third volume or *catalogue raisonné* to Sellers's two-volume biography of the artist.

19. TITIAN PEALE

Poesch, Jessie, *Titian Ramsay Peale, 1799–1885, and His Journals of the Wilkes Expedition* [American Philosophical Society, *Memoirs*, Vol. 52]. Philadelphia, 1961. Pp. x, 214.

Well-documented biography of the pioneer artist-naturalist Titian Ramsay Peale, youngest son of the famous artist, Charles Willson Peale.

20. MATTHEW PRATT

Sawitzky, William, *Matthew Pratt, 1734–1805.* New York, 1942. Pp. x, 103. 43 plates.

Following an analysis of Pratt's portrait painting and a chronology of his life, Sawitzky has compiled a detailed descriptive catalogue of the artist's paintings and has added 43 plates of illustrations to accompany it.

21. CHRISTIAN REMICK

Cunningham, Henry Winchester, *Christian Remick: An Early Boston Artist.* Boston, 1904. Pp. 28.

A paper read at the Club of Odd Volumes, Boston, Feb. 24, 1904. Remick has become famous for his several water-color views of Boston Harbor with the British ships of war lying at anchor off Long Wharf in 1768.

22. C. B. J. FEVRET DE ST.-MÉMIN

Norfleet, Fillmore, *Saint-Mémin in Virginia: Portraits and Biographies.* Richmond, 1942. Pp. xix, 235.

Although emphasizing the artist's work in Virginia, this book is at the same time the best general account of Saint-Mémin. The artist's itineraries have been established by Norfleet from newspaper advertisements and other sources. Illustrated with reproductions of 56 crayon portraits, drawn with the help of the ingenious "physiognotrace" machine, and 142 engravings.

Rice, Howard C., Jr., "Saint-Mémin's Portrait of Jefferson," *The Princeton University Library Chronicle,* 20 (Summer 1959): 182–92.

A model of writing on a clearly defined subject, thoroughly researched, concisely written, and impressively illustrated. Rice brings up-to-date the bibliography on Saint-Mémin and in his "Note on the Physiognotrace" explains the artist's method of drawing.

The St.-Mémin Collection of Portraits; Consisting of Seven Hundred and Sixty Medallion Portraits, Principally of Distinguished Americans, Photographed by J. Gurney and Son, of New York. New York, 1862. Pp. iv, 104.

A most valuable illustrated catalogue of Saint-Mémin's engraved portraits of Americans, made from his life-size profile portraits executed between the time of the French *émigré* artist's arrival in America in 1793 and his return to his native city of Dijon in 1814. This set of prints, one of three "reference" sets of Saint-Mémin's work assumed to have been assembled by the artist himself, was acquired by Elias Dexter in the late 1850's, sold by S. V. Henkels in Philadelphia in 1904, and has recently been acquired for the collection of Paul Mellon. The second set is in the Corcoran Gallery in Washington, D.C., and the third is in the Cabinet des Estampes, Bibliothèque Nationale, Paris. (On these and other collections of Saint-Mémin's work, see Rice, "Saint-Mémin's Portrait of Jefferson," pp. 186–87, cited above.)

23. SHARPLES FAMILY

Knox, Katharine McCook, *The Sharples: Their Portraits of George Washington and his Contemporaries.* . . . New Haven, 1930. Pp. xvi, 133.
James Sharples, his 3d wife Ellen, their children James Jr. and Rolinda, and a son, Felix, by his 2d wife, all came to America in the early 1790's. Between that time and James Sharples' death in 1811, when the family returned to England to continue portrait painting in Bristol, the whole family executed, largely in pastels, an incredible number of likenesses of politically prominent Americans.

24. JOHN SMIBERT

Foote, Henry Wilder, *John Smibert, Painter: With a Descriptive Catalogue of Portraits, and Notes on the Work of Nathaniel Smibert.* Cambridge, 1950. Pp. vii, 292.
Foote's approach is that of the biographer and historian, yet there is a seventy-page catalogue of "Extant Portraits" and he adds an eleven-page account of "Portraits Destroyed or Not Located."

25. GILBERT STUART

Flexner, James Thomas, *Gilbert Stuart: A Great Life in Brief*, New York, 1955. Pp. viii, 197.
A short, sound, sympathetic biography with a complete, up-to-date bibliography on the artist. Unfortunately, the author has included no illustrations.

Morgan, John Hill, *Gilbert Stuart and His Pupils*. New York, 1939. Pp. 102.
Biographical information on many of the young artists who worked in Stuart's studio.

Mount, Charles Merrill, *Gilbert Stuart: A Biography*. New York, 1964. Pp. 384.
This latest biography of Stuart is filled with a vast amount of information: most of it is less original than the author and publisher would have us believe, and probably no more reliable than its predecessors. If the omissions and misdating of the John Adams portraits by Stuart are any measure, this biography should be used with extreme caution. In this case, it was simply a failure to research widely available sources.

Park, Lawrence, *Gilbert Stuart, an Illustrated Descriptive List of His Works*. 4 vols., New York, 1926. [vols. 1 and 2:] Pp. 1–983; [vols. 3 and 4:] Plates 1–606.
A monumental work of scholarship. Two volumes are a descriptive catalogue of sitters, arranged alphabetically, followed by two volumes of illustrations, arranged and numbered to follow the descriptions. William Sawitzky made some new attributions and corrected some of Park's errors in "Some Unrecorded Portraits by Gilbert Stuart," *Art in America*, 31 (1932–33): 15–27, 39–48, 81–96.

Whitley, William T., *Gilbert Stuart*. Cambridge, 1932. Pp. xiv, 240.
A straight biography following the chronology of Stuart's life from his youth in Rhode Island, his years in London (1775–87), in Ireland (1787–93), in New York and Philadelphia (1793–96), in Philadelphia and Washington (1796–1805), and in Boston (1805–28).

26. THOMAS SULLY

Biddle, Edward, and Mantle Fielding, *The Life and Works of Thomas Sully, 1783–1872*. Philadelphia, 1921. Pp. viii, 411.
An extraordinarily complete catalogue of 2,631 paintings by Thomas Sully, compiled from the artist's own register of his paintings (now owned by the Historical Society of Pennsylvania) in which he recorded the names of sitters, beginning and ending dates, sizes, and prices. The compilers have added the present locations, when known. Unfortunately there are only fifteen plates of illustrations.

27. JEREMIAH THEUS

Middleton, Margaret Simons, *Jeremiah Theus: Colonial Artist of Charles Town*. Columbia, S.C., 1953. Pp. xviii, 218.

Theus, of Switzerland, came to South Carolina in 1735 and settled in Charleston in 1740 as a painter of portraits, landscapes, crests, and coats of arms; he worked there and in Georgia until his death in 1774. There is a "Biographical Checklist" of around 200 of his surviving portraits appended to the biography.

28. JOHN TRUMBULL

Sizer, Theodore, *The Works of Colonel John Trumbull: Artist of the American Revolution*. New Haven, 1950. Pp. xviii, 117.
Check list of Trumbull's work in all media (including maps and architecture) and of all categories of painting: portraits; historical, mythological, allegorical, literary, and religious subjects; landscapes and figure studies. It lists the astonishing number of over 750 portraits.

The Autobiography of Colonel John Trumbull: Patriot-Artist, 1756– 1843. Ed. Theodore Sizer, New Haven, 1953. Pp. xxiii, 404.
A new edition of Trumbull's 1841 memoirs with exhaustive textual annotation by Sizer; the editor has added a Supplement to his 1950 check list of the artist's production.

29. BENJAMIN WEST

Evans, Grose, *Benjamin West and the Taste of His Times*. Carbondale, Ill., 1959. Pp. xii, 210.
A careful study of the artistic and literary sources of the art of Benjamin West, but little else.

30. JOHN WHITE

Hulton, Paul, and David Beers Quinn, *The American Drawings of John White, 1577–1590, With Drawings of European and Oriental Subjects*. 2 vols., London and Chapel Hill, 1964. Pp. xvii, 1791. 160 plates.
A remarkable account of John White, the history of the drawings, White's contributions to ethnology, natural history, cartography, and his influence in America, a detailed descriptive catalogue, bibilography, and index. Volume two contains the original drawings reproduced in color facsimile and monochrome plates of the derivative drawings.

C. Portraits by Subjects

1. ADAMS FAMILY

Smithsonian Institution, *The Opening of the Adams-Clement Collection.* Washington, D.C., 1951. Pp. 23.
Brief résumé of fifteen portraits, costumes and jewelry, and porcelain given to the Smithsonian Institution by Miss Mary Louisa Adams Clement in 1950.

2. BENJAMIN FRANKLIN

Sellers, Charles Coleman, *Benjamin Franklin in Portraiture.* New Haven and London, 1962. Pp. xi, 452. 44 pages of plates.
A monumental work combining a biography and a catalogue, bringing together all the known likenesses of Franklin.

3. ALEXANDER HAMILTON

Bland, Harry MacNeill, and Virginia W. Northcott, "The Life Portraits of Alexander Hamilton," *William and Mary Quarterly*, 3d ser., 12 (Apr. 1955): 187–98.
A descriptive essay with eighteen reproductions, including one portrait of Elizabeth Schuyler Hamilton.

4. PATRICK HENRY

Hall, Virginius Cornick, Jr., "Notes on Patrick Henry Portraiture," *Virginia Magazine of History and Biography*, 71 (Apr. 1963): 168–84.
Divided into a discussion of life portraits, posthumous portraits, and lost portraits; 12 pages of illustrations.

5. THOMAS JEFFERSON

Bush, Alfred L., *The Life Portraits of Thomas Jefferson: Catalogue of an Exhibition at the University of Virginia Museum of Fine Arts, 12 through 26 April 1962.* Charlottesville, 1962. Pp. 101.
Illustrated catalogue of the twenty-six portraits known to have been taken of Jefferson (some now lost), between 1786 and 1825.

Kimball, Fiske, "The Life Portraits of Jefferson and Their Replicas," American Philosophical Society, *Proceedings*, 88 (1944): 497–534.

6. JEFFERSON FAMILY

Thomas Jefferson Memorial Foundation, *The Monticello Family: Catalogue of an Exhibition Held at the University of Virginia Museum of Fine Arts, April 12–May 13, 1960*. Charlottesville, 1960. Pp. 16. 12 pages of plates.
 Paintings and busts, silhouettes and daguerreotypes of Jefferson's family and descendants.

7. JAMES MADISON

Bolton, Theodore, "The Life Portraits of James Madison," *William and Mary Quarterly*, 3d ser., 8 (Jan. 1951): 25–47.

8. INCREASE MATHER

Murdock, Kenneth B., *The Portraits of Increase Mather, with Some Notes on Thomas Johnson, an English Mezzotinter*. Cleveland, 1924. Pp. x, 70.
 A model study, compiled by Increase Mather's distinguished biographer, printed by Bruce Rogers at Harvard University Press, and distributed by William Gwinn Mather of Cleveland.

9. OLIVER FAMILY

Oliver, Andrew, comp., *Faces of a Family: An Illustrated Catalogue of Portraits and Silhouettes of Daniel Oliver, 1664–1732, and Elizabeth Belcher, His Wife, Their Oliver Descendants and Their Wives Made between 1727 and 1850*. [New York], 1960. Pp. xvii, 42. 32 plates.
 An excellent iconographic study of an important family over a number of generations.

10. PITTS FAMILY

Payne, Elizabeth H., *Portraits of Eight Generations of the Pitts Family, From the Seventeenth to the Twentieth Century*. Detroit, 1959. Pp. 59.

Ancestral portraits of the Pitts family, which included Bowdoins, Mountforts, and Warners of Massachusetts and New Hampshire in the eighteenth century painted by Smibert, Badger, Blackburn, and Copley. The family migrated to Detroit in the 1830's.

11. SALTONSTALL FAMILY

Crossman, Carl, and Mrs. William S. Carlisle, comps., *A Special Exhibition of the Saltonstall Family Portraits.* Salem, 1962. Pp. 12. 16 plates.
An exhibition of sixteen family portraits recently given to the Peabody Museum of Salem by Senator Leverett Saltonstall, dating from the middle of the seventeenth century.

12. GEORGE WASHINGTON

Baker, William S., *The Engraved Portraits of Washington, with Notices of the Originals and Brief Biographical Sketches of the Painters.* Philadelphia, 1880. Pp. ix, 212.
Arranged chronologically by paintings under the names of the artists, with the engravings after the painting grouped beneath. All of the engravings are given one numerical ordering (in spite of the chapter divisions), with the engraver's name for the caption.

Baker, William S., *Medallic Portraits of Washington, with Historical and Critical Notes and a Descriptive Catalogue of the Coins, Medals, Tokens, and Cards.* Philadelphia, 1885. Pp. vii, 252.
A useful catalogue of Washington coins and medals celebrating his lifting the siege of Boston, his part in the Declaration of Independence, the Peace of 1783, his military and civil career, his home of Mount Vernon, the centennial of his birth in 1832, Indian peace medals, etc. Important to understanding the myth-making surrounding Washington.

Eisen, Gustavus A., *Portraits of Washington.* 3 vols., New York, 1932. Pp. lxxii, 1021 [continuous pagination].
The first volume concerns itself exclusively with Gilbert Stuart portraits in oil (schematized down through series and subseries of types); the second volume covers portraits by Peale, Sharples, Saint-Mémin, and others; and the third is on sculptured portraits.

Morgan, John Hill, and Mantle Fielding, *Life Portraits of Washington and Their Replicas.* Philadelphia, 1931. Pp. xxiii, 432.

Contains extensive descriptions of the life portraits of Washington made by twenty-seven painters and sculptors as well as admirable illustrations.

D. Catalogues of Portrait Collections

1. AMERICAN ANTIQUARIAN SOCIETY

Weis, Frederick L., *Checklist of the Portraits in the Library of the American Antiquarian Society*. Worcester, 1947. Pp. 76. Also printed in American Antiquarian Society, *Proceedings*, 56 (April 1946): 55–128.

2. AMERICAN PHILOSOPHICAL SOCIETY

American Philosophical Society, *A Catalogue of Portraits and Other Works of Art in the Possession of the American Philosophical Society*. Philadelphia, 1961. Pp. viii, 173, which includes 59 plates.

3. ESSEX INSTITUTE

Essex Institute, *Catalogue of Portraits in the Essex Institute, Salem, Massachusetts*. Introduction by Henry Wilder Foote, Salem, 1936. Pp. xii, 306.
Catalogue of over 400 portraits; updated in 1950 by Russell Leigh Jackson in an *Additions* . . . , Salem, 1950, 82 pp., covering 134 more portraits.

4. MUSEUM OF FINE ARTS, BOSTON

Museum of Fine Arts, Boston, *Massachusetts Bay Colony Tercentenary, Loan Exhibition of One Hundred Colonial Portraits*. Boston, 1930. Pp. 100.
Illustrations with minimum catalogue information.

5. VIRGINIA HISTORICAL SOCIETY

Weddell, Alexander Wilbourne, *Portraiture in the Virginia Historical Society, with Notes on the Subjects and Artists*. Richmond, 1945. Pp. 192.

Catalogue of 92 portraits, 6 miscellaneous paintings, 5 miniatures, 16 silhouettes, and a few busts and casts of persons associated with Virginia history, 1585–1830.

6. HARVARD UNIVERSITY

Huntsinger, Laura M., *Harvard Portraits: A Catalogue of Portrait Paintings at Harvard University*. Cambridge, 1936. Pp. 158.

7. HISTORICAL SOCIETY OF PENNSYLVANIA

Sawitzky, William, *Catalogue, Descriptive and Critical, of the Paintings and Miniatures in The Historical Society of Pennsylvania*. Philadelphia, 1942. Pp. xiv, 285.

8. NEW-YORK HISTORICAL SOCIETY

[Shelley, Donald A., and others], *Catalogue of American Portraits in The New-York Historical Society: Oil Portraits, Miniatures, Sculptures*. New York, 1941. Pp. viii, 374.

9. PEABODY MUSEUM, SALEM

Peabody Museum, *Portraits of Shipmasters and Merchants in the Peabody Museum of Salem*. Introduction by Walter Muir Whitehill, Salem, 1939. Pp. xii, 185.
Contains biographical information in addition to descriptions of the portraits.

10. PRINCETON UNIVERSITY

Egbert, Donald Drew, *Princeton Portraits*. Princeton, 1947. Pp. vii, 360.
There are 236 reproductions of portraits of Princeton's presidents, faculty, trustees, and others connected with the institution, accompanied with biographical sketches.

11. VALENTINE MUSEUM, RICHMOND

Valentine Museum, *Richmond Portraits in an Exhibition of Makers of Richmond, 1737–1860*. Richmond, 1949. Pp. xvii, 286.

Largely portraits and biographical sketches of the professional men and merchants who made the community of post-Revolutionary Richmond to 1860.

12. YALE UNIVERSITY

Yale University Portrait Index, 1701–1951. Preface by John Marshall Phillips, New Haven, 1951. Pp. ix, 185.

VI. SCULPTURE AND CARVING

Barba, Preston A., *Pennsylvania German Tombstones* [The Pennsylvania German Folklore Society, Vol. 18]. Allentown, 1954. Pp. 232.
Treats tombstones down to 1850 and contains numerous line drawings of designs and symbols, as well as of entire stones.

Brewington, M. V., *Shipcarvers of North America.* Barre, Mass., 1962. Pp. xiv, 173.
An authoritative study of American shipcarvers, those half-artists and half-tradesmen whose skill with the chisel gave so much beauty to the sailing ship. Using the previously published books on the subject, city directories, journal and magazine articles, manuscript collections, newspapers, photograph and scrap book collections, ship models and plans, and collections of figureheads, Mr. Brewington has pulled together about all that can be learned about these shipcarvers and the specimens of their work that have been preserved. The trade in its early years was dominated by the Skillin dynasty in Boston and William Rush in Philadelphia. A "List of American Shipcarvers" arranged by states concludes the book.

Forbes, Harriette Merrifield, *Gravestones of Early New England and the Men Who Made Them, 1653–1800.* Boston, 1927. Pp. 141.
An important study containing whole chapters on such important stonecutters as the Lamsons of Charlestown and the Fosters of Dorchester. An appendix lists alphabetically the New England stonecutters working before 1800. The work was supplemented by Mrs. Forbes in "Early Portrait Sculpture in New England," *Old-Time New England,* 19 (Apr. 1929): 159–73.

Gardner, Albert TenEyck, *Yankee Stonecutters: The First American School of Sculpture, 1800–1850.* New York, 1945. Pp. 84. 12 plates.

Gardner stresses the relationship between sculpture and politics in the early national period. Under the first appendix, "The Precursors," he lists the sculptors, stonecutters, carvers, and modelers working in America before 1800.

Gerdts, William H., *A Survey of American Sculptures: Late 18th Century to 1962.* Newark, 1962. Pp. 44.
Catalogue of an exhibition held at the Newark Museum in 1962. In its early pages it covers the work of Samuel McIntire of Salem, William Rush of Philadelphia, Hezekiah Augur of New Haven, and John Frazee of New York City.

Hart, Charles Henry, *Browere's Life Masks of Great Americans,* [New York], 1899. Pp. xiv, 123.
Illustrated catalogue of the life masks of distinguished Americans, done between 1817 and Browere's death in 1834.

Marceau, Henri, *Works of William Rush, 1756–1833, the First Native American Sculptor.* Philadelphia, 1937. Pp. 85. 86 plates.
An introduction containing biographical material and a complete list of the known Rush works.

Newark Museum, *American Folk Sculpture: The Work of Eighteenth and Nineteenth Century Craftsmen.* Newark, 1931. Pp. 108.
An exhibition catalogue of wood carving (ships' figureheads, cigar store figures, portraits, eagles, Schimmel carvings, decoy birds, toys, etc.) and work in metal (weather vanes, firemarks, iron stove plates, etc.) held at the Newark Museum in 1931–32.

Taft, Lorado, *The History of American Sculpture.* New York and London, 1903. Pp. xiii, 544.
Taft's first chapter, "Early efforts in Sculpture," describes the work of Patience Wright, William Rush, Hezekiah Augur, John Frazee, and the American work of Houdon and Cerracchi.

VII. GRAPHIC ARTS

A. Engraving

Allen, Charles Dexter, *American Book-Plates: A Guide to Their Study With Examples,* New York and London, 1894. Pp. xiv, 437.
A general discussion of the subject is followed by lists of engravers, known book-plates, signed plates, and mottoes.

Baltimore Museum of Art, *The World Encompassed: An Exhibition of the History of Maps Held at the Baltimore Museum of Art,*

October 7 to November 23, 1952. Baltimore, 1952. Pp. xiv, 125. 60 plates.

A catalogue growing out of a cooperative exhibition sponsored by the Baltimore Museum of Art, the Peabody Institute Library, the Walters Art Gallery, and the John Work Garrett Library of Johns Hopkins University. Compiled by E. Baer, Lloyd A. Brown, and Dorothy E. Miner. A basic reference work on maps; numbers 201–62 concern America.

Borneman, Henry S., *Pennsylvania German Bookplates, A Study.* Philadelphia, 1953. Pp. iv, 169. 24 plates.

A thorough study on the variety, designs and designers, collecting, and message of the bookplates made by the Pennsylvania Germans, mostly in the first quarter of the nineteenth century.

Brigham, Clarence S., *Paul Revere's Engravings.* Worcester, 1954. Pp. xvi, 181.

A detailed and highly articulate analysis of Revere's 72 copperplate engravings, based largely on the American Antiquarian Society's collection of Revere material that Brigham built up over the years. There are 77 collotype reproductions of both Revere's engravings and the English sources which he sometimes copied. The author has given proper balance to the range of the engraver's subjects, giving a great deal of space and probably the last word on his more important "Boston Massacre" and "View of the Colleges in Cambridge" while still directing his attention to the engraver's bookplates and paper money.

Brown, Lloyd A., *Early Maps of the Ohio Valley: A Selection of Maps, Plans, and Views Made by Indians and Colonials from 1673 to 1783.* Pittsburgh, 1959. Pp. xv, 132.

Fifty-four beautifully reproduced maps with excellent accounts of their historical provenance.

Cumming, William P., *The Southeast in Early Maps: With an Annotated Check List of Printed and Manuscript Regional and Local Maps of Southeastern North America during the Colonial Period.* Princeton, 1958. Pp. ix, 275.

Indispensable index to maps of the southeast during the colonial period; Cumming enters each map under the date of its first appearance and then notes the dates of subsequent reprints. In his introductory essay the author explains the evolution of geographical knowledge of the region, and by a chart indicates basic prototype maps, their derivatives, and plagiarisms made of them. There are 59 maps reproduced superbly by the Meriden Gravure Company.

Dresser, Louisa, *Early New England Printmakers*, Worcester, 1939. Pp. 77. 12 plates.

Catalogue of an exhibition held at the Worcester Art Museum in collaboration with the American Antiquarian Society, 1939–40. Examples by the famous engravers are described, such as prints by John Foster, Peter Pelham, James Turner, Nathaniel Hurd, John Singleton Copley, Paul Revere, John Norman, Benjamin Blyth, Samuel Hill, etc.

Fielding, Mantle, *American Engravers upon Copper and Steel: Biographical Sketches and Check-Lists of Engravings: A Supplement to David McNeely Stauffer's American Engravers*. Philadelphia, 1917. Pp. xi, 365.

A one-volume supplement that updates and fills out Stauffer's two-volume compendium (see below).

Green, Samuel Abbott, *John Foster, The Earliest American Engraver and the First Boston Printer*. Boston, 1909. Pp. 149.

An important book for its time on America's first wood engraver; a helpful bibliographical list of Foster imprints is appended. Recent articles by Gillett Griffin on Foster's woodcut of Richard Mather and by Richard B. Holman on his woodcut map of New England (*Printing and Graphic Arts*, 7 [1959]: 1–19; 8 [1960]: 53–93) have fortunately helped to bring knowledge on Foster up to date.

Karpinski, Louis C., *Bibliography of the Printed Maps of Michigan, 1804–1880, with a Series of Over One Hundred Reproductions of Maps Constituting an Historical Atlas of the Great Lakes and Michigan*. Lansing, 1931. Pp. 539.

A thorough compendium of nearly a thousand maps. A large part of bibliography is a list of the "Fundamental Maps of the Great Lakes Area"—those maps issued before the year 1805 which may properly be called fundamental in the historical determination of the cartography of Michigan. The second half of the book, dealing with the period after Michigan became a territory, divides the maps by region (Great Lakes area), territory and state, counties, cities, and towns.

Karpinski, Louis C., and Priscilla Smith, *Early Maps of Carolina and Adjoining Regions from the Collection of Henry P. Kendall*. 2d edn., Charleston, 1937. Pp. viii, 67.

An annotated exhibition catalogue of nearly two hundred maps of the Carolinas, dated 1540–1869.

Le Gear, Clara Egli, comp., *United States Atlases: A List of National, State, County, City, and Regional Atlases in the Library of Congress*. Washington, 1950. Pp. viii, 445.

Bibliography of atlases of the United States, divided into two groups. The first, a group of general atlases, is chronologically ar-

ranged. The second, a group of special atlases, is alphabetically arranged by subject. Under each state, the atlases are arranged in four groups; namely, (1) the state as a whole in chronological order; (2) counties in alphabetic-chronological order; (3) cities in alphabetic-chronological order; and (4) regions in alphabetic order. Compiled by the Maps Division and published by the Reference Department of the Library of Congress.

Lewis, Benjamin Morgan, *A Guide to Engravings in American Magazines, 1741–1810.* New York, 1959. Pp. iv, 60.
Arranged in three parts: (1) alphabetical listing of magazines with engravings by date, (2) subject and title index to magazine engravings, and (3) register of the engravers.

Lunny, Robert M., *Early Maps of North America.* Newark, N.J., 1961. Pp. 48.
A narrative account of the spread of geographical knowledge of North America from the discovery to 1800, illustrating in 26 plates the great maps from Mercator's map of the world in 1538 to Abel Buell's map of the United States in 1784. A publication of the New Jersey Historical Society.

Middendorf, J. William, II, *et al. Prints Pertaining to America: A List of Publications in English, Relating to Prints about that Portion of America now Included in the United States with Emphasis on the Period, 1650–1850, and A Checklist of Prints in an Exhibition to Commemorate the 1962 Fall Meeting of the Walpole Society Selected from the Collection of the Henry Francis du Pont Winterthur Museum.* Walpole Society, 1963. Pp. 99.
A catalogue of engraved prints in the Winterthur Museum with an extensive bibliography on American prints, engravers, printing, etc.

Mugridge, Donald H., comp., *An Album of American Battle Art, 1755–1918.* Washington, 1947. Pp. xvi, 319. 150 plates.
A catalogue of an exhibition held in 1944 at the Library of Congress, based largely on the collection of the Prints and Photographs Division. The plates are grouped in ten sections, each representing a war or group of wars (French and Indian War, American Revolution, Revolutionary France and the Barbary Pirates, War of 1812, etc.). Of the 150 entries (all illustrated), the first 49 engravings date before 1826.

Phillips, P. Lee, *A List of Maps of America in the Library of Congress.* Washington, 1901. Pp. 1137.
Lists all known American maps.

Princeton University Library, *Early American Book Illustrators and Wood Engravers, 1670–1870; A Catalogue of a Collection of*

American Books Illustrated for the Most Part with Wood Cuts and Wood Engravings in the Princeton University Library. With an Introductory Sketch of the Development of Early American Book Illustration by Sinclair Hamilton. With a Foreword by Frank Weitenkampf. Princeton, 1958. Pp. xlvii, 265.

A splendid volume by a distinguished collector that begins with the earliest known relief cuts on wood or metal, which appeared as book illustrations; covers a period of over two hundred years, to the beginning of the school of illustrators and wood-engravers best known from the pages of *Harper's, Scribner's Monthly,* and *Century* magazines.

Rice, Howard C., Jr., *New Jersey Road Maps of the 18th Century.* Princeton, 1964. Pp. 48.

The four following maps from the collections of the Princeton University Library are reproduced in facsimile: "A Map of the Road from Trenton to Amboy," copied by G. Bancker, 1762, from John Dalley's survey of 1745; "A Map of the Division line Between the Counties of Middlesex & Somerset," by Azariah Dunham, 1766; seven maps by Louis-Alexandre Berthier depicting the route of the French army across New Jersey in August 1781; and the engraved maps from *The Traveller's Directory* (Philadelphia, 1804) showing the road from Philadelphia to New York. Mr. Rice has introduced each map with an informed headnote.

Stauffer, David McNeely, *American Engravers upon Copper and Steel.* 2 vols., New York, 1907. Pp. xxxi, 391; x, 566.

Divided into two volumes or "Parts"; (1) "Biographical Sketches" of American engravers upon copper and steel through the nineteenth century, and (2) "Check-List of the Works of the Earlier Engravers," that is, a list under the names of engravers of work done before 1825.

Stephens, Stephen DeWitt, *The Mavericks, American Engravers.* New Brunswick, N.J., 1950. Pp. xx, 219.

History of the Maverick family, who were engaged in various forms of engraving and lithography, from the latter part of the eighteenth century through the first quarter of the nineteenth, producing book illustrations, book plates, maps, certificates, portraits, trade cards and on occasion a town view. There is a large catalogue of their many print productions.

Stokes, I. N. Phelps, and Daniel C. Haskell, *American Historical Prints: Early Views of American Cities, Etc., from the Phelps Stokes and Other Collections.* New York, 1932. Pp. xxxvi, 327.

Detailed catalogue of selected views of 160 towns and cities in the United States and 40 cities outside of this country, made between 1497 and 1891. Handsomely illustrated, chronologically arranged, and indexed by subject and engravers.

Thompson, Edmund, *Maps of Connecticut before the Year 1800: A Descriptive List*. Windham, Conn., 1940. Pp. 66.

Descriptive list of all maps, either printed or in manuscript, that are primarily of Connecticut or of parts of the state before the year 1800. (General maps of North America or of New England on which Connecticut is but an incidental part have been omitted.)

B. Caricature

Nevins, Allan, and Frank Weitenkampf, *A Century of Political Cartoons: Caricature in the United States from 1800 to 1900*. New York, 1944. Pp. 191.

One hundred cartoons with their explanatory descriptions are reproduced here; nine date before 1826.

Weitenkampf, Frank, comp., *Political Caricature in the United States in Separately Published Cartoons*. New York, 1953. Pp. 184.

An annotated list of political cartoons published separately as prints in the United States between 1787 and 1898. Those issued in colonial days, as well as those published in periodicals and books, are excluded. Over seventy-five are listed before 1826. Published by the New York Public Library which issued it originally in installments through 1952 in their *Bulletin*.

C. Printing

Brigham, Clarence S., *History and Bibliography of American Newspapers, 1690–1820*. 2 vols., Worcester, 1947. Pp. xvii, 1508.

One cannot overexaggerate the usefulness of these two volumes to researchers in all fields, but for the purposes of this bibliography the information on printers is invaluable. Brigham has provided a short factual history of each newspaper with such information as date of establishment, suspensions of publication, changes in title and imprint, and complete identification of printers. There is also a bibliography and a list of printers, publishers, and editors.

Bristol, Roger Pattrell, *Index of Printers, Publishers, and Booksellers Indicated by Charles Evans in his American Bibliography*. Charlottesville, 1961. Pp. iv, 172.

This index makes Charles Evans's *American Bibliography* a doubly useful tool for the student of American graphic arts. Using this index and the American Antiquarian Society's microcard edition of Evans, students can have immediately before them the work of any one of the

majority of American printers before 1801. No attempt has been made to correct Evans's errors.

Brown, H. Glenn, and Maude O. Brown, *A Directory of the Book-Arts and Book Trade in Philadelphia to 1820, Including Painters and Engravers.* New York, 1950. Pp. 129.
Directory of those whose work was related to book arts and book trade in Philadelphia, modeled after McKay's *Register* for New York City.

Brown, H. Glenn, and Maude O. Brown, *A Directory of Printing, Publishing, Bookselling & Allied Trades in Rhode Island to 1865.* New York, 1958. Pp. 211.
Same scheme as the preceding, for Rhode Island, listing printers, publishers, booksellers, auctioneers who sold books, binders, and paper and press manufacturers. Artists and engravers have not been included.

Charvat, William, *Literary Publishing in America: 1790–1850.* Philadelphia, 1959. Pp. 94.
Essays delivered as lectures of the annual Rosenbach Fellowship in Bibliography. A history of the slow, uneven maturation of the publishing trade, beginning with the first national copyright law in 1790. The author explores the formation of the publishing centers in New York, Philadelphia, and Boston; the relations between authors and publishers; and the role of publisher as bookseller.

Ford, Paul Leicester, ed., *The Journals of Hugh Gaine, Printer.* New York, 1902; 2 vols. [Vol. 1:] *Biography and Bibliography;* [Vol. 2:] *Journals and Letters.* Pp. xii, 240; xii, 235.
Full-scale treatment of Hugh Gaine (1726 or 1727–1807), New York printer, with a biography, a bibliography (1752–1800), his journals (1757–58, 1777–82, and 1797–98), and scattered letters.

Ford, Worthington Chauncey, *The Boston Book Market, 1679–1700.* Boston, 1917. Pp. xii, 198.
Ford is as interested in the titles and kinds of books being both imported and printed locally as he is in the printers, bookbinders, and booksellers. His book is as much a guide to the tastes in reading as anything. A Club of Odd Volumes publication.

[Ford, Worthington Chauncey, comp.,] *Broadsides, Ballads, etc. Printed in Massachusetts, 1639–1800* (Massachusetts Historical Society, *Collections*, vol. 75). Boston, 1922. Pp. xvi, 483.
Listed chronologically by year, and alphabetically under each year, with a single over-all numbering. The Evans number and the institutions owning the broadside are given when they are known.

Hildeburn, Charles R., *Printers and Printing in Colonial New York.*
New York, 1895. Pp. xiv, 189.

This book, printed by the DeVinne Press, is a superb example of printing itself. It is a synopsis of biographical and bibliographical information on the leading printers of the colony: William Bradford (printer to the Province of New York, 1693–1742), the Zengers (especially John Peter Zenger and the celebrated struggle for liberty of the press), the Parkers, the minor presses of mid-century, Hugh Gaine the Irish printer, the Whig John Holt, the loyalist brothers James and Alexander Robertson, and James Rivington and his "Lying Gazette."

Hunter, Dard, *Papermaking in Pioneer America.* Philadelphia, 1952.
Pp. xvi, 178.

The history of the first mills to make paper by hand in America, with a check list of papermakers, 1680–1817. This book contains essentially all the text from his earlier (1950), privately printed *Papermaking by Hand in America.*

Hyder, Darrell, "Philadelphia Fine Printing, 1780–1820," *Printing and Graphic Arts*, 9 (1961): 69–99.

The author emphasizes the art of printing (types used, format, paper, presswork, etc.) rather than the literary aspects.

Kaser, David, *Joseph Charless: Printer in the Western Country.*
Philadelphia, 1963. Pp. 160.

Biography of Joseph Charless (1772–1834), Dublin-born printer, who came to America in 1795 and established himself as an editor, bookseller, and publisher, first in Lewiston, Penna., next in Lexington, Ky., and finally St. Louis where he published the *Missouri Gazette*, 1808–20, and held the position of Printer to the Territory.

Klapper, August, *The Printer in Eighteenth-Century Williamsburg.*
[Williamsburg Craft Series.] Williamsburg, 1958. Pp. ii, 34.

An interpretation of the printer and his craft, his shop, and his place in the agricultural economy of eighteenth-century Williamsburg. Much incidental information on rare imprints and the important *Virginia Gazette* has also been included. There is a biographical list of the dozen master printers of the town, 1730–80.

Lawrence, Alexander A., *James Johnston: Georgia's First Printer.*
Savannah, 1956. Pp. 54.

Johnston was the official printer for Georgia and editor of its first newspaper from 1763 until 1802.

Littlefield, George Emery, *The Early Massachusetts Press, 1638–1711.* 2 vols., Boston, 1907. Pp. 269; 100, and 90 pages of facsimile.

A series of biographical sketches of early Cambridge and Boston printers: Richard Steere, James Cowse, Rev. Joseph Glover, Stephen Day, Matthew Day, Rev. John Eliot, Samuel Green, Marmaduke Johnson, John Foster, Samuel Sewall, Samuel Green, Jr., James Glen, Richard Pierce, Bartholomew Green, John Allen, Timothy Green, and James Printer. In volume two Littlefield has reprinted in facsimile *A Monumental Memorial* (1684) and *The Daniel Catcher* (1713). A Club of Odd Volumes publication.

McCorison, Marcus A., comp., *Vermont Imprints, 1778–1820: A Check List of Books, Pamphlets, and Broadsides*. Worcester, 1963. Pp. xxiv, 597.
A model bibliography that concludes with a section on "The Printing Trades in Vermont, 1778–1820"—a list of printers, publishers, booksellers, and others engaged in the execution or distribution of printing within the state of Vermont before 1820.

McKay, George L., comp., *A Register of Artists, Engravers, Booksellers, Bookbinders, Printers & Publishers in New York City, 1633–1820*. New York, 1942. Pp. 78.
List of names of individuals and firms connected with the graphic arts in the town of New York in the first two centuries of its history.

Miner, Ward L., *William Goddard, Newspaperman*. Durham, 1962. Pp. x, 223.
Goddard was a newspaper publisher in Philadelphia before the Revolution and at Baltimore during and after the war. Here we learn much about the colonial printer's vocation and role as craftsman, editor, and businessman.

Munsell, J., *A Chronology of Paper and Paper-Making*, 3d edn., Albany, 1864. Pp. vii, 174.
A chronological listing of significant advances in the technology of paper-making and the establishment of paper mills, particularly in America (see p. 22 ff.).

Nash, Ray, *American Writing Masters and Copybooks, History and Bibliography Through Colonial Times*. Boston, 1959. Pp. xiii, 77.
Preprinted from volume 42 of *Publications* of the Colonial Society of Massachusetts as the third of *Studies in the History of Calligraphy* of the Harvard College Library and the Newberry Library.

Nichols, Charles Lemuel, *Isaiah Thomas: Printer, Writer & Collector*. Boston, 1912. Pp. xi, 145.
Most important for a bibliography of books, pamphlets, newspapers, and broadsides printed by Thomas in Boston and Worcester. A Club of Odd Volumes publication.

Shelley, Donald A., *The Fraktur-Writings or Illuminated Manuscripts of the Pennsylvania Germans* [The Pennsylvania German Folklore Society, Vol. 23]. Allentown, 1961. Pp. 375.
Excellent general account, as well as lists of fraktur illuminators, printing centers, and printers, with an extensive bibliography. Lavishly illustrated in both color and black and white.

Shipton, Clifford K., *Isaiah Thomas: Printer, Patriot and Philanthropist, 1749–1831*. Rochester, N.Y., 1948. Pp. xii, 94.
A full biography of the Worcester printer whose fame rests on his craftsmanship, his *Massachusetts Spy*, his *History of Printing*, and his promotion of learning through the American Antiquarian Society.

Sutton, Walter, *The Western Book Trade: Cincinnati as a Nineteenth-Century Publishing and Book-Trade Center*. Columbus, Ohio, 1961. Pp. xv, 360.
In the first part, "The Hand Press Serves the Frontier," the author discusses printing and publishing in Cincinnati before 1830. The city was to flourish both as the Queen City of the inland waterways and as the center of book-trade activity in the country west of the Allegheny Mountains.

Thomas, Isaiah, *The History of Printing in America, with a Biography of Printers, and an Account of Newspapers*. 2 vols., Worcester, 1810. Pp. vi, 487; iv, 576.
The material for this work Thomas gathered partly from personal interviews with printers and memoranda furnished by them, but chiefly from his own memory, extending over a period of half a century, and the facts obtained from his own vast collection of American printed books, pamphlets, and newspapers. It has and will remain one of the classics on early American printing. Several years after the *History* was published, William McCulloch, one of the leading printers of Philadelphia, wrote Thomas six communications offering a few additions and corrections. Clarence S. Brigham published them as "William McCulloch's Additions to Thomas's History of Printing," in the *Proceedings of the American Antiquarian Society*, 31 (1921): 89–247.

Tremaine, Marie, "A Half-Century of Canadian Life and Print, 1751–1800," *Essays Honoring Lawrence C. Wroth*. Portland, 1951. Pp. 371–90.
A brief but good survey of early printing in eastern Canada.

Weeks, Stephen B., *The Press of North Carolina in the Eighteenth Century*. Brooklyn, N.Y., 1891. Pp. iv, 80.
Biographical sketches of North Carolina printers (James Davis, Andrew Steuart, Adam Boyd, Robert Keith, Abraham Hodge,

William Boylan, Joseph Gales, and others), an account of the manufacture of paper, and a bibliography of imprints, 1749–1800.

Wheeler, Joseph T., *The Maryland Press, 1777–1790*. Baltimore, 1938. Pp. xiv, 226.
A series of biographical sketches of the most prominent printers in Maryland during the years of the Revolution and those of the decade following: William Goddard, Mary Katherine Goddard, Eleazer Oswald, Edward Langworthy, James Angell, John Dunlap, James Hayes, Jr., John Hayes, Matthias Bartgis, and Frederick and Samuel Green. Wheeler also discusses printing at Baltimore, Easton, Hagerstown, and Georgetown. His bibliography of Maryland imprints, 1777–1790, with the addition of his narrative chapters, form a continuum of Wroth's Maryland book (see below).

Winship, George Parker, *The Cambridge Press, 1638–1692: A Reexamination of the Evidence Concerning The Bay Psalm Book and the Eliot Indian Bible as well as other Contemporary Books and People*. Philadelphia, 1945. Pp. ix, 385.
The definitive story of the first Anglo-American press, between fixed terminal dates—the arrival of the printing press in Massachusetts and the passing of the printing leadership from Cambridge to Boston.

Winslow, Ola Elizabeth, ed., *American Broadside Verse from Imprints of the 17th & 18th Centuries*. New Haven, 1930. Pp. xxvi, 224.
Contains many early broadsides in facsimile with bibliographical information and commentary.

Wroth, Lawrence C., *The Colonial Printer*. 2d edn., Portland, Maine, 1938. Pp. xxiv, 368.
The best treatment of all aspects of printing in colonial America: printing presses, type and type founding, printing ink and paper, printers and the general conditions of their trade, journeymen and apprentices, and bookbinding. Mr. Wroth concludes the book with an analysis of the product of the colonial press, from its content to its external characteristics. *The Colonial Printer* has been reprinted in paperback by the University Press of Virginia.

Wroth, Lawrence C., "The First Work with American Types," *Bibliographical Essays: A Tribute to Wilberforce Eames*. Cambridge, 1924. Pp. 128–42.
Until 1770 the American printer was dependent for his printing type upon importation from Europe. The earliest successful attempts at letter casting and type manufacturing in America were made in the 1770's by Abel Buell of Killingworth, Conn.; David Mitchelson

of Boston; and Christopher Sower, Jr., Justus Fox, and Jacob Bay of Germantown, Penna.

Wroth, Lawrence C., *A History of Printing in Colonial Maryland, 1686–1776*. Baltimore, 1922. Pp. xvi, 277.
A model discussion of Maryland printers and their art followed by a listing of Maryland imprints, 1689–1776.

D. Bookbinding

French, Hannah D., "The Amazing Career of Andrew Barclay, Scottish Bookbinder of Boston," *Studies in Bibliography*, 14 (1961): 145–62.
A Boston bookbinder, 1765–76.

French, Hannah D., "Early American Bookbinding by Hand," in *Bookbinding in America*, ed. Hellmut Lehmann-Haupt. Portland, Maine, 1941. Pp. 3–127.
The major work in the field: treats materials, techniques, decoration and style of bindings, centers of activity, names of binders, and identification of bindings. Lists of American binders, 1636–1820, and of bindings (ownership and location of extant examples) are included as an Appendix.

Samford, C. Clement, *The Bookbinder in Eighteenth-Century Williamsburg*. [Williamsburg Craft Series.] Williamsburg, 1959. Pp. 32.
An explanatory study of technical aspects of binding books—the tools, nomenclature, etc. The author has reprinted a number of newspaper advertisements of bookbinders in Williamsburg, and from these and other sources explains the relationship between binders and printers. This pamphlet was based largely on a study prepared jointly by Samford and John M. Hemphill II of Colonial Williamsburg.

Spawn, Willman and Carol, "The Aitken Shop: Identification of an Eighteenth-Century Bindery and Its Tools," Bibliographical Society of America, *Papers*, 57 (Oct.-Dec. 1963): 422–37.
Philadelphia binder, bookseller, and printer, 1771–1802.

VIII. MEDALS, SEALS, AND HERALDIC DEVICES

Betts, C. Wyllys, *American Colonial History Illustrated by Contemporary Medals*. New York, 1894. Pp. viii, 332.
A catalogue of 623 medals, dating 1556–1783, illustrating American subjects and events. Indexed by (1) legends and inscrip-

tions, (2) die sinkers and engravers, and (3) persons, places, and subjects.

Bolton, Charles Knowles, *Bolton's American Armory: A Record of Coats of Arms Which Have Been in Use Within the Present Bounds of the United States.* Boston, 1927. Pp. xxiii, 223.
A detailed record of those coats of arms that have been in use within the bounds of the present United States. Arranged alphabetically. In addition to a full description of the heraldic elements within these coats of arms, Bolton gives his source of information (generally bookplates, seals, and engraved crests on silver plate).

Boyd, Julian, *et al.*, "Notes on American Medals Struck in France," *The Papers of Thomas Jefferson*, Princeton, 1961, 16:53–79. 12 plates.
A cluster of four Jefferson documents on medals, 1786–92, with a definitive headnote and textual annotation by Boyd, on a series of American commemorative medals struck in France. A most impressive piece of scholarship in its masterful recapitulation of the subject. These medals were executed by the best French artists; they set influential standards for subsequent medals executed in the United States. Important too for the concept of commemorative medals and their role in national life, and for the arts as an incentive to patriotism.

Loubat, J. F., *The Medallic History of the United States of America, 1776–1876.* 2 vols., New York, 1878. Pp. lxix, 478. 86 plates.
An elegantly produced pair of folio books out of the Centennial celebration that is still the basic work on the subject of American medals. Most of the medals are richly documented with numerous letters printed *in extenso*. The first volume is text; the second is devoted to 86 plates of 170 etchings by Jules Jacquemart.

Sommer, Frank H., "Emblem and Device: The Origin of the Great Seal of the United States," *Art Quarterly*, 24 (Spring 1961): 56–76.
Between 1776 when the Continental Congress set up a committee "to prepare a device for a Seal of the United States of America" and 1782 when the devices for the great seal were finally approved, a number of proposals were made and sketches drawn which were rejected that tell much about the American use of the emblem and device. The Pennsylvania-German William Barton and the Secretary of Congress, Charles Thomson, in the end were largely responsible for the use of the German imperial eagle, the olive branch, the bundle of arrows, and the Horatian "E pluribus unum."

Zieber, Eugene, *Heraldry in America.* 2d edn., Philadelphia, 1909. Pp. 427.

First published in 1894. Over 950 illustrations of seals and coats of arms. Lengthy discussion of the terminology and symbolism of heraldry. Also a chapter on colonial societies and American orders.

IX. CRAFTS

Belknap, Henry Wyckoff, comp., *Artists and Craftsmen of Essex County, Massachusetts.* Salem, 1927. Pp. viii, 127.

Under the categories of artists (architects, engravers, painters, paper cutters, photographers, sculptors and carvers, and silhouette and wax portrait makers) and craftsmen (cabinetmakers, gilders and painters, glass makers, silversmiths, metal workers, potters, and turners), Belknap has compiled biographical registers on them up through 1860, arranged in alphabetical order within each of the fourteen groups. He gives birth and death dates, marriage, town, military career, anything known about their occupation, and dates in that trade. The author has compiled this information from Probate and Vital Records of Essex County, Salem newspapers and directories, and town and family histories. Unfortunately, however, Belknap has not given his sources under the individual entries; one therefore can only guess from place and date about where he got his information if further research is being planned.

Belknap, Henry Wyckoff, *Trades and Tradesmen of Essex County, Massachusetts: Chiefly of the Seventeenth Century.* Salem, 1929. Pp. 96.

Belknap has quoted and paraphrased in a chronological sequence from the published *Probate Records* and *Quarterly Courts Records* of Essex County relevant passages on artisans.

Brewington, M. V., *The Peabody Museum Collection of Navigating Instruments with Notes on Their Makers.* Salem, 1963. Pp. xii, 154.

A descriptive catalogue, liberally illustrated with collotype plates of instruments for location from the heavens, of direction, of time, speed and distance, and the like, assembled by the museum since its foundation in 1799 by the Salem East India Marine Society, with notes on instrument makers, dealers and designers, including material supplied by the National Maritime Museum, Greenwich, and the Liverpool Public Museums.

Bridenbaugh, Carl, *The Colonial Craftsman.* New York, 1950. Pp. xii, 214.

A highly detailed survey of handicraft production in urban centers, that focuses upon the men, and in some cases women, who made

things. Emphasis on market production, trade, institutions of craft production, and the social and political aspirations of the craftsman class.

Dow, George Francis, *The Arts & Crafts in New England, 1704–1775: Gleanings From Boston Newspapers*. Topsfield, Mass., 1927. Pp. xxxii, 325.
A useful reprinting of newspaper advertisements of craftsmen and artists.

Eckhardt, George H., *Pennsylvania Clocks and Clockmakers, An Epic of Early American Science, Industry and Craftsmanship*. New York, 1955. Pp. xviii, 229.
A combination of general information, pictures of clocks arranged in chronological order, and annotated lists of clock and watchmakers of Philadelphia and Pennsylvania, 1682–1850.

Gottesman, Rita Susswein, comp., *The Arts and Crafts in New York, 1726–1776: Advertisements and News Items from New York City Newspapers* (The New-York Historical Society, *Collections*, vol. 69). N.Y., 1938. Pp. xviii, 450.

Gottesman, Rita Susswein, comp., *The Arts and Crafts in New York, 1777–1799: Advertisements and News Items from New York City Newspapers* (The New-York Historical Society, *Collections*, vol. 81). N.Y., 1954. Pp. xix, 484.
Mrs. Gottesman has painstakingly collected direct transcripts of advertising and items of news from all the extant files of three dozen New York newspapers for the period of these two volumes. Each of the major arts and crafts is covered in such a way that these are source books for the study of pre-1800 craftsmen, artisans, and artists, as well as for their respective work.

Hoopes, Penrose R., *Connecticut Clockmakers of the Eighteenth Century*. Hartford, 1930. Pp. 178.
A general discussion of Connecticut clockmaking, an alphabetical listing of 79 clockmakers with biographical notes, 56 illustrations, bibliography, and index.

Hoopes, Penrose R., *Shop Records of Daniel Burnap, Clockmaker*. Hartford, 1958. Pp. viii, 188.
Extended excerpts from the surviving account books and a complete transcription of the Memorandum Book of Daniel Burnap, Connecticut clockmaker, form the bulk of this book. A biographical sketch and illustrations of his clocks, dials, movements, tools, and patterns have also been provided.

Mercer, Henry C., *Ancient Carpenters' Tools Illustrated and Explained together with the Implements of the Lumberman, Joiner and Cabinet Maker, in Use in the Eighteenth Century.* Doyleston, Penna., 1929. Pp. vii, 328.
A minutely detailed historical account of carpenters' and other woodworkers' tools divided into chapters by use: felling, splitting, and log sawing; moving and measuring; holding and gripping; surfacing, chopping, and paring; shaping and fitting; fastening and unfastening; and sharpening. The book is published by and heavily illustrated from the magnificent collections of the Bucks County Historical Society. A large part of the material was originally published serially in *Old-Time New England.*

Palmer, Brooks, *The Book of American Clocks.* New York, 1950. Pp. viii, 318.
The most extensive list of American watch and clockmakers; 312 clocks are illustrated in chronological order.

Prime, Alfred Coxe, comp., *The Arts & Crafts in Philadelphia, Maryland and South Carolina, 1721–1785: Gleanings from Newspapers.* The Walpole Society, 1929. Pp. xvi, 323.

Prime, Alfred Coxe, comp., *The Arts & Crafts in Philadelphia, Maryland and South Carolina, 1786–1800: Series Two, Gleanings from Newspapers.* The Walpole Society, 1932. Pp. xii, 331.
These two volumes are composed of an assembly of advertisements gleaned from Philadelphia, Maryland, and South Carolina newspapers relating to arts and crafts: e.g., portrait painters, engravers, silversmiths, pewterers, potters, glassmakers, clock makers, wallpaper merchants, housewrights, architects, house painters, sign painters, and stone cutters. This is a selective printing; the complete card file compiled by Prime is in the Winterthur Museum. These volumes are an extremely useful kind of documentary publication.

Walsh, Richard, *Charleston's Sons of Liberty: A Study of the Artisans, 1763–1789.* Columbia, S.C., 1959. Pp. xii, 166.
Mr. Walsh addresses himself to the two thousand or more artisans and mechanics of eighteenth-century South Carolina, and focuses in the main on the political and economic aspects of their lives.

Wildung, Frank H., *Woodworking Tools at Shelburne Museum.* Shelburne, Vt., 1957. Pp. 79.
A handy illustrated glossary of woodworking tools in the Shelburne Museum, covering adzes, axes, chisels, draw knives, gouges, planes, routers, squares, wood saws, veneer hammers, etc. Number 3 in the Shelburne Museum Pamphlet Series.

Williamson, Scott Graham, *The American Craftsman*. New York, 1940. Pp. xiv, 239.
A dated, and now largely superseded, account of the skills, tools, and working conditions of housewrights, cabinetmakers, potters, glassmakers, silversmiths, weavers, ironmasters, pewterers, printers, etc.

X. FURNITURE

A. General Works

Andrews, Edward Deming, and Faith Andrews, *Shaker Furniture: The Craftsmanship of an American Communal Sect*. New York, 1950. Pp. xi, 133.
First published in 1937. The authors make clear that the Shakers' functionalism, plain but refined style, fine craftsmanship, and finish were all part of a larger canon issuing from an entire way of life. Shaker furniture was the Shaker faith externalized. Also available in paperback.

Bjerkoe, Ethel Hall, *The Cabinetmakers of America*. Garden City, N.Y., 1957. Pp. xvii, 252.
A good, though far from exhaustive, check list of American cabinetmakers.

Comstock, Helen, *American Furniture, Seventeenth, Eighteenth, and Nineteenth Century Styles*. New York, 1962. Pp. 336.
The best recent survey of American furniture, with five essays on period styles (William and Mary, 1640–1720; Queen Anne, 1720–55; Chippendale, 1755–90; Classical period, 1790–1830; and Early Victorian, 1830–70). Illustrated profusely with 665 plates. One of the most important features of this book is its bibliography on American furniture, six pages of double column in length.

Downs, Joseph, *American Furniture, Queen Anne and Chippendale Periods in the Henry Francis du Pont Winterthur Museum*. New York, 1952. Pp. xl, 401 illustrations with accompanying captions.
A dozen years after its publication, still the *magnum opus* on American furniture. This volume is the result of one of those fortuities of scholarship that brought together the leading authority on American furniture of his day to Mr. du Pont's Winterthur collection, incomparable in breadth and quality. This catalogue is the first of a projected trilogy; the remaining two are in preparation by the colleague and successor of the late Mr. Downs, Charles F. Montgomery.

Halsey, R. T. H., and Charles O. Cornelius, *A Handbook of the American Wing*. New York, 1924. Pp. xv, 288.

The handbook of the American Wing of the Metropolitan Museum of Art, first published in 1924, went through successive printings of successive editions. Covering to some extent all of the decorative arts, it is largely, however, devoted to American furniture. This is still one of the most important books ever written on the subject of early furniture. Its major defect for the contemporary user is its organization: as a guide to the collection, it is divided into three sections by floors, and into chapters by period rooms.

Harvard Tercentenary Exhibition, *Catalogue of Furniture, Silver, Pewter, Glass, Ceramics, Paintings, Prints, Together with Allied Arts and Crafts of the Period, 1636–1836.* Cambridge, 1936. Pp. ix, 114. 70 plates.

A catalogue of decorative arts assembled for the Tercentenary, which (except for the portraits of Harvard graduates) had little rationale except that the objects were "used in New England during the early development of Harvard College."

Hipkiss, Edwin J., *Eighteenth-Century American Arts: The M. and M. Karolik Collection of Paintings, Drawings, Engravings, Furniture, Silver, Needlework & Incidental Objects Gathered to Illustrate the Achievements of American Artists and Craftsmen of the Period from 1720 to 1820.* Boston and Cambridge, 1941. Pp. xvii, 366.

A catalogue of the 275 objects, largely furniture, given to the Museum of Fine Arts, Boston, by the Karoliks, compiled by Edwin J. Hipkiss with "Comments on the Collection" by Maxim Karolik. This is not only one of the most important collections of American decorative arts, but this catalogue represents the first successful attempt by specialists to deal with furniture in an authoritative and scholarly fashion. The book went out of print and was given a second printing by offset in 1950 by the Meriden Gravure Company.

Lea, Zilla Rider, ed., *The Ornamental Chair: Its Development in America, 1700–1890.* Rutland, 1960. Pp. 173.

While largely concerned with the post-1815 period, the essays by seven authorities do include information on English antecedents and American developments from 1790.

Lockwood, Luke Vincent, *Colonial Furniture in America.* 3d edn., 2 vols., New York, 1951. Pp. xxiv, 398; xx, 354.

A milestone in writing on the decorative arts, originally published in 1913; a second edn. in 1926. This 3d edn. is simply a photographic reproduction of the 1926 edn. While the material was drawn largely

from New England collections, the illustrations are not labeled so as to indicate exact sources.

Lockwood, Luke Vincent, *The Furniture Collectors' Glossary*. The Walpole Society, 1913. Pp. viii, 55.

A most useful and detailed alphabetical listing of furniture nomenclature, "compiled with the idea of bringing together in convenient form the words used in the cabinetmaker's art."

Nutting, Wallace, *Furniture of the Pilgrim Century, 1620–1720, Including Colonial Utensils and Hardware*. Boston, 1921. Pp. ix, 587.

In April 1922 a broadside was published by Edward Guy, maker of hand wrought iron, titled "Ironwork of the Pilgrim Century Made in 1918." Guy stated that he made wrought iron for Wallace Nutting, Inc., for five years and that some of it was pictured in *Furniture of the Pilgrim Century:* "I have counted over 150 pieces shown in both the catalogue [of Wallace Nutting, Inc.] and the book. Old and new are mixed together. I make this statement in self defense, because I made much of the ironwork to be sold as modern work in old style, and I still make it. Honest ironwork is my living."

Nutting, Wallace, *Furniture Treasury*. 3 vols., Framingham, Mass., 1928–33. [vol. 1:] 1–1773 plates; [vol. 2:] 1774–4995 plates, index; [vol. 3:] Pp. 550.

The first volume illustrates case pieces, tables, beds, and sofas; volume 2, chairs and miscellaneous items. Volume 3, published as a supplement, supplies details on styles, dates, and construction. This Nutting work must be treated with the same skepticism as his *Furniture of the Pilgrim Century* for it is impossible to tell where authenticity ends and Nutting reproductions begin. The third volume even contains an advertisement for the reproductions: "The fine and even the simple old pieces [as pictured in vols. 1 and 2] are now so difficult to find, even in poor condition, that it has become the vogue of many persons of the best taste to obtain beautiful, carefully built, correct reproductions. Most wise persons have discerned that the style is the thing, and that the perfect lines of good furniture fit perfectly in new houses."

Ormsbee, Thomas Hamilton, *Early American Furniture Makers: A Social and Biographical Study*. New York, 1930. Pp. xviii, 183.

A curious attempt at synthesis in social history and the decorative arts. Working with the limited amount of information on American cabinetmaking that was known in 1930, Ormsbee used labeled furniture and concentrated on the more well-known cabinetmakers to make dubious claims for the status of the craft and the prominence

of most of its practitioners. He makes his point in a strange final chapter, "From Furniture to Politics," which looks for some kind of significance in the fact that Thomas Lincoln (the President's father), Stephen A. Douglas, and William Marcy "Boss" Tweed were all at one time in their lives cabinetmakers.

Roe, F. Gordon, *Windsor Chairs*, London, 1953. Pp. 96.
 Chapter IV is on American Windsors.

Sack, Albert, *Fine Points of Furniture: Early American*. New York, 1950. Pp. xvi, 303.
 Primarily a picture book of about 800 illustrations, comparing pieces of furniture in categories of "Good," "Better," and "Best." Heavy emphasis on chairs and tables.

Singleton, Esther, *The Furniture of Our Forefathers*. 2 vols., New York, 1900–1901. Pp. xii, 1–312; xvi, 315–664.
 An important work, if for no other reason than it was compiled so early in the historiography of this field of American furniture. But today Miss Singleton's volumes have limited use. She made little attempt to distinguish American from English objects, nor to date them beyond calling them "early" or "late."

B. Cabinetmakers

1. DUNCAN PHYFE

Cornelius, Charles Over, *Furniture Masterpieces of Duncan Phyfe*, Garden City, N.Y., 1922. Pp. xii, 86.
 An early, though highly interpretative and solidly documented study of Phyfe—the cabinetmaker, his furniture, and his times—published for the Metropolitan Museum of Art. Phyfe's furniture remains distinctive for its design as a whole (proportion and line) and for its carved decoration. These elements are clearly illustrated in 56 photographs and 5 line drawings.

McClelland, Nancy, *Duncan Phyfe and the English Regency, 1795–1830*. New York, 1939. Pp. xxix, 364.
 Part I of this significant study examines the development of the English Regency style in furniture, its two most important designers (Thomas Hope and George Smith), and its decorative motifs from antiquity (sphinx, lions' heads, columns, entablatures, etc.). Part II deals directly with Duncan Phyfe—his work, competitors, and customers. An "addenda" concludes the book with excerpts from court records shedding light on Phyfe.

2. SAMUEL MCINTIRE

Essex Institute, *Samuel McIntire: A Bicentennial Symposium, 1757–1957.* Ed. Benjamin W. Labaree, Salem, 1957. Pp. vii, 118.
A collection of essays on the achievement and influence of Samuel McIntire in furniture and architecture by Fiske Kimball, Abbott Lowell Cummings, Dean A. Fales, Jr., Nina Fletcher Little, Mabel Munson Swan, and Oliver W. Larkin, with a bibliography by Benjamin W. Labaree.

3. JOHN AND THOMAS SEYMOUR

Randall, Richard H., Jr., "Seymour Furniture Problems," *Bulletin*, Museum of Fine Arts, Boston, 57 (1959): 102–13.
Randall deals with problems of furniture attribution which are of more general interest than the title implies.

Stoneman, Vernon C., *John and Thomas Seymour, Cabinetmakers in Boston, 1794–1816.* Boston, 1959. Pp. 393.
A collection of 291 illustrations of desks, secretaries, sideboards, card tables, sewing tables, bureaus, tables, and chairs attributed to the father-and-son cabinetmakers, John and Thomas Seymour. Stoneman has gathered information on many of the trademarks by which the Seymours' furniture can be recognized: tambour shutters; combinations of grained wood inlays; Sheraton legs; ivory urn-shaped escutcheons; acanthus carving; interiors lined with blue-green paint or paper; mahogany, chestnut, and ash for secondary woods; and fine dovetailing.

C. Regional Studies

Baltimore Museum of Art, *Baltimore Furniture.* Baltimore, 1947. Pp. 195.
A well-written catalogue of Baltimore and Annapolis furniture, most examples of which are from the Hepplewhite-Sheraton period. Preliminary remarks and the descriptive entries stress three topics: structure, including secondary woods; character of design; and decorative treatment (i.e., veneering, carving, inlay, and painting).

Bissell, Charles S., *Antique Furniture in Suffield, Connecticut, 1670–1835.* Hartford, 1956. Pp. ix, 128.
A perfect example of a clearly defined regional study gathering all the information known on carpenters and joiners of Suffield, yet de-

voting a full chapter to the one prominent cabinetmaker, John Fitch Parsons, who worked during the first quarter of the nineteenth century.

Burroughs, Paul H., *Southern Antiques*. Richmond, 1931. Pp. xi, 197.
An attempt to disprove the notion that most early furniture in the South was imported. While the author indicates that he found "the names of more than seven hundred cabinetmakers in the South from 1737 to 1820," it is most unfortunate that he did not furnish a list of them.

Burton, E. Milby, *Charleston Furniture, 1700–1825*. Charleston, 1955. Pp. 150.
One of the best regional studies on early American furniture; it covers styles and influences, exports and imports, prices and labels, primary and secondary woods used, and a full biographical check list of Charleston cabinetmakers. A publication of The Charleston Museum, of which Mr. Burton is the Director.

Carpenter, Ralph E., Jr., *The Arts and Crafts of Newport, Rhode Island, 1640–1820*. Newport, 1954. Pp. xiii, 218.
A catalogue (mostly of furniture, with some engravings, paintings, and silver, made by Newport artists and craftsmen) patterned on the form developed by Joseph Downs in the Winterthur catalogue *American Furniture*. These objects were loaned from public and private collections for an exhibition held in 1953 at the Nichols-Wanton-Hunter House in Newport. This is an important book, because of the attempt made in it to survey in depth the arts and crafts of a defined region; it is numbered "Volume I" of what was to have been a series of studies on Newport, which has regrettably never materialized.

Connecticut Historical Society, *Connecticut Chairs in the Collection of The Connecticut Historical Society*. Introduction by Newton C. Brainard, Hartford, 1956. Pp. 67.
Catalogue of an exhibition of chairs held in 1956; the book does not include the Connecticut Historical Society's specimens from their George Dudley Seymour collection—given as a collection and to get a separate catalogue later.

Dorman, Charles G., *Delaware Cabinetmakers and Allied Artisans, 1655–1855*. Wilmington, 1960. Pp. 107.
An impressive collection of short biographies, listed alphabetically, with information drawn from newspapers and city directories, deeds and wills, apprentice indentures and tax assessment lists. Illustrated

with documented pieces of furniture and cabinetmakers' labels. Originally published as part of vol. 9 of *Delaware History* by the Historical Society of Delaware.

Heuvel, Johannes, *The Cabinetmaker in Eighteenth-Century Williamsburg*. [Williamsburg Craft Series.] Williamsburg, 1963. Pp. 40.
Based largely on an unpublished monograph by Mills Brown of the Colonial Williamsburg research staff, this compact study deals with the woodworking crafts (joinery and cabinetmaking) in eighteenth-century Williamsburg. There is a discussion of the primary woods (walnut, mahogany, and cherry) and the secondary woods (yellow pine and tulip poplar) used in the southern colonies, a section on cabinetmakers' tools, and a description of the art of veneering. A biographical check list of the thirteen cabinetmakers working in eighteenth-century Williamsburg has been added.

Hornor, William MacPherson, Jr., *Blue Book of Philadelphia Furniture, William Penn to George Washington with Special Reference to the Philadelphia-Chippendale School*. Philadelphia, 1935. Pp. xv, 340. 502 plates.
Extremely rare survey of the best Philadelphia Chippendale furniture—case pieces, tables, sofas, beds, and chairs. Hornor devotes chapters to a comparison of Marlborough and Cabriole chair legs, an analysis of Federal fashions, looking glasses and picture frames, and Windsor and rush-bottom chairs. This book is a classic which should be reprinted.

Kettell, Russell Hawes, *The Pine Furniture of Early New England*. New York, 1949. Pp. 370.
A reprint of a 1929 limited edition, that soon went out of print. The singular distinction of this book is its completeness in its field. It deals with the pine tree, its variations, beauties, uses, and limitations; types of construction and finish; different kinds of joints; and surveys the development of the hardware.

Luther, Clair Franklin, *The Hadley Chest*. Hartford, 1935. Pp. xxii, 144.
A unique book due to the character of the subject matter. Because Hadley chests were often decorated with the initials of the owner and because most of them derive from the Connecticut Valley section of Massachusetts, their provenance is more often than not determinable. As a consequence Luther has been able to compile a check list of all known Hadley chests in existence and has identified most of them. The author published a separate four-page "Supplementary List" in 1938.

Miller, V. Isabelle, *Furniture by New York Cabinetmakers, 1650 to 1860.* New York, 1956. Pp. 84.
Catalogue of a 1956–1957 exhibition held at the Museum of the City of New York. New York furniture has been synonymous with the names of its famous cabinetmakers: Gilbert Ash, Samuel Prince, and Thomas Burling of the Chippendale period; Duncan Phyfe in the Sheraton and Hepplewhite periods; Honoré Lannuier in the style of the early Empire; and John Henry Belter in the finest expression of Victorian furniture.

Newark Museum, *Early Furniture Made in New Jersey, 1690–1870.* Newark, 1958. Pp. 89.
Descriptive catalogue of an exhibition held at the Newark Museum, Oct. 1958–Jan. 1959, compiled by Margaret E. White, the Curator of Decorative Arts. Following a lucid introduction and an illustrated catalogue of 85 pieces of furniture, there is a biographical check list of over 1,000 "Furniture Makers of New Jersey."

Palardy, Jean, *The Early Furniture of French Canada.* Translated by Éric McLean. Toronto, 1963. Pp. 404. 585 plates.
The first serious monograph on the regional or traditional furniture of French Canada. The range is comprehensive—chests, armoires, buffets, dressers, beds, chairs, tables, desks, commodes, etc. Examples have been selected widely from public and private collections. Following the larger section, "History and Catalogue Raisonné of the Early Furniture," there follows numerous informative chapters on furniture fabrics, brass work, woods, apprenticeship, preservation and restoration, and lists of cabinetmakers and carvers, to name a few. The time period covered is the seventeenth to the nineteenth centuries, but most of the objects were made in the years 1785 to 1820.

Randall, Richard H., Jr., " 'Boston Chairs'," *Old-Time New England,* 54 (Summer 1963): 12–20.
"Boston" chairs—maple framed, covered with leather, with a shaped cresting, heavy rectlinear stretchers on the sides and back, and ball-and-ring turnings on the center of the front stretcher— were exported in the coastwise trade, particularly to Philadelphia. They were actually a mid-eighteenth-century type of chair made in New England, from New Hampshire to Rhode Island.

Randall, Richard H., Jr., *The Decorative Arts of New Hampshire, 1725–1825.* Manchester, N.H., 1964. Pp. 73.
An illustrated catalogue of an exhibition of New Hampshire decorative arts, largely furniture, held at the Currier Gallery of Art in 1964 which attempted "to bring together as much documented material as

was possible in the interest of giving a tentative definition of the New Hampshire style." The elegance of Portsmouth cabinetmaking is illustrated in the work of the Gaines family, and the simple dignity of rural southern New Hampshire furniture in those pieces by the Dunlaps. Randall has carefully and brilliantly isolated many of the distinguishing regional characteristics of New Hampshire joinery, carving, and veneering.

XI. SILVER

A. General Works

Avery, Clara Louise, *Early American Silver*. New York, 1930, Pp. xliv, 378.
In addition to Phillips's book, one of the best general works on American silver. It draws heavily on documentary materials and includes line drawings that illustrate the introduction and development of forms.

Buhler, Kathryn C., *American Silver*. Cleveland and New York, 1950. Pp. 64.
A short, though good, survey of American silver and silversmiths, representative of all the colonies; 44 illustrations.

[Buhler, Kathryn C.], *Colonial Silversmiths, Masters and Apprentices*. Boston, 1956. Pp. 98. 48 plates.
Illustrated catalogue of the exhibition held by the Museum of Fine Arts to commemorate the fiftieth anniversary of the first recognized exhibition of American silver, arranged by the Museum in 1906, with an introductory essay on the craftsmen by Kathryn C. Buhler.

Buhler, Kathryn C., *Mount Vernon Silver*. Mount Vernon, Va., 1957. Pp. 75.
An intriguing account of Washington's silver at Mount Vernon (some pieces of which have returned there, and others which remain in private and public collections elsewhere), documented from his published correspondence. 39 illustrations.

Currier, Ernest M., *Marks of Early American Silversmiths*. Portland, 1938. Pp. xv, 179.
Of the numerous dictionaries of American silversmiths' marks, this is the most informed. Kathryn Buhler edited the book after the death of the author and happily included some of his notes on silver including a list of New York City silversmiths, 1815–41.

Ensko, Stephen G. C., *American Silversmiths and Their Marks III.*
New York, 1948. Pp. 285.
Two alphabetical lists—one by the surname of the silversmith
and the other by the first element in his touch mark—of American
silversmiths who were working between 1650 and 1850; the place
of occupation and dates when the craftsman was active are added, so
far as they are known.

Fales, Martha Gandy, *American Silver in the Henry Francis du Pont
Winterthur Museum.* Winterthur, Del., 1958. [Pp. 60.] 142
plates.
An ideal example of an illustrated catalogue of a collection; de-
scriptions give marks, maker, decoration, provenance, measurements,
etc.

Hipkiss, Edwin L., *The Philip Leffingwell Spalding Collection of
Early American Silver.* Cambridge, 1943. Pp. 84.
A model catalogue of fifty pieces made by thirty craftsmen which
form a significant part of the Boston Museum of Fine Arts collection
of American silver.

Jones, E. Alfred, *The Old Silver of American Churches.* Privately
printed, 1913. Pp. lxxxvii, 566.
An impressive folio (11" × 15" and over 3½" thick), printed in
England on rag stock in dual colors, this is a superb example of
bookmaking. But its great merit is its comprehensive coverage and
authoritative treatment of most of the pre-1825 church silver in this
country. Jones discusses in great detail around 2,000 pieces of silver
(1,640 by American silversmiths, 250 by British, and the remainder
Continental), and illustrates over half of these on 145 plates. The
arrangement is alphabetical by the name of the town or parish, be-
ginning with Abingdon Parish, Va., and ending with York Village,
Maine. On every count the book is a tour de force.

Phillips, John Marshall, *American Silver.* New York, 1949. Pp. 128.
A brief but perceptive survey of the silversmith and his craft in
America from the seventeenth through the nineteenth century. It
stands as the best general treatise on American silver. Phillips ex-
plains the social and economic background surrounding the patron
and craftsman, and emphasizes the time-lag in colonial styles.

Phillips, John Marshall, *Early American Silver Selected from The
Mabel Brady Garvan Collection, Yale University.* New Haven,
1960. Pp. 48.
The first of a series of picture books on the Garvan Collection,
edited by Meyric C. Rogers, with the posthumous publication of

notes on the Garvan silver prepared by John Marshall Phillips in 1952, the year before his death.

B. Silversmiths

1. ABEL BUELL

Wroth, Lawrence C., *Abel Buell of Connecticut: Silversmith, Type Founder & Engraver*. Middletown, Conn., 1958. Pp. xiv, 102.
Revised version of a limited edition monograph originally published in 1926. Buell was an important craftsman and inventor, whose early talents as silversmith and engraver were shadowed by a conviction for counterfeiting, and whose mature genius as an engraver and type founder was frustrated by defects of character and repeated misfortunes.

2. JOHN CONEY

Clarke, Hermann Frederick, *John Coney, Silversmith, 1655–1722*. Boston, 1932. Pp. xv, 92.
A balanced, full study of the life and works of John Coney (1655–1722), native-born Boston silversmith. A "List of Examples of John Coney's Work" follows the biographical sketch.

3. JEREMIAH DUMMER

Clarke, Hermann Frederick, and Henry Wilder Foote, *Jeremiah Dummer, Colonial Craftsman & Merchant, 1645–1718*. Boston, 1935. Pp. xix, 209.
The life and work of Dummer is of interest particularly since he was one of the first major silversmiths of New England birth. Clarke has discovered and catalogued 108 examples of Dummer's silver made between 1676 and his death.

4. JOHN HULL

Clarke, Hermann Frederick, *John Hull, A Builder of the Bay Colony*. Portland, 1940. Pp. xiv, 221.
A full biographical portrait of John Hull (1624–83), silversmith, who was born in England and who arrived in Massachusetts Bay in 1635 to both practice his trade and serve as an elected official. There is a descriptive list of extant examples of his work in silver appended.

5. JACOB HURD

French, Hollis, *Jacob Hurd and His Sons, Nathaniel & Benjamin, Silversmiths, 1702–1781.* The Walpole Society, 1939. Pp. xvii, 148.
The history of an eighteenth-century dynasty of Boston silversmiths and engravers: Jacob Hurd (1702–58), and his sons Nathaniel (1730–78) and Benjamin (1739–81). Catalogues are appended of the extant silver known to have been made by each of them, with a list of the engravings and bookplates made by Nathaniel.

6. MYER MYERS

Rosenbaum, Jeanette W., *Myer Myers, Goldsmith, 1723–1795.* Philadelphia, 1954. Pp. 141.
A short but significant biography and illustrated catalogue of a master New York silversmith, whose career covered the second half of the eighteenth century. A descriptive list of Myers's silver in the form of "Technical Notes" is added.

7. PAUL REVERE

Buhler, Kathryn C., *Paul Revere, Goldsmith, 1735–1818.* Boston, 1956. Pp. 42.
A catalogue of 65 illustrations of the rich collection of silver by and portraits of Paul Revere in the Museum of Fine Arts, Boston, happily combining a descriptive text by the leading authority on American silver, Mrs. Kathryn Buhler, type composition by The Stinehour Press, and collotype printing by The Meriden Gravure Company.

Forbes, Esther, *Paul Revere & The World He Lived In.* Boston, 1942. Pp. xiii, 510.
His silver and his engravings are but lightly dealt with, but Revere's youth, his gradual rise to a secure position as craftsman, his leadership among the artisans of Boston, his services in the Revolution, and his subsequent steady rise in the field of manufacture— all these Miss Forbes makes plain in this biography.

C. Regional Studies

Brix, Maurice, *List of Philadelphia Silversmiths and Allied Artificers from 1682 to 1850.* Philadelphia, 1920. Pp. vii, 125.

Unfortunately a mere alphabetical listing giving only the particular trade and dates.

Burton, E. Milby, *South Carolina Silversmiths, 1690–1860*. Charleston, 1942. Pp. xvii, 311.

Biographical sketches of South Carolina's ante-bellum silversmiths, grouped alphabetically under their towns, which are listed in alphabetical order. The author has in many cases reproduced as an illustration to accompany the text, a silversmith's newspaper advertisement, in addition to examples of his work, his touch mark, and a portrait when any were found.

Curtis, George Munson, *Early Silver of Connecticut and Its Makers*. Meriden, 1913. Pp. 115. 33 plates.

Following an explanatory text on the technology and skill of craftsmen, and on the stylistic changes of the forms, Munson provides an annotated check list, by alphabet, of Connecticut silversmiths who were working before 1830.

Cutten, George Barton, *The Silversmiths of Georgia, together with Watchmakers & Jewelers, 1733 to 1850*. Savannah, 1958. Pp. viii, 154.

Here, Cutten, as in his other books on the silversmiths of a particular colony or state, has assembled an impressive amount of biographical information. An illuminating introduction has much to say on the prevalence and distribution of silversmiths in Georgia: e.g., about forty per cent prior to 1850 were residents of Savannah, over twenty per cent worked in Augusta, the remainder in smaller towns and villages, and none were found in Atlanta. In this book the silversmiths are arranged alphabetically under their towns, which are themselves arranged alphabetically.

Cutten, George Barton, *The Silversmiths of North Carolina*. Raleigh, 1948. Pp. v, 93.

Published by the State Department of Archives and History. Organized in the same fashion as Cutten's other books on silversmiths.

Cutten, George Barton, *The Silversmiths of Virginia (Together with Watchmakers and Jewelers) from 1694 to 1850*. Richmond, 1952. Pp. xxiv, 259.

An introductory section on the place of the silversmith in Virginia, then the main corpus of the book: biographical accounts of the silversmiths, watchmakers, and jewelers, arranged alphabetically under their towns, which are listed in alphabetical order.

Cutten, George Barton, *The Silversmiths, Watchmakers, and Jewelers of the State of New York, Outside of New York City*. Hamilton, N.Y., 1939. Pp. 47.

De Matteo, William, *The Silversmith in Eighteenth-Century Williamsburg.* [Williamsburg Craft Series.] Williamsburg, 1956. Pp. 36.

Based largely on an unpublished monograph by Thomas K. Bullock of the Colonial Williamsburg research staff, this is a highly useful survey of the tools and techniques of the colonial silversmith. A biographical check list of the sixteen Williamsburg silversmiths before the Revolution has been appended.

Hiatt, Noble W. and Lucy F., *The Silversmiths of Kentucky, Together With Some Watchmakers and Jewelers, 1785–1850.* Louisville, 1954. Pp. xxi, 135.

A check list of 244 Kentucky silversmiths with extensive biographical information on most of them.

Knittle, Rhea Mansfield, *Early Ohio Silversmiths and Pewterers, 1787–1847.* [Cleveland,] 1943. Pp. 63.

A study of Ohio silversmiths and pewterers during the territorial period and after statehood had been attained in 1803. The craftsmen are studied by local regions (Tuscarawas Valley, Muskingum Valley, Upper Hockhocking Valley, Gallipolis, and early Cincinnati). Knittle includes a check list of early Ohio silversmiths, pewterers, and makers of Britannia Ware.

Rice, Norman S., *Albany Silver, 1652–1825.* Albany, 1964. Pp. 81.

Catalogue of an exhibition of Albany silver held at the Albany Institute of History and Art, March–May 1964. There are 153 plates divided into sections devoted to the major silversmiths. Biographical sketches of those silversmiths are supplied: the Ten Eycks, the Lansings, Van Veghten, Cluett, Schuyler, Cuyler, Folsom, Hutton, Bassett, Warford, Shepherd, Boyd, Hall, and Rice. Text and descriptions by Norman S. Rice; introduction by Kathryn C. Buhler.

Traquair, Ramsay, *The Old Silver of Quebec.* Toronto, 1940. Pp. xi, 169.

Williams, Carl M., *Silversmiths of New Jersey, 1700–1825, With Some Notice of Clockmakers Who Were Also Silversmiths.* Philadelphia, 1949. Pp. xii, 164. 46 plates.

Biographical accounts of sixty-four early New Jersey silversmiths, one of the more famous being Nathaniel Coleman (1765–1842) of Burlington. The craftsmen are listed under their places of residence which in turn are alphabetically arranged.

XII. PEWTER

Kerfoot, J. B., *American Pewter*. Boston, 1924. Pp. xxiii, 239.
The important predecessor of Laughlin, but now superseded.

Laughlin, Ledlie Irwin, *Pewter in America, Its Makers and Their Marks*. 2 vols., Boston, 1940. Pp. xvii, 139; viii, 239.
Not only the most important work on American pewter, but unquestionably one of the most significant pieces of documentary writing on the decorative arts. After preliminary chapters on the work of the pewterer and the distinction between household and ecclesiastical pewter, Laughlin treats the pewterers geographically, moving north to south. The volumes conclude with chapters on Britannia, fakes, cleaning, collecting, unidentified touches, and a check list of American makers of pewter and Britannia. A revised and expanded edition is planned.

XIII. OTHER METALS AND WOODEN WARE

Bohan, Peter J., *American Gold, 1700–1860: A Monograph Based on a Loan Exhibition, April 2–June 28, 1963, Yale University Art Gallery*. New Haven, 1963. Pp. 52.
The descriptive list of 147 items is supplemented by nine pages of illustrations and an excellent introduction which summarizes the known information on the subject.

Boyer, Charles S., *Early Forges & Furnaces in New Jersey*. Philadelphia, 1931, reprinted 1963. Pp. xv, 287.
A study of the more than sixty-seven forges and furnaces in New Jersey which were established before the close of the eighteenth century. New Jersey was particularly endowed with the natural resources necessary for this type of early American industry—plentiful timberland for making charcoal, sufficient creeks and rivers to supply water power, and several classes of the "hard ores" used for making iron. The histories of these numerous ironworks (arranged by chapters alphabetically) necessarily provide a great deal of information on the utensils, tools, and household furnishings used in early America.

Deas, Alston, *The Early Ironwork of Charleston*. Columbia, 1941. Pp. 111.

A skillful descriptive listing with drawings. Some ironwork has been identified by maker; the two best-known early Charleston smiths were Tunis Tebout and William Johnson.

Gould, Mary Earle, *Antique Tin and Tole Ware*. Rutland, 1958. Pp. xvi, 136.
A respectable, though occasionally sentimental, history of the tin household utensils of the farmers and mechanics of the early American period.

Gould, Mary Earle, *Early American Wooden Ware and Other Kitchen Utensils*. Rutland, 1962. Pp. xii, 243.
A revision of a 1942 limited edition containing chapters on manufacturing methods and the tools used therein as well as descriptions of the utensils and their use.

Hartley, E. N., *Ironworks on the Saugus: The Lynn and Braintree Ventures of the Company of Undertakers of the Ironworks in New England*. Norman, 1957. Pp. xvi, 328.
The history of the integrated ironworks (two blast furnaces and two forges, with a rolling and slitting mill) built on the Saugus River in Massachusetts in 1646–47; the death of the concern came in the 1670's.

Kauffman, Henry J., *Early American Copper, Tin, and Brass*. New York, 1950. Pp. 112.
A short but serious attempt to describe the construction and use of various types of copper, tin, and brass utensils; includes check lists of coppersmiths and braziers, brass founders, and tinsmiths in early America.

Lindsay, J. Seymour, *Iron and Brass Implements of the English and American Home*. Boston, no date. Pp. xii, 212.
Largely an illustrated guide to fireplace implements used at the hearth, cooking utensils, lighting devices, pipe tongs, and tobacco cans. The explanatory text is thin, but an important chapter called "Some Remarks on American Colonial Implements" is included.

Mercer, Henry C., *The Bible in Iron, or The Pictured Stoves and Stove Plates of the Pennsylvania Germans*. Doylestown, Penna., 1914. Pp. iv, 174.
After half a century Mercer's *Bible in Iron* has yet to be replaced with anything better; good as it is, however, it sorely needs to be updated. Curiously, it was published in October 1914 in part to offset the propaganda of Germany's "enemies in America," who "misreading her history, accuse her of barbarism." The larger half of the book is devoted to decorated iron stoves of colonial America, with a background chapter on those of Europe and another chapter

on colonial firebacks. Though very much out of date, there is a list of early American furnaces appended at the end. A publication of the Bucks County Historical Society.

Powers, Beatrice Farnsworth, and Olive Floyd, *Early American Decorated Tinware*. New York, 1957. Pp. 267.
An illustrated history of tinware and tinsmiths carried back to the beginnings of oriental lacquer and forward to a tin-wedding celebration in 1873.

Sonn, Albert H., *Early American Wrought Iron*. 3 vols., New York, 1928. Pp. xvi, 263; vi, 205; vii, 263.
A magnum opus in sheer bulk and thoroughness. The three volumes, provided with over 300 drawings by the author, cover door hardware, balconies, braces, railings, newels, gates, and grilles.

XIV. POTTERY

Barret, Richard Carter, *Bennington Pottery and Porcelain: A Guide to Identification*. New York, 1958. Pp. 342.
A brief history of the Bennington Pottery works begun in 1793 by Captain John Norton and carried on by successive generations of Nortons until 1894. There follows 450 plates illustrating what must be every important Bennington pottery form known, accompanied with substantial descriptions.

Christensen, Erwin O., *Early American Designs: Ceramics*. New York, 1952. Pp. 48.
Decorative elements by the artisan using either a brush or stylus on pottery.

Ramsay, John, *American Potters and Pottery*. [New York], 1939. Pp. xx, 304.
A study of potters and pottery by regions; followed by a historical discussion of pottery types (redware, stoneware, brownware, and yellowware) and whitewares (earthenware and porcelain). A valuable check list of American potters and a check list of potters' marks are appended.

Spargo, John, *The Potters and Potteries of Bennington*. Boston, 1926. Pp. xv, 270. 43 plates.
A full history of the Norton potteries in Bennington, 1793–1894; the competitor Fenton potters and their short-lived United States Pottery; a discussion of the varieties and types of ware made; and

finally, interesting biographical sketches of the craftsmen who worked in the Bennington potteries.

Watkins, Lura Woodside, *Early New England Potters and Their Wares*. Cambridge, 1950. Pp. x, 291.
 The best reference work on American pottery published; section on indigenous character of New England earthenware, discussion of excavations on pottery sites, and check list of over 600 potters.

Watkins, Lura Woodside, *Early New England Pottery*. Sturbridge, Mass., 1959. Pp. 22.
 An abbreviated account containing the high points of the author's more lengthy study of New England pottery. An Old Sturbridge Village Booklet.

XV. GLASS

Innes, Lowell, *Early Glass of the Pittsburgh District, 1797–1890*. Pittsburgh, 1949. Pp. 56.
 While written for an exhibition at the Carnegie Museum, this is not a mere catalogue, for it provides a full discussion of the subject with good illustrations.

Lee, Ruth Webb, *Sandwich Glass: The History of the Boston & Sandwich Glass Company*. Framingham Centre, Mass., 1939. Pp. xxxiii, 526. 203 plates.
 A lengthy, rambling history of a famous nineteenth-century glass works in Massachusetts and its even more famous glass. The company was founded in the 1820's, shortly before the terminal date imposed on this bibliography.

McKearin, George S. and Helen, *American Glass*. New York, 1941. Pp. xvi, 622.
 Without question one of the masterpieces in the field of the American decorative arts. Comprehensive in scope, buttressed with a staggering amount of documentation, and illustrated with 1,000 drawings of glass forms and 2,000 illustrations on 262 pages in addition to the 622 pages of text.

McKearin, Helen and George S., *Two Hundred Years of American Blown Glass*. Garden City, N.Y., 1950. Pp. xvi, 382.
 An extension and elaboration of sections of the preceding book. Carefully printed, lavishly illustrated with 114 plates (many in color), thoroughly researched, and completely comprehensive, this work on American blown glass will not soon be superseded. The best, as well

as representative, examples of Amelung, Stiegel, blown three mold, pattern-molded, lily pad, South Jersey type, free-blown, and historical and pictorial flasks are pictured and described.

Watkins, Lura Woodside, *American Glass and Glassmaking*. New York, 1950. Pp. 104.
A history of glassmaking ventures from the seventeenth century (Jamestown, Salem, New York, and Philadelphia) through the eighteenth (Wistar, Stiegel, and Amelung), down into the nineteenth (Cambridge, Sandwich, and Pittsburgh).

Wilson, Kenneth M., *Glass in New England*. Sturbridge, Mass., 1959. Pp. 34.
A well-illustrated account of glassmaking procedures, factories, and forms. An Old Sturbridge Village Booklet.

XVI. LIGHTING DEVICES

Hayward, Arthur H., *Colonial Lighting*. Boston, 1923. Pp. xxv, 159.
An old but still rather useful history of artificial illumination from the early seventeenth century through the nineteenth, illustrated with 114 plates. A random collection of information on iron "Betty" lamps; tin, pewter, and brass lamps for grease, camphene, and whale oil; tin lanterns; candlesticks in iron, tin, pewter, and brass; tin wall sconces; early glass lamps; and astral and lustre lamps and ornamental candle holders. Also available in paperback.

Hebard, Helen Brigham, *Early Lighting in New England, 1620– 1861*. Rutland, Vt., 1964. Pp. 88.
A slight work by every measure and too highly personalized to be of much use, yet it is the only regional study on early American lighting published. The later chapters on oil, astral, and Argand lamps, are a little stronger than the earlier ones on rushlights and candlesticks, largely because some manufacturers are known and identified.

Thwing, Leroy, *Flickering Flames: A History of Domestic Lighting through the Ages*. Rutland, Vt., 1958. Pp. xvi, 138.
Published for the Rushlight Club, the most recent and probably the best book on lighting devices. A useful bibliography and glossary of terms used in this rarefied field of collections. Yet one feels a book of much more depth and quality could and should be done on this subject.

XVII. WALL DECORATION

Little, Nina Fletcher, *American Decorative Wall Painting, 1700–1850*. New York, 1952. Pp. xvii, 145.
A carefully written study of early American interior wall decorations divided into two sections: (1) painted woodwork (house painting, woodwork with pictorial decoration, overmantle landscape paintings, decorated chimney boards, and painted floors) and (2) painted plaster walls (freehand designs in repeat patterns, stencils, figure and subject pieces, and scenic panoramas).

McClelland, Nancy, *Historic Wall-Papers from Their Inception to the Introduction of Machinery*. Philadelphia and London, 1924. Pp. xvi, 458.
A detailed history of wallpaper, from the earliest block-printed papers in France and England; the papers imitating tapestries, woven stuffs, and printed fabrics; papers designed in the Chinese taste; papers imitating French and English painted panels; to the late eighteenth-century epoch of scenic papers. Chapter XI deals specifically with early American wallpapers.

Waring, Janet, *Early American Stencils on Walls and Furniture*. New York, 1937. Pp. xv, 149.
The definitive study of the sources, prevalence, and patterns of stencilled decorations on walls and furniture by regions.

XVIII. FOLK ART

Espinosa, José E., *Saints in the Valleys: Christian Sacred Images in the History, Life and Folk Art of Spanish New Mexico*. Albuquerque, 1960. Pp. xiii, 122.
A scholarly study of New Mexican *santos* or religious folk images, covering the period 1775–1900, in three mediums: *retablos*, paintings on pine panels in tempera; *bultos*, figures carved in the round from cottonwood, and painted; and paintings on animal skins in tempera. These art objects are skillfully related by the author to the religion and cultural life of colonial New Mexico. Concludes with an excellent bibliography.

Ford, Alice, *Edward Hicks: Painter of the Peaceable Kingdom*. Philadelphia, 1952. Pp. xvi, 161.
Handsomely printed biography (but not a catalogue of his works) of the Quaker preacher Edward Hicks, who also has the most con-

spicuous reputation in the field of primitive painting for his allegories and landscapes.

Kauffman, Henry J., *Pennsylvania Dutch American Folk Art*. New York and London, 1946. Pp. 136.
Succinct account of the "Pennsylvania Dutch" and straightforward analysis of their art, architecture, furniture, pottery, metalwork, textiles, needlework, certificates and manuscripts, and Stiegel glass. A paperback edition was published by Dover in 1964.

Lichten, Frances, *The Folk Art of Rural Pennsylvania*. New York, 1946. Pp. xvi, 276.
Mildly quaint, but adequate treatment of the objects made by the Pennsylvania Germans: from the "Historic Soil" (decorated pottery known as "sgraffito"), from the "surface of the earth" (flax for household linens and samplers), from "on the earth" (wool for ornamental coverlets), from the "woodlands" (furniture and carved objects), from "beneath the surface of the earth" (stone for gravestones and houses and iron for stove plates and ornamental hardware), and "Salvage Arts" (quilts and rag paper for their love of design, and *fractur* painting). Charles Scribner's Sons reprinted the book in 1964.

Lipman, Jean, *American Primitive Painting*. London, 1942. Pp. 158.
American primitives—portraits, landscapes, genre scenes, ship pictures, memorials, and still-life paintings—flourished in the first three quarters of the nineteenth century. They spring from craft rather than painters' traditions and are typically non-derivative, individual, unpretentious, and most often anonymous. Long ignored, they now suffer from "the undiscriminating enthusiasm of discovery." Mrs. Lipman tries to redress the balance and to define the American Primitive in terms of its special period and its intrinsic, even if crude, style.

Lipman, Jean, and Alice Winchester, *Primitive Painters in America, 1750–1950*. New York, 1950. Pp. 182.
An authoritative book on American primitives and their painters, to which is added a check list of about 600 primitive painters.

Lipman, Jean H., *American Folk Art in Wood, Metal and Stone*. New York, 1948. Pp. 193.
An exploration of native creative expression in various inventive styles of wood-carving, stone-cutting, and metal-casting. The contents are arranged by figureheads, weathervanes, cigar-store figures, toys, and decoys.

Little, Nina Fletcher, *The Abby Aldrich Rockefeller Folk Art Collection: A Descriptive Catalogue*. Boston, 1957. Pp. xvi, 402.

A skillful and scholarly catalogue of Mrs. Rockefeller's large folk art collection of more than 400 items now on permanent public display at Colonial Williamsburg. There are 165 illustrations in color of paintings in oil, paintings in watercolor and pastel, needlework and painted textiles, paintings on glass, fracturs and calligraphic drawings, and sculpture in wood and metal. The book concludes with the best bibliography on American folk art in print.

Little, Nina Fletcher, *Country Art in New England, 1790–1840.* Sturbridge, Mass., 1960. Pp. 32.
A useful study relating utilitarian and decorative country art to country life. An Old Sturbridge Village Booklet.

Robacker, Earl F., *Pennsylvania Dutch Stuff, A Guide to Country Antiques.* Philadelphia, 1944. Pp. 163.
A better than average discussion of "Pennsylvania Dutch" folk arts, covering cupboards to clocks, spatterware to gaudy Dutch china, and pottery to painted tin.

Stoudt, John Joseph, *Pennsylvania Folk-Art: An Interpretation.* Allentown, 1948. Pp. xix, 403.
Second and enlarged edition of *Consider the Lilies, How They Grow* (1937). The thesis of the author is that the Pennsylvania German decorative motifs are symbolic and express a deeply religious mystical faith. The author covers the Arts of Ephrata, *Fractura*, Portraits, Decorated Household Objects, Ceramics, Textiles, Architectural Decoration, and Tombstones.

Wilder, Mitchell A., with Edgar Breitenbach, *Santos: The Religious Folk Art of New Mexico.* Colorado Springs, 1943. Pp. 49. 64 plates.
Santo is a generic term used in New Mexico to denote representations of saints or holy persons; a crucifix, a religious print, or a statue are each referred to as a *santo*. This illustrated and fully annotated catalogue of the *santos* in the Taylor Museum of the Colorado Springs Fine Arts Center represents a major artistic expression of generations of colonials in New Mexico, from the time the country was resettled around 1700 until the infiltration of Anglo-American civilization in the nineteenth century.

XIX. TEXTILES

Barbeau, Marius, *Saintes artisanes.* Montréal, [1943–1948?]; 2 vols. [vol. 1:] *Les brodeuses;* [vol. 2:] *Mille petites adresses.* Pp. 116; 157.

The first volume is a scholarly description of the history of weaving and embroidery in Quebec, especially of the work of Ursuline sisters in the seventeenth century, and including a chapter on porcupine quill-work and birch-bark embroidery. The second volume is a mélange, including weaving, sculpture, painting, bookbinding, and (somewhat unexpectedly) baking.

Bendure, Zelma, and Gladys Pfeiffer, *America's Fabrics: Origin and History, Manufacture, Characteristics and Uses.* New York, 1946. Pp. xv, 688.
A lengthy work devoted largely to the contemporary textile industry in America, in which the historical sections serve as background material for each chapter. Organized topically—wool, cotton, linen, silk, weaving, knitting, twisting, felting, dyeing, printing, finishing, etc.

Bolton, Ethel Stanwood, and Eva Johnston Coe, *American Samplers.* Boston, 1921. Pp. viii, 416.
A long, heavy treatise on American samplers, whose highly conventionalized designs are based largely on early pattern books and follow a certain tradition. This book was written long enough ago for the authors to have undertaken the hopeless task of a register of American samplers between 1600–1830. A more useful anthology of sampler verse is included.

Born, Wolfgang, "Early American Textiles," *Ciba Review,* no. 76 (Oct. 1949), pp. 2774–98.
Whole number devoted to early American textiles, covering handwoven fabrics and their patterns, quilting and patchwork, cotton prints, and hooked rugs. Published in Basle and therefore filled with what would appear to an American a great deal of superfluous elementary colonial history.

Clouzot, Henri, *Painted and Printed Fabrics: The History of the Manufactory at Jouy and Other Ateliers in France, 1760–1815.* New York, 1927. Pp. xvii, 108. 92 plates.
Important for an added chapter by Frances Morris, "Notes on the History of Cotton Printing, especially in England and America" (pp. 75–89). A publication of the Metropolitan Museum of Art.

Cummings, Abbott Lowell, comp., *Bed Hangings, A Treatise on Fabrics and Styles in the Curtaining of Beds, 1650–1850.* Boston, 1961. Pp. ix, 60.
The result of a seminar conducted by the Society for the Preservation of New England Antiquities, this is one of the most useful and important books published recently in the field of the American decorative arts. It includes essays on "Fabrics and Documentary

Sources," "Pictorial Sources," and "Technical Notes" in addition to excellent illustrations.

Early American Embroideries in Deerfield, Massachusetts. Deerfield, 1963. Pp. 32.
A good pictorial survey with informative captions. Particularly strong in examples of crewelwork.

Fennelly, Catherine, *Textiles in New England, 1790–1840.* Sturbridge, Mass., 1961. Pp. 40.
A well-documented study of New England home-woven fabrics and their use as bed furniture and in clothing. An Old Sturbridge Village Booklet.

Harbeson, Georgiana Brown, *American Needlework, A History of Decorative Stitchery and Embroidery from the Late 16th to the 20th Century.* New York, 1938. Pp. xxxiii, 232.
The best and most comprehensive book on the subject; contains many useful photographs. Has been reprinted.

Hedlund, Catherine A., *A Primer of New England Crewel Embroidery.* Sturbridge, Mass., 1963. Pp. 47.
An account of early and revival crewelwork with numerous illustrations. An Old Sturbridge Village Booklet.

Little, Frances, *Early American Textiles.* New York, 1931. Pp. xvi, 267.
Chatty and general but a pioneer study. As the only book-length work of its type to date, it emphasizes the need for several specific and detailed regional studies.

Parslow, Virginia D., *Weaving and Dyeing Processes in Early New York with a Description of Spinning Fibers.* Cooperstown, 1949. Pp. 20.
A good discussion of domestic cloth production in eighteenth- and early nineteenth-century New York State. The steps in the preparation of flax, wool, and cotton are clearly outlined, as are simple methods of textile decoration.

Peto, Florence, *American Quilts and Coverlets.* New York, 1949. Pp. 63.
A thin but useful account of the decoration and geometrical patterns on quilting; these designs have been copied and named, an aid in determining their date and origin. This sort of book, however, seems plagued with the necessity to include "a manual of instruction for beginners" section as an addendum.

Reath, Nancy Andrews, *The Weaves of Hand-Loom Fabrics*. Philadelphia, 1927. Pp. 64.
Concise definitions of terms used in fabric identification.

Reinert, Guy F., *Coverlets of the Pennsylvania Germans* [The Pennsylvania German Folklore Society, Vol. 13]. Allentown, 1949. Pp. 264.
Contains lists of weavers, manuscript pattern books, early books on dyeing, numerous illustrations, and an English translation of Solomon Kuder's dyebook.

Stearns, Martha Genung, *Homespun and Blue*. New York, 1940. Pp. x, 96.
A very good study of early American crewel embroidery; this sort of decoration was the outgrowth of individual freehand designs, drawn in most cases by the worker directly upon the fabric and worked in wool or linen thread as her fancy dictated. Based largely on New England collections.

XX. SERIAL PUBLICATIONS

The following alphabetical list of serial publications includes those titles which should prove most helpful to users of this bibliography. Instead of the usual open-entry form for current periodicals, the volume which carried the last number published prior to June 1964 has been listed in parentheses, to give a better indication of the number of volumes which have been issued. In the case of a serial which has ceased publication, the entry is closed and the parentheses omitted. All significant changes of titles are indicated in the notes.

The compilers have faced the imposing task of choosing from a wide selection of commercial and professional journals that, by the definition of this bibliography, are marginal: *Art in America* (vol. 1–[52], New York, 1913–[June 1964], bimonthly), under the editorship of Jean Lipman, has published in the past a number of articles on nineteenth-century American art and architecture, such as studies of the watercolors and oils of "primitive" painters, New England gravestone sculpture, Shaker architecture, etc. The May 1955 issue (vol. 43, no. 2), in fact, devoted to "Restoration

Villages," remains still an indispensable collection of articles on Shelburne Museum, Colonial Williamsburg, Old Sturbridge Village, the Farmers' Museum at Cooperstown, Old Deerfield, and Mystic Seaport. The main orientation of *Art in America*, however, has always been the practice and role of the arts in contemporary American society. *Connoisseur* (vol. 1–[156], London, 1901–[June 1964], monthly) and the *Connoisseur Year Book* (vol. 1–[12], London, 1953–[1964], annual) have in late years, largely through the efforts of the recent editors of the American contributions (Malcolm Vaughan and Helen Comstock) included among their articles on English fine and decorative arts, a small number on historic American houses (Boscobel, Van Cortlandt Manor, and Stratford Hall), American furniture (by Meyric R. Rogers), and American silver (by Mrs. Yves Henry Buhler). Nonetheless, the heavy emphasis here has always properly been England. *Museum News* (vol. 1–[42], New York, 1924–[June 1964], monthly [Sept.–June]), published by the American Association of Museums, prints sound articles on Presidential mansions (Monticello and The Hermitage), historic houses, and restorations; yet the magazine essentially remains the publication of the professional museum curator. *The Annual Report of the American Scenic and Historic Preservation Society* (vol. 1–30, Albany, 1896–1925, annual), the publication of a semi-official conservation group founded in New York State in 1895 by Andrew H. Green, mixed with their discussion of state and national parks, a great deal of useful information on New York historic sites: iron works, old mills, historic houses, military headquarters, milestones, etc. *New York History* (vol. 1–[45], Cooperstown, Oct. 1919–[April 1964], quarterly), published by the New York State Historical Association, is only the most conspicuous of some of the state historical journals which are increasingly devoted to an analysis of the role of the arts in America's social past. Indeed, the bulletins of most major American museums could also have been entered below, because of articles and accession notes on their own holdings in American painting, furniture, and silver; but here again the percentage of yield of information on American art would be too low to warrant sending the average reader to them. In all of these publications

the articles on the American arts are ancillary to their central focus; for that reason they are given only passing mention in this headnote. And it should be added parenthetically here that publications devoted exclusively to the collecting of antiques, such as *American Antiques Journal* and *Hobbies*, have been omitted here because of their irrelevance.

American Collector: The Monthly Magazine of Art and Antiques, vol. 1–17. New York, Dec. 1933–Nov. 1948. Monthly.

Originally published in 1933 as a "Biweekly for Dealers and Collectors," edited by T. H. Ormsbee, in a four-column newspaper format. Through the 1930's it remained oriented to the antiques trade; news items about dealers, decorators, collectors, museums, and associations filled the early issues. Articles that did appear were largely written by Ormsbee. By the 1940's, under the editorship of Malcolm Vaughan, the magazine had become heavily imitative of *Antiques* magazine in content, format, and frequency of publication. In fact, Vaughan organized occasional issues around a single topic or theme (e.g., the Oct. 1947 issue was completely devoted to Washington Irving's "Sunnyside"), as *Antiques* has frequently done. The *American Collector* ceased publication with the issue of Nov. 1948 (vol. 17, no. 10); just why a magazine that began in the trough of the Great Depression should fold on the wave of post-World War II prosperity is not entirely clear.

American Quarterly, vol. 1–(16). Philadelphia, Spring 1949–(Summer 1964). Published five times a year.

The journal of the American Studies Association with the stated purpose of publishing articles that are of a "speculative, critical, and informative nature, which will assist in giving a sense of direction to studies in the culture of America, past and present." The editors have been William Van O'Connor, vols. 1–2; Anthony N. B. Garvan, vols. 3–9; and Hennig Cohen, vol. 10 to the present. A number of short seminal articles on nineteenth-century painting and architecture have been published there, particularly under Garvan's editorship, written by such social and art historians as George B. Tatum, Lloyd Goodrich, Clay Lancaster, Oliver Larkin, David S. Lovejoy, Donald A. Ringe, and Robert L. White.

The Antiquarian: A Monthly Magazine for the Collector of Antiques, Works of Art and Rarities, vol. 1–20. New York, Aug. 1923– Aug. 1933. Monthly.

The Antiquarian was obviously a commercial venture, planned by its publisher, The Antiquarian Publishing Company, to catch

some of the readership and advertisers of the more successful *Antiques* which had commenced publication a year and a half earlier. The magazine had a succession of editors during its ten years of existence: Esther Singleton, Aug. 1923; Charles Messer Stow, Jan. 1927; Edward Wenham, Jan. 1928; Arthur F. Bollinger, Feb. 1929; and finally Alfred M. Frankfurter, Nov. 1929. Under Miss Singleton's tutelage the scope of the subject matter was wide, covering all the major periods from ancient to modern. Nearly all of the articles on American art and antiques were written by her. Moreover, she cluttered the magazine with a number of quaint regular features: "Ye Olde Book Shelf," "Echoes from the Galleries," "The Antiquarians' Letter Box," "At the Sign of the Lantern," and the like. In 1925 *The Antiquarian* concentrated its attention almost exclusively on the American field, using for the first time a variety of authors on this subject. In Dec. 1931 under the editorship of Frankfurter the magazine changed its name to *The Fine Arts* and more importantly shifted its emphasis back to world art, with consultants in religious art, European pictorial and decorative art, American pictorial art, Oriental art, American decorative art, and English decorative art. By its demise in Aug. 1933 (in all probability a victim of the depression) the magazine was greatly reduced in format and hopelessly floundering between antiques and contemporary architecture and interior decoration.

Antiques, vol. 1–(85). New York, Jan. 1922–(June 1964). Monthly.

The magazine *Antiques*, for its continuity and frequency of publication over forty-two years and for its consistent devotion to a widely though clearly defined scope of subject matter, is without a doubt the most valuable single repository of published material on the American arts, particularly the decorative arts, that exists. No museum or library devoted to the history of American life is complete without it. Museum curators are generally more aware than historians of the magazine's usefulness as a richly documented source for information on the artifacts of America's past, both early and recent. Much of the credit for this achievement unquestionably belongs to its two successive editors who have labored quite successfully to maintain professionally high standards of scholarship in it: Homer Eaton Keyes, editor from 1922 to 1938; and Alice Winchester, associate editor, 1934–1938, and editor, 1939 to the present. Most users of this bibliography will be fully cognizant of the fact that numerous *Antiques* articles could have been selected for nearly every category of this bibliography; this has purposefully not been done because of the arbitrariness of any single individual's selection from the hundreds, if not thousands, of articles that have appeared there. Without fear of

exaggeration it could be said that no student of the American arts should begin serious research on any phase of his subject without first consulting the pages of *Antiques*. The burden is but slightly lessened by the five indexes published by *Antiques* in the format of the magazine: vol. 1–30, 1922–1936 (46 p.); vol. 31–40, 1937–1941 (27 p.); vol. 41–50, 1942–1946 (44 p.); vol. 51–60, 1947–1951 (21 p.); and vol. 61–70, 1952–1956 (31 p.). These indexes are at best feeble finding aids, frequently inconsistent internally from index to index. For a magazine as successful commercially and as useful professionally as *Antiques*, much more serious thought and planning by the staff should be given to a full and detailed one-volume index to aid users, most of whom are by now severely crippled under the sheer bulk and proportions that the magazine has reached. It would not be too early to begin compilation of such an index to coincide with or shortly follow the publication of volume 100 of *Antiques* in 1971.

The Art Bulletin, vol. 1–(46). New York, 1913–(June 1964). Quarterly.

Published by The College Art Association of America; the first four issues of volume 1 cover 1913–1918. It began to be published on a quarterly basis in 1920. Mr. Whitehill has listed for illustrative purposes the articles in *The Art Bulletin* dealing with American subjects (see above, pp. 4–5). The College Art Association of America and the Index Society have published *The Art Bulletin, An Index to Volumes I–XXX, 1913–1948* (New York, 1950), compiled by Rosalie B. Green in 426 pages. The editor-in-chief is currently H. W. Janson and the managing editor, Harriet Anderson.

Art Index: A Cumulative Author and Subject Index to a Selected List of Fine Arts Periodicals, vol. 1–(35). New York, Jan. 1929–(April 1964). Quarterly.

An indispensable bibliographical control over some one hundred American and European museum bulletins, fine arts journals, and architectural and archaeological publications. Authors and subjects are arranged in one alphabetical file; helpful cross-references are used liberally. Cumulative indexes are published both annually and tri-annually.

The Art Quarterly, vol. 1–(26). Detroit, Winter 1938–(Summer 1963). Quarterly.

Published by the Founders Society, Detroit Institute of Arts; edited by W. R. Valentiner (1938–1943), W. R. Valentiner and E. P. Richardson (1943–1958), and E. P. Richardson and Paul L.

Grigaut (1958 to the present). This is certainly one of the most distinguished serial publications being issued out of an American museum; it contains soundly documented articles both by museum curators and art history professors. Each year about 5–10 articles are published on American art, largely painting.

The Glass Club Bulletin, no. 1–(70). Marion, Mass., Jan. 1938–
 (June 1964). Quarterly.

Official organ of The National Early American Glass Club. A printed newsletter of 8–12 pages, published only occasionally in the earlier years, now published quarterly. There are short articles on American glass, but a large part of the space is given over to club news, minutes of meetings, obituaries, and pictures of members with their collections.

Historic Preservation, vol. 1–(16). Washington, D.C., March 1949–
 (April 1964). Quarterly.

Published by the National Trust for Historic Preservation. Began as a mimeographed quarterly report; first printed in letterpress with the first issue of vol. 4 (Spring 1952). Most of the articles are short reports on the preservation of historic districts, architectural monuments threatened with destruction, news of preservation movements in various cities and towns, information on relevant federal and local legislation, brief histories of architecturally important houses, etc. Edited by Helen Duprey Bullock.

Journal of Glass Studies, vol. 1–(6). Corning, N.Y., 1959–(1964).
 Annual.

A handsomely printed annual journal sponsored by The Corning Museum of Glass, "conceived to meet the need for recording those discoveries, interpretations, acquisitions and publications which affect the art and history of glassmaking." Each issue has 15–20 heavily documented and profusely illustrated articles; some are of a scientific-technical nature, others are archaeological and art historical in emphasis. Nearly every issue has at least one article on American glass; so far scholarly attention has been given to Amelung glass, excavations of seventeenth-century wine bottles at Jamestown, and the glass factories at Zanesville, Ohio, Glastonbury, Conn., and Ontario, N.Y. Each issue of the *Journal* concludes with a thorough "Check List of Recently Published Articles and Books on Glass" for the previous year, which is divided into chronological sections, one devoted to American glass.

Journal of the Society of Architectural Historians, vol. 1–(23). Amherst, Mass., Jan. 1941–(May 1964). Quarterly.

Unquestionably the most significant journal on architectural history published today. From impoverished beginnings it was mimeographed for the first ten years under the able editorship of Turpin C. Bannister; it was first printed in letterpress beginning with vol. 10 (March 1951) under Walter L. Creese, then Alan K. Laing, and finally J. D. Forbes as successive editors; since the first number of vol. 18 (March 1959) it has been edited by Paul F. Norton at the University of Massachusetts and magnificently printed in offset at The Meriden Gravure Company from type set by The Stinehour Press. The *SAH Journal* is a most agreeable combination of sound scholarship in architectural history and fine craftsmanship in the graphic arts. Articles on architectural history are limited neither by geographical nor by chronological boundaries. A fair number of major articles are on American architecture; moreover, a section of "American Notes" under the editorship of Charles E. Peterson provides an outlet for brief articles of a limited scope. Book reviews in double-column and a smaller type face are deliberately longer, more comprehensive and informative, if not controversial, than those conventionally found in professional journals.

Old-Time New England, vol. 1–(55). Boston, May 1910–(Summer 1964). Quarterly.

Published by the Society for the Preservation of New England Antiquities; through volume 10 (1919), known as the *Bulletin* of that society. The sub-title of this journal best describes its contents: "A Quarterly Magazine Devoted to the Ancient Buildings, Household Furnishings, Domestic Arts, Manners and Customs, and Minor Antiquities of the New England People." Since the appointment of Bertram K. Little as director of the Preservation Society in 1947 and Abbott Lowell Cummings as assistant director and editor of *Old-Time New England* in 1956, it has shown an increasing sophistication in methodological approach and relevance in subject matter. The record of articles published, particularly in recent years, on old houses, important either for their architectural importance and/or historical association, is quite distinguished.

The Pewter Collectors' Club of America, *Bulletin,* no. 1–(50). n.p., 1934–(March 1964). Biyearly.

Newsletter format with a great deal of space given to messages from the president, announcements of meetings, news of exhibitions,

obituaries of noted collectors, etc. The articles are highly specialized, tending to be either the historical analysis of a pewter form (e.g., chalices, flagons, communion tokens, etc.) or the discussion of new discoveries (e.g., a touch mark, an early newspaper advertisement of a pewterer, etc.) On the pragmatic side, there are notes on collecting, repairing, and restoring pewter. Even though the primary emphasis is on American pewter, the Continental and English metal is also discussed. New books on or related to this subject are given a brief review notice. Because of the rarity of the earliest numbers of this Bulletin, the first five numbers were reprinted in photofacsimile as a Supplement to no. 46 (Feb. 1962).

The Rushlight, vol. 1–(30). Boston, Nov. 1934–(May 1964). Quarterly.

Published by the Rushlight Club, organized in Nov. 1932 and devoted to the collecting and study of old lighting devices. *The Rushlight* is a mimeographed club newsletter; nevertheless it is filled with informative articles on grease lamps (the wrought-iron crusie and the Betty), rushlight holders, early candles, candlesticks (brass, pewter, and iron pricket), brass pan type candleholders, and Argand and astral lamps.

The White Pine Series of Architectural Monographs, vol. 1–26. New York, 1915–1940. Bimonthly.

The main purpose of this publication was undeniably commercial; its subtitle did not try to disguise the fact: "A Bi-Monthly Publication Suggesting the Architectural Uses of White Pine and Its Availability Today as a Structural Wood." However, the *White Pine Series*, edited for its complete life by Russell F. Whitehead, is an invaluable photographic record of early American architecture (particularly New England) during the quarter-century before World War II. Most issues were sixteen pages in length and filled with full-page architectural photographs and measured drawings, except the annual August issue which featured the winning renderings by architects in the "White Pine Architectural Competition" for suburban houses, community center buildings, roadside taverns, and the like. Each issue was in a sense a brief monograph in that it was written by a single author and generally concentrated its attention on the early architecture of a particular town or region, occasionally a state. But the distinction here are the photographs, taken by trained architects with an eye for design and craftsmanship in wood in an era just before the restoration craze swept the country. In 1927 with volume 13, the name was changed to *The Monograph Series, Records of Early American Architecture* and the format was slightly altered. Weyer-

haeuser Forest Products and the National Lumber Manufacturers Association continued to provide most of the advertising revenue, buying numerous full-page advertisements. But if anything the publication improved with time; Whitehead brought Frank Chouteau Brown into partnership as associate editor to provide more measured drawings to accompany the photographs. In 1932 with volume 18, *The Monograph Series* was incorporated into *Pencil Points*, a journal of contemporary architecture promoting building materials.

Winterthur Portfolio, vol. 1. Winterthur, Del., 1964. Annual.

A new annual publication of the Henry Francis du Pont Winterthur Museum of which only the first number has so far appeared. The *Portfolio* will in some measure reflect the collections at Winterthur and will contain articles "which will extend current information about an object which appeared in an American home or its setting during the seventeenth, eighteenth, and nineteenth centuries" and those that "explore the material of which an object is made, the manner in which an object was created, distributed, and used, as well as approaches to research and preservation." This first number has a number of articles on Winterthur (the estate, the museum, the development of the house, the evolution of the rooms, the library, and the program in early American culture), the Corbit-Sharp family, Peale's engravings, a Stuart portrait, pewter communion tokens, English hardware, Philadelphia Windsor chairs, and John Adams. The first number of the Portfolio is a presage of a distinguished annual.

INDEX

A

Abbott, Stanley W., ix
Abby Aldrich Rockefeller Folk Art Collection, 139–40
Adams, Charles Francis, 37
Adams, Charles Francis, 2d, *Letters and Papers of J. S. Copley*, 88–89
Adams, Eleanor B., 76
Adams, John, 95, 151
Adams family, 18, 97
Adamson, Anthony, *Ancestral Roof*, 57
Addison Gallery of American Art, 90
Addresses on Opening of American Wing, 40
Aitken, Robert, 114
Alabama, architecture of, 73
Albany, N.Y., 63; artists of, 87; silversmiths of, 132
Alexander, Edward P., 29
Allen, Charles D., *Amer. Book-Plates*, 103
Allen, John, 111
Allston, Washington, 86, 87
Amelung glass, 137, 148
American Academy of Design, 42
American Antiquarian Society, 83, 105; Evans microcard edition of, 24, 108; portrait collection of, 100; Revere Collection of, 104; and Isaiah Thomas, 112
American Association of Museums, 14–15, 144
American Collector, 145
American Institute of Architects, 21
American Philosophical Society, portrait collection of, 100

American Quarterly, 145
American Scenic and Historic Preservation Society, *Annual Report*, 144
American School of Classical Studies at Athens, 16–17
American Studies Association, 145
American studies programs, 8
American Wing. *See* Metropolitan Museum of Art
Ames, Ezra, 87
Amory, Martha B., *John Singleton Copley*, 88
Anderson, Harriet, 147
Andrews, Edward D., *Shaker Furniture*, 119
Andrews, Wayne, *Architecture*, 47
Angell, James, 113
Annapolis, Md., Hammond-Harwood House in, 50; architecture of, 67; furniture of, 123
Antiquarian, 145–46
Antiquarianism, 37, 41
Antiques magazine, 40, 42, 146–47
Appleton, William Sumner, 38
Archaeology, 22–24
Architects, 26, 50–55, 72, 74. *See also* under individual names
Architecture, 20–22, 26–27, 47–78, 149, 150–51. *See also* under individual names of regions, states, and cities
Archives of American Art, viii, ix, 24–25
Armorial devices, 115–16
Art Bulletin, 4–5, 147
Arthaud, Claude, 76
Art in America, 143–44
Art Index, 147

Artisans, 116–19
Artists, dictionary of Amer., 84
Art Quarterly, 147–48
Ash, Gilbert, 126
Ashbee, C. R., 21
Association for Preservation of Virginia Antiquities, 31
Athens, Greece, Agora, 16–17
Atlantic Neptune, 80
Atlases, 105–6
Auction catalogues, 45
Augur, Hezekiah, 103
Avery, Clara L., *Early Amer. Silver*, 127

B

Badger, Joseph, 81–82, 84, 87, 99,
Baer, E., 104
Baer, Kurt, *Architecture of Calif. Missions*, 75–76; *Paintings and Sculpture*, 76
Bail, Hamilton V., *Views of Harvard*, 78
Bailey, Rosalie Fellows, *Pre-Revolutionary Dutch Houses*, 64
Baird, Joseph A., Jr., *Time's Wondrous Changes*, 76
Baker, William S., 36; *Engraved Portraits of Washington*, 99; *Medallic Portraits*, 99
Baltimore, Md., Saint Mary's Seminary in, 52; Washington column in, 55; architecture of, 67; furniture of, 123
Baltimore Museum of Art, *World Encompassed*, 103–4; *Baltimore Furniture*, 123
Bancker, G., 107
Banner, Peter, 62
Bannister, Turpin C., 149; "Oglethorpe's Sources," 78–79
Barba, Preston A., *Pa. German Tombstones*, 102
Barbeau, Marius, *Trésor*, 42; *Saintes artisanes*, 140–41
Barclay, Andrew, 114
Barker, Virgil, *Amer. Painting*, 81
Barrell, Joseph, 50–51
Barret, Richard C., *Bennington Pottery*, 135
Barrett, Robert, *Modern Warres*, 79
Bartgis, Matthias, 113
Barton, William, 115

Battle art, 106
Bay, Jacob, 114
Bayley, Frank W., Dunlap's *History*, 44; *Five Colonial Artists*, 81–82; *John Singleton Copley*, 88
Bear, James A., Jr., *Old Pictures*, 52–53
Beard, Charles A., 41
Bed hangings, 141–42
Beirne, Rosamond R., *William Buckland*, 50
Belknap, Henry W., *Artists and Craftsmen*, 116; *Trades and Tradesmen*, 116
Belknap, W. P., Jr., "Robert Feke," 5; *Amer. Colonial Painting*, 8, 33, 82–83
Bell, Whitfield J., Jr., viii, 19–20
Belter, John Henry, 126
Bendure, Zelma, *America's Fabrics*, 141
Bennett, W. J., 27
Bennington pottery, 135–36
Berenson, Bernard, 4
Berman, Eleanor D., *Jefferson Among the Arts*, 53
Berthier, Louis-Alexandre, 107
Betts, C. Wyllys, *Amer. Colonial History*, 114–15
Bibliothèque Nationale, 94
Biddle, Edward, *Thomas Sully*, 95
Bill, Alfred Hoyt, *House Called Morven*, 64
Birley, A. R., *Hadrian's Wall*, 21
Bissell, Charles S., *Antique Furniture*, 123–24
Bizardel, Yvon, *Amer. Painters in Paris*, 82
Bjerkoe, Ethel H., *Cabinetmakers of Amer.*, 119
Blackburn, Joseph, 81–82, 87–88, 99
Bland, Harry MacN., "Alexander Hamilton," 97
Blyth, Benjamin, 82, 105
Bohan, Peter J., *Amer. Gold*, 133
Bolles, Eugene, 39
Bollinger, Arthur F., 146
Bolton, Charles K., 88; *Founders*, 82; *Amer. Armory*, 115
Bolton, Ethel S., *Amer. Samplers*, 141
Bolton, Theodore, *Portrait Draughtsmen*, 82; *Portrait Painters in*

Miniature, 82; *Ezra Ames*, 87; "Life Portraits of Madison," 98

Bookbinding, 114

Bookplates, 103–4, 130

Books, architectural, published in Amer., 48; architectural, available in Amer., 49; Jefferson's fine arts, 54; on architectural design, in Indiana, 74

Book trade, 108–14

Born, Wolfgang, "Early Amer. Textiles," 141

Borneman, Henry S., *Pa. German Bookplates*, 104

Boston, Mass., Paul Revere House in, 31–32; architecture of, 51, 60–61; Massachusetts State House in, 51, 61; topographical history of, 81; book trade in, 109; printers of, 110–11, 113; bookbinding in, 114; furniture of, 126. *See also* Museum of Fine Arts, Boston

Boston and Sandwich Glass Company, 136

Boudinot, Elias, 64

Bowdoin family, 99

Boyd, Adam, 112

Boyd, Julian, "Notes on Amer. Medals," 115

Boyer, Charles S., *Forges and Furnaces*, 133

Boylan, William, 113

Bradford, William, 110

Bradstreet, Anne, 32–33

Brainard, Newton C., 124

Brass and brass founders, 134

Breitenbach, Edgar, *Santos*, 140

Brewington, M. V., *Shipcarvers of North America*, 12–13, 102; *Navigating Instruments*, 13, 116

Bricks, 68–69

Bridenbaugh, Carl, 9; *Peter Harrison*, 52; *Colonial Craftsman*, 116–17

Briggs, Martin S., *Homes of Pilgrim Fathers*, 9–10, 47

Brigham, Clarence S., 112; *Paul Revere's Engravings*, 104; *Amer. Newspapers*, 108

Brimo, René, *L'évolution*, 43

Bristol, Roger P., *Index of Printers*, 108–9

Britannia ware, 132–33

British Museum, catalogues of, 16

Brix, Maurice, *Philadelphia Silversmiths*, 130–31

Broadsides, 109, 113

Brock, Henry I., *Colonial Churches*, 68

Brockway, Jean L., "Trumbull's Sortie," 5

Brooks, Alfred M., "Drawings by West," 5

Browere, John H. I., 103

Brown, Frank C., 151; "Joseph Barrell Estate," 50–51

Brown, H. Glenn, *Directory of Book-Arts*, 109

Brown, Lloyd A., *Maps of Ohio Valley*, 104

Brown, Mather, 82, 84

Brown, Maude O., *Directory of Book-Arts*, 109

Brown, Mills, *The Cabinetmaker*, 125

Browne, Nina E., *A.L.A. Portrait Index*, 84

Brumbaugh, G. Edwin, *Colonial Architecture of Pa. Germans*, 65

Buckland, William, 50

Bucks County Historical Society, 118, 135

Buell, Abel, 106, 113, 129

Buhler, Kathryn C., 132, 144; *Belknap Collection*, 82–83; *Amer. Silver*, 127; *Colonial Silversmiths*, 127; *Mt. Vernon Silver*, 127; *Paul Revere, Goldsmith*, 130

Buley, R. Carlyle, *Old Northwest*, 74

Bulfinch, Charles, 5, 50–51, 61

Bulfinch, Ellen S., *Bulfinch Life and Letters*, 51

Bullock, Helen Duprey, 148

Bullock, Thomas K., *The Silversmith*, 132

Burling, Thomas, 126

Burnap, Daniel, 117

Burns, Lee, "Early Architects and Builders," 74

Burroughs, Alan, *Limners and Likenesses*, 83; *XVIIth Century Painting*, 83; *John Greenwood*, 90

Burroughs, Paul H., *Southern Antiques*, 124

Burton, E. Milby, 14, *Charleston Furniture*, 124; *S.C. Silversmiths*, 131

Bush, Alfred L., *Life Portraits of Jefferson*, 18, 97
Butterfield, L. H., 12

C

Cabinetmakers, 119–27
Cadillac, Antoine de Lamothe, 44
Cadwalader, Gen. John, 66–67
Cady, John H., *Civic and Architectural Development*, 61
Cahokia, Ill., 75
Cali, François, *L'Art des Conquistadores*, 76
California, architecture of, 75–78; early paintings of, 79, 81
California Historical Society, 76
Calligraphy, 111
Cambridge, Mass., architecture of, 61; views of, 78; printers of, 110–11, 113
Canada, decorative arts of, 42–43, 45–46; architecture of, 44–46, 55–58; early historical views of, 79–80; painting of, 85; printers of, 112; furniture of, 126; textiles of, 140–41
Caner, Henry, 51–52
Cape Cod house, 59
Capitol. *See* Washington, D.C.
Cappon, Lester J., viii, x
Caricature, 108
Carlisle, William S., *Saltonstall Family Portraits*, 99
Carnegie Corporation, 72
Carnegie Museum, Pittsburgh, 136
Carolina Art Association, 14, 72, 79
Carpenter, Ralph E., Jr., *Arts and Crafts*, 124
Carpenters' tools, 118
Cartier, Jacques, 80
Cartography, 80, 103–8
Cartoons, political, 108
Carving, 102–3
Catalogues, museum, 15–18
Centennial Exposition of 1876, 36, 43
Ceramics, 135–36, 139–40
Cerracchi, Giuseppe, 103
Chairs, ornamental, 120; Windsor, 122, 151; Connecticut, 124; "Boston," 126
Chandler, Joseph E., 32

Charless, Joseph, 110
Charleston, S. C., 14; architecture of, 72; early watercolors of, 79; artists of, 86, 95–96; artisans of, 118; furniture of, 124; ironwork of, 133–34
Charleston Museum, 14, 124
Charlottesville, Va., 52–54
Charvat, William, *Literary Publishing*, 109
Chastellux, François Jean, Marquis de, 6, 26, 30, 32
Chattahoochee Valley Historical Society, 73
Chavez, Fray Angelico, 76
Chicago, Ill., architecture of, 75
Chinard, Gilbert, 52
Christensen, Erwin O., *Index Amer. Design*, 43; *Ceramics*, 135
Cincinnati, Ohio, book trade in, 112
Claiborne, Herbert A., *Virginia Brickwork*, 68–69
Clark, Edna M., *Ohio Art and Artists*, 83
Clarke, Grahame, *Archaeology and Society*, 23
Clarke, Hermann F., *Jeremiah Dummer*, 129; *John Coney*, 129; *John Hull*, 129
Classical style, exhibition of, 46
Clement, Mary L. A., 97
Clocks and clockmakers, 117–18, 131–32
Clouzot, Henri, *Painted and Printed Fabrics*, 141
Club of Odd Volumes, Boston, 93, 109, 111
Coats of arms, 115–16
Coe, Eva J., *Amer. Samplers*, 141
Cohen, Hennig, 145
Coleman, Nathaniel, 132
Coles, John, 88
Collectors and collections, early Amer., 43, 45
College Art Association, 4–5, 147
College of William and Mary, 47–48, 70, 71
Colonial Williamsburg, viii; publications of, 17–18; restorations of, 31
Colorado Springs Fine Arts Center, 78, 140
Columbian Centinel, 61
Columbia University, 79

Comstock, Helen, 144; *Concise Encyclopedia*, 43; *Amer. Furniture*, 119

Condit, Carl W., *Amer. Building Art*, 47

Coney, John, 129

Congdon, Herbert W., *Early Amer. Homes*, 59; *Old Vermont Houses*, 59

Connally, Ernest A., "Cape Cod House," 59

Connecticut, architecture of, 62–63; maps of, 108; clockmakers of, 117; furniture of, 124; silversmiths of, 131

Connecticut Historical Society, *Conn. Chairs*, 124

Connoisseur, 144

Constable, W. G., *Art Collecting*, 43

Constitutional Convention, portrait exhibition of participants of, 36

Coolidge, John, 9; "Hingham Builds a Meetinghouse," 59; *Mill and Mansion*, 59–60

Coolidge, Thomas Jefferson, Jr., 53

Copley, John Singleton, 81–82, 83, 84, 88–89, 99, 105

Copper and coppersmiths, 134

Corbit, William, 67

Corcoran Gallery, 94

Cornelius, Charles O., *Handbook of Amer. Wing*, 120; *Furniture of Duncan Phyfe*, 122

Corning Museum of Glass, 148

Cortelyou, Irwin F., *Ezra Ames*, 87

Cortlandt, Van Dyke H., *Georgian Architecture*, 47–48

Cotter, John L., *Archeological Excavations*, 69

Coulter, Edith M., *Calif. Pictorial*, 81

Cousins, Frank, *Samuel McIntire*, 54; *Colonial Architecture of Salem*, 60; *Colonial Architecture of Philadelphia*, 65

Cowse, James, 111

Crafts and craftsmen, 116–19

Creese, Walter L., 149

Crewelwork, 142–43

Crossman, Carl, *Saltonstall Family Portraits*, 99

Cumming, William P., *Southeast in Early Maps*, 104

Cummings, Abbott Lowell, ix, 123, 149; *Architecture in Early New England*, 17, 58; *Bed Hangings*, 23, 141–42; "Parson Barnard House," 32–33, 60; *Rural Inventories*, 43; "Bulfinch and Boston's West End," 51; "Old Feather Store," 60; "Scotch-Boardman House," 60

Cunningham, Henry W., *Christian Remick*, 93

Currier, Ernest M., *Marks of Amer. Silversmiths*, 127

Currier Gallery of Art, 126

Curtis, George M., *Early Silver of Conn.*, 131

Cutten, George B., *Silversmiths of Ga.*, 131; *Silversmiths of N.Y.*, 131; *Silversmiths of N.C.*, 131; *Silversmiths of Va.*, 131

D

Dalley, John, 107

Davidson, Marshall G., *Life in Amer.*, 43–44

Davidson, William H., *Pine Log*, 73

Davies, Thomas, 80

Davis, James, 112

Davison, Carolina V., "Godefroy," 52

Day, Matthew, 111

Day, Stephen, 111

Deas, Alston, *Early Ironwork*, 133–34

De Forest, Robert Weeks, 38–40

Delaware, architecture of, 67; portraiture of, 85; cabinetmakers of, 124–25

De Matteo, William, *The Silversmith*, 132

De Peyster family, 82

Des Barres, J. F. W., 80

Detroit Institute of Arts, 24, 147; *French in Amer.*, 44

Dexter, Elias, 94

Dexter, Franklin B., 37

Dickinson, Anson, 89

Dickson, Harold E., *Hundred Pa. Buildings*, 65; *John Wesley Jarvis*, 91

Dill, Alonzo T., *Governor Tryon*, 71

Documentary publications, and iconography, 37

Domínguez, Fray F. A., *Missions of New Mexico*, 76–77
Donnelly, Marian C., "New England Meetinghouses," 58
Dorman, Charles G., *Delaware Cabinetmakers*, 124–25
Dornbush, Charles H., *Pa. German Barns*, 65
Dorsey, Stephen P., *Early English Churches*, 47
Douglas, Stephen A., 122
Dow, George Francis, *Arts and Crafts*, 117
Downing, Antoinette F., *Architectural Heritage of Newport*, 62; *Early Homes of R.I.*, 62
Downs, Joseph, 124; *Amer. Furniture*, 119
Dresser, Louisa, *XVIIth Century Painting*, 27, 83; *Early N.E. Printmakers*, 105
Drury, John, *Historic Midwest Houses*, 74
Dummer, Jeremiah, 129
Dunham, Azariah, 107
Dunlap, John, 113
Dunlap, William, 36; *History*, 26, 44
Dunlap family, 127
Du Simitière, Pierre Eugène, 89–90

E

Earl, Ralph, 84, 90
Early Amer. Embroideries in Deerfield, 142
Eberlein, Harold D., *Georgian Architecture*, 47–48; *Manors and Homes of Hudson Valley*, 63; *Manors and Homes of Long and Staten Islands*, 63
Eckhardt, George H., *Pa. Clocks*, 117
Egbert, Donald D., *Princeton Portraits*, 101
Eisen, Gustavus A., *Portraits of Washington*, 99
Eliot, Rev. John, 111
Elwell, Newton W., 37
Engravings and engravers, 82–83, 85, 103–8, 130
Ensko, Stephen G. C., *Amer. Silversmiths*, 128
Espinosa, José E., *Saints in the Valleys*, 138

Essex Co., Mass., architecture of, 47, 54, 59–61; artists and craftsmen of, 116
Essex Institute, 54; *Catalogue of Portraits*, 100; *Samuel McIntire*, 123
Evans, Charles, *American Bibliography*, 24, 108–9
Evans, Grose, *Benjamin West*, 96
Ewers, John C., "Charles Bird King," 91

F

Fabrics, 140–43
Fairman, Charles E., *Art and Artists of Capitol*, 67
Fales, Dean A., Jr., 123
Fales, Martha G., *Amer. Silver*, 17, 128
Farlow, Catherine H., *Mass. State House*, 61
Federal Art Project, 43
Feke, Robert, 5, 28, 81–82, 84, 90
Feld, Stuart P., "St. Michael's Church," 60
Fennelly, Catherine, *Textiles in New England*, 142
Fenton family, 135
Fielding, Mantle, *Thomas Sully*, 95; *Life Portraits of Washington*, 99–100; *Amer. Engravers*, 105
Fisher, George B., 80
Fleming, E. McClung, ix
Flexner, James T., "Robert Feke," 5; *First Flowers*, 83; *Old Masters*, 83; *Light of Distant Skies*, 84; *John Singleton Copley*, 88; *Gilbert Stuart*, 94
Florida, architecture of, 73
Floyd, Olive, *Decorated Tinware*, 135
Foley, Suzanne, "Christ Church, Boston," 60
Folk art, 138–40
Foote, Henry W., *John Smibert*, 28, 94; *Robert Feke*, 28, 90; "Joseph Blackburn," 87–88; *Catalogue of Portraits*, 100; *Jeremiah Dummer*, 129
Forbes, Esther, *Paul Revere*, 130
Forbes, Harriette M., "Early Portrait Sculpture," 102; *Gravestones of Early N.E.*, 102
Forbes, J. D., 149

Ford, Alice, *Edward Hicks*, 138–39
Ford, Paul Leicester, 37; *Journals of Hugh Gaine*, 109
Ford, Worthington C., 37; *Letters and Papers of J. S. Copley*, 88–89; *Boston Book Market*, 109; *Broadsides*, 109
Forgeries, 29–30
Forges and furnaces, in N.J., 133; in Saugus, Mass., 134
Forman, Henry C., *Architecture of Old South*, 68
Foster, John, 105, 111
Foster family, 102
Fox, Sir Cyril, *Personality of Britain*, 22
Fox, Dixon Ryan, *History of Amer. Life*, 41
Fox, Justus, 114
France, and Amer. colonization, 44
Frankfurter, Alfred M., 146
Franklin, Benjamin, 37, 97
Franklin, N. H., 61
Frary, I. T., *They Built Capitol*, 68; *Early Homes of Ohio*, 74
Fraser, Charles, *Charleston Sketchbook*, 79
Frazee, John, 103
French, Hannah D., "Andrew Barclay," 114; "Early Amer. Bookbinding," 114
French, Hollis, *Jacob Hurd*, 130
French Canada. *See* Canada
Frick Art Reference Library, 24
Frontier fallacy, 7–8
Fulton, Robert, 27, 38, 82, 84
Furniture, 119–27. *See also* Chairs

G

Gaine, Hugh, 109, 110
Gaines family, 127
Gales, Joseph, 113
Gallagher, H. M. P., *Robert Mills*, 55
Gardner, Albert TenEyck, *Yankee Stonecutters*, 102–3
Garrett, Wendell D., *Apthorp House*, 61
Garvan, Anthony N. B., 48, 63, 145; *Architecture and Town Planning*, 62
Georgia, architecture of, 73; artists

of, 96; book trade in, 110; silversmiths of, 131
Gerdts, William H., *Classical Amer.*, 46; *Survey of Amer. Sculptures*, 103
Gibbons, Mary, "Changing Face of Princeton," 64
Gibbs, James, 6
Gilchrist, Agnes A., *William Strickland*, 55
Gjessing, Frederik C., "Evolution of Oldest House," 73
Glass and glassmaking, 136–37, 148
Glass Club Bulletin, 148
Glen, James, 111
Glover, Rev. Joseph, 111
Goddard, Mary Katherine, 113
Goddard, William, 111, 113
Godefroy, Eliza, 52
Godefroy, Maximilian, 52
Gold and goldsmiths, 133
Goodrich, Lloyd, 145
Goodspeed, Charles E., Dunlap's *History*, 44
Gottesman, Rita S., *Arts and Crafts*, 117
Gould, Mary E., *Tin and Tole Ware*, 134; *Wooden Ware*, 134
Gowans, Alan, ix, x, 8, 10; *Images*, 26, 44–45; *Church Architecture*, 55–56; *Looking at Architecture*, 56; "New England Architecture in Nova Scotia," 56; *Architecture in New Jersey*, 64
Graphic arts, 103–14
Gravestones, 102, 139–40, 143
Great Britain, architectural and topographical studies in, 20–22
Great Lakes, maps of, 105
Great Seal of the United States, 115
Greiff, Constance, "Changing Face of Princeton," 64
Green, Andrew H., 144
Green, Bartholomew, 111
Green, Constance McL., *Washington*, 79
Green, Frederick, 113
Green, Rosalie B., 147
Green, Samuel, 111, 113
Green, Samuel A., *John Foster*, 105
Green, Timothy, 111
Greenwood, John, 90
Griffin, Gillett, 105
Grigaut, Paul L., 44, 147–48

Grigg, Milton, 54
Groce, George C., *Dictionary of Artists*, 84
Gullager, Christian, 27
Gutmann, Joseph, "Jewish Participation," 45
Guy, Edward, 121
Guyol, François, 27

H

Hadley chests, 125
Hagen, Oskar, *Birth of Amer. Tradition*, 84
Haidt, John Valentine, 90–91
Hall, Edward H., *Hudson-Fulton Celebration*, 39
Hall, Virginius C., Jr., "Patrick Henry," 97
Halsey, R. T. H., 39; *Handbook of American Wing*, 40, 120
Hamilton, Alexander, 37, 97
Hamilton, Elizabeth Schuyler, 97
Hamilton, Sinclair, *Amer. Book Illustrators*, 106–7
Hamlin, Talbot, *Greek Revival Architecture*, 48; *Latrobe*, 54
Hammond, John M., *Colonial Mansions*, 67
Harbeson, Georgiana B., *Amer. Needlework*, 142
Harrison, Peter, 52, 61
Hart, Charles H., 36–37, 38; *Browere's Life Masks*, 103
Hartley, E. N., *Ironworks on the Saugus*, 134
Harvard Guide to Amer. History, 29
Harvard University, early buildings of, 61; early views of, 78; portrait collection of, 101; catalogue of decorative arts of, 120
Harvey, John, 13
Haskell, Daniel C., *Amer. Historical Prints*, 107
Hawks, John, 71
Hay, Ian, *Scottish Architecture*, 10
Hayes, James, Jr., 113
Hayes, John, 113
Hayward, Arthur H., *Colonial Lighting*, 137
Hebard, Helen B., *Early Lighting*, 137
Hebert-Stevens, François, 76

Hedlund, Catherine A., *Primer of N.E. Crewel Embroidery*, 142
Hemphill, John M., *The Bookbinder*, 114
Henkels, S. V., 94
Henry, Patrick, 97
Heraldic devices, 114–16
Heriot, George, 80
Hesperia, 16
Heuvel, Johannes, *The Cabinetmaker*, 125
Heyl, John K., 65
Hiatt, Lucy F., *Silversmiths of Ky.*, 132
Hiatt, Noble W., *Silversmiths of Ky.*, 132
Hicks, Edward, 138–39
Hildeburn, Charles R., *Printers and Printing*, 110
Hill, John, 27
Hill, Samuel, 105
Hipkiss, Edwin J., *Eighteenth-Century Amer. Arts*, 120; *Spalding Collection*, 128
Historical editing, 12, 37
Historical Manuscript Commission, 25
Historical Society of Delaware, 125
Historical Society of Pennsylvania, 95, 101
Historic American Buildings Survey, 21–22, 24, 25, 48, 59
Historic Philadelphia, 65
Historic Preservation, 148
History of American Life series, 41
Hitchcock, Henry-Russell, *Architectural Books*, 48
Hitchings, Sinclair H., *Mass. State House*, 61
Hodge, Abraham, 112
Holman, Richard B., 105
Holt, John, 110
Honeyman, Robert B., Jr., 79
Hoopes, Penrose R., *Conn. Clockmakers*, 117; *Shop Records of Daniel Burnap*, 117
Hope, Thomas, 122
Hornor, William MacP., Jr., *Blue Book*, 125
Hoskins, W. G., *Making of the English Landscape*, 22
Houdon, Jean Antoine, 103
Howells, John Mead, *Architectural*

Heritage of Piscataqua, 58; *Architectural Heritage of Merrimack*, 61

Howland, Garth A., "John V. Haidt," 90–91

Howland, Richard H., *Architecture of Baltimore*, 67

Hudson, J. Paul, 69

Hudson-Fulton Celebration of 1909, 38–39

Hudson River Valley, school of landscape artists, 45; architecture of, 63–64

Hull, John, 129

Hulton, Paul, *Amer. Drawings of John White*, 96

Hummel, Charles F., Jr., ix

Hunter, Dard, *Papermaking*, 110

Huntsinger, Laura M., *Harvard Portraits*, 101

Hurd, Benjamin, 130

Hurd, Jacob, 130

Hurd, Nathaniel, 105, 130

Huth, Hans, "Du Simitière," 89

Hyder, Darrell, "Phila. Fine Printing," 110

I

Illinois, architecture of, 75

Indiana, architecture of, 74–75; painters in, 85–86

Indiana Historical Society, 74–75

Indians, 45; and Southwest architecture, 78; King's portraits of, 91; and Ohio Valley maps, 104

Ingerman, Elizabeth A., 23, 25

Iñiguez, Diego Angulo, *Arte hispano-americano*, 77

Innes, Lowell, *Early Glass*, 136

Inventories, household, 43

Ironwork, 133–35, 139–40

Irving, Washington, 145

Isham, Norman M., *Early Amer. Houses*, 48; *Glossary*, 48

J

Jackson, Russell Leigh, 100

Jacquemart, Jules, 115

Jamestown, Va., 69

Janson, H. W., 147

Jarvis, John Wesley, 91

Jay, William, 73

Jefferson, Thomas, as architect, 6, 30, 52–54; portrait check list of, 37; and Robert Mills, 55; and planning of Washington, 80; portraits of, 93, 97–98; and medals, 115

Jennings, Samuel, 5

Jennys, Richard, 91

Jesuits, in French Canada, 42–43

Jews, and the arts, 45; miniatures of, 85

Johns Hopkins University, 104

Johnson, Marmaduke, 111

Johnson, Thomas, 98

Johnson, Williams, 134

Johnston, Frances B., *Early Architecture of N.C.*, 71–72; *Early Architecture of Ga.*, 73

Johnston, Henry P., 37

Johnston, James, 110

Johnston, John, 27, 82

Jones, E. Alfred, *Old Silver*, 128

Jones, Guernsey, *Letters and Papers of J. S. Copley*, 88–89

Jones, Howard Mumford, *O Strange New World*, 45

Journal of Glass Studies, 148

Journal of Society of Architectural Historians, 149

Jusserand, J. J., 79

K

Karolik Collection, 86, 120

Karpinski, Louis C., *Early Maps of Carolina*, 105; *Printed Maps of Michigan*, 105

Kaser, David, *Joseph Charless*, 110

Kauffman, Henry J., *Amer. Copper, Tin, and Brass*, 134; *Pa. Dutch Amer. Folk Art*, 139

Keith, Elmer D., "Peter Banner," 62

Keith, Robert, 112

Kelly, J. Frederick, *Early Conn. Meetinghouses*, 62; *Early Domestic Architecture*, 63

Kendall, Henry P., 105

Kentucky, architecture of, 73–74; silversmiths of, 132

Kerfoot, J. B., *Amer. Pewter*, 133

Kettell, Russell H., *Early Amer. Rooms*, 49; *Pine Furniture*, 28, 125

Keyes, Homer Eaton, 146; and *Antiques* magazine, 40

Kidder, Mary H., *Anson Dickinson*, 89
Kilham, Walter H., *Boston After Bulfinch*, 61
Kimball, Fiske, 123; *Domestic Architecture*, 49; *Thomas Jefferson*, 53; *Samuel McIntire*, 54; "Life Portraits," 98
King, Charles Bird, 27, 91
King, Samuel, 27
Kirker, Harold, *Bulfinch's Boston*, 51; *Calif.'s Architectural Frontier*, 77
Kirker, James, *Bulfinch's Boston*, 51
Kite, Elizabeth S., *L'Enfant and Washington*, 79
Klapper, August, *The Printer*, 110
Knittle, Rhea M., *Ohio Silversmiths*, 132
Knox, Katharine McCook, *The Sharples*, 94
Kouwenhoven, John A., *Columbia Historical Portrait*, 79
Kubler, George, *Art and Architecture*, 77; *Religious Architecture*, 77–78
Kuder, Solomon, 143

L

Labaree, Benjamin W., 123
Laing, Alan K., 149
Lambeth, William A., *Thomas Jefferson*, 53
Lamson family, 102
Lancaster, Clay, 145; "Oriental Forms," 5
Lancaster, Robert A., Jr., *Historic Va. Homes*, 69
Lancour, Harold, *Auction Catalogues*, 45
Lane, William C., *A.L.A. Portrait Index*, 84
Langworthy, Edward, 113
Lannuier, Honoré, 126
Lapham, Samuel, Jr., 72
Larkin, Oliver W., 123, 145; *Art and Life*, 45
Latrobe, Benjamin Henry, 54; *Anniversary Oration*, 26; and apprentices, 55; and planning of Washington, 80
Laughlin, Ledlie I., *Pewter in Amer.*, 133

Lawrence, Alexander A., *James Johnston*, 110
Lawson, Alexander, 27
Lea, Zilla R., *Ornamental Chair*, 120
Lee, Cuthbert, *Portrait Painters*, 84
Lee, Ruth W., *Sandwich Glass*, 136
Le Gear, Clara E., *U.S. Atlases*, 105–6
Leiding, Harriette K., *Historic Houses*, 72
L'Enfant, Pierre Charles, 27, 79–80
Leoni, Giacomo, 6
Lester, C. Edwards, 36
Lethaby, W. R., 13
Lewis, Benjamin M., *Engravings in Amer. Magazines*, 106
Library of Congress, measured architectural drawings in, 21–22, 48; Copley Papers of, 88; list of atlases in, 105–6; maps in, 106
Lichten, Frances, *Folk Art of Rural Pa.*, 139
Lighting devices, 137, 150
Lincoln, Thomas, 122
Lindsay, J. Seymour, *Iron and Brass Implements*, 134
Lipman, Jean, 143; *Amer. Folk Art in Wood*, 139; *Primitive Painters*, 139; *Primitive Painting*, 139
Little, Bertram K., 149
Little, Frances, *Early Amer. Textiles*, 142
Little, Nina Fletcher, 123; *Decorative Wall Painting*, 138; *Abby Aldrich Rockefeller Collection*, 139–40; *Country Art*, 140
Littlefield, George E., *Early Mass. Press*, 110–11
Liverpool Public Museums, 116
Lockwood, Luke V., *Colonial Furniture*, 120–21; *Furniture Collectors' Glossary*, 121
London, Hannah R., *Miniatures*, 85
London County Council, 21
Long Island, N.Y., architecture of, 63
Loubat, J. F., *Medallic History*, 115
Lovejoy, David S., 145
Lowell, Mass., architecture of, 59–60
Loyalists, Canadian architecture of, 56–57
Lubschez, Ben Judah, 72
Lunny, Robert M., *Maps of North America*, 106
Luther, Clair F., *Hadley Chest*, 125

M

McClelland, Nancy, *Duncan Phyfe*, 122; *Historic Wall-Papers*, 138
McClintock, Gilbert S., *Valley Views*, 79
McClure's Magazine, 37
McCorison, Marcus A., *Vermont Imprints*, 111
McCoubrey, John W., *Amer. Tradition*, 85
McCoy, Garnett, ix
McCulloch, William, 112
McDermott, J. F., 26
McInnes, Graham, *Canadian Art*, 85
McIntire, Samuel, 103; architecture of, 54; furniture of, 123
McKay, George L., *Register of Artists, Engravers*, 111
McKearin, George S., *Amer. Glass*, 136; *Amer. Blown Glass*, 136–37
McKearin, Helen, *Amer. Glass*, 136; *Amer. Blown Glass*, 136–37
MacRae, Marion, *Ancestral Roof*, 57
Madison, James, 98
Magazines, illustrated monthlies and decorative arts, 36; engravings in, 106
Maine, architecture of, 58
Malbone, Edward Greene, 82, 84, 92
Manhattan Island, N.Y., iconography of, 80
Manning, Warren H., *Thomas Jefferson*, 53
Maps, 103–8
Marblehead, Mass., St. Michael's Church, 60
Marceau, Henri, *Works of William Rush*, 103
Maritime Provinces, architecture of, 55–58
Maryland, architecture of, 50, 52, 55, 67; book trade in, 113, 114; arts and crafts in, 118
Massachusetts, architecture of, 47, 59–61; early portraiture of, 83; broadsides printed in, 109; book trade in, 110–11
Massachusetts Historical Commission, 22
Massachusetts Historical Society, 16; Jefferson's architectural drawings in, 17, 53
Massachusetts Spy, 112

Massey, James C., *Philadelphia Architectural Drawings*, 66
Mather, Increase, 98
Mather, William Gwinn, 98
Maverick family, 107
Medals and medallic portraits, 28, 99, 114–15
Mellon, Paul, 94
Mendelowitz, Daniel M., *History*, 45
Meng, John, 27
Mercator, 106
Mercer, Henry C., *Ancient Carpenters' Tools*, 118; *Bible in Iron*, 134–35
Meriden Gravure Company, picture books of, 16
Merrimack River, 59, 61
Metals, 133–35
Metropolitan Museum of Art, 44, 122, 141; opening of American Wing, 36, 38–40; *Annual Reports* of, 38; American Wing *Handbook*, 120
Mexico, 76–78
Michigan, architecture of, 75; maps of, 105
Middendorf, J. William, II, *Prints Pertaining to Amer.*, 106
Middle states, architecture of, 63–68
Middleton, John I., 27
Middleton, Margaret S., *Jeremiah Theus*, 95–96
Miller, V. Isabelle, *Furniture by N.Y. Cabinetmakers*, 126
Mills, Paul, *Early Paintings of Calif.*, 79
Mills, Robert, 55
Miner, Dorothy E., 104
Miner, Ward L., *William Goddard*, 111
Miniatures, 82, 85, 87, 92
Minnesota, architecture of, 75
Mission churches, 75–78
Missouri Gazette, 110
Mitchelson, David, 113
Monograph Series, 150–51
Montgomery, Charles F., viii, 119
Monticello, 6, 30, 52–54
Moravian Church, 91
Morgan, John H., "Joseph Blackburn," 87–88; *Gilbert Stuart*, 95; *Life Portraits of Washington*, 99–100

Morison, Samuel Eliot, "Old College at Harvard," 61

Morisset, Gérard, *Coup d'œil*, 45; *L'Architecture en Nouvelle-France*, 57; *Les arts au Canada Français*, 85

Morris, Frances, 141

Morris, Robert, 6

Morrison, Hugh, *Early Amer. Architecture*, 49

Morse, William I., *Land of New Adventure*, 57

Moulthrop, Reuben, 92

Mount, Charles M., *Gilbert Stuart*, 95

Mountfort family, 99

Mount Vernon, 99; silver of, 127

Mugridge, Donald H., *Amer. Battle Art*, 106

Munroe, John A., viii

Munsell, J., *Chronology of Paper*, 111

Murdock, Kenneth B., *Portraits of Increase Mather*, 98

Murtagh, William J., "Philadelphia Row House," 66

Museum of Fine Arts, Boston, 16, 86, 89; portrait exhibition, 100; Karolik Collection of, 120; silver exhibition, 127; Spalding Collection of silver, 128; Revere silver and portraits, 130

Museum of the City of New York, 126

Museum News, 144

Museums, 13–18

Myers, Myer, 130

N

Naeve, Milo M., ix

Nash, Ray, *Amer. Writing Masters*, 111

National Early American Glass Club, 148

National Gallery of Art, 43

National Library of Mexico, 77

National Maritime Museum, Greenwich, 116

National Museum of Canada, 43

National Park Service, 21–22, 65, 69, 75

National Society of Colonial Dames of America in Delaware, *Portraits in Del.*, 85

National Trust for Historic Preservation, 148

Navigating instruments, 116

Needlework, 140–43

Neuhaus, Eugen, *History and Ideals*, 85

Nevins, Allan, *Century of Political Cartoons*, 108

Newark Museum, *Amer. Folk Sculpture*, 103; *Early Furniture*, 126

Newcomb, Rexford, *Architecture in Old Ky.*, 73–74; *Architecture of the Old Northwest*, 75; *Old Mission Churches*, 78

New England, household inventories of, 43; architecture of, 58–63, 150–51; portraiture of, 83; stonecutters and gravestones of, 102, 143; engravers of, 105; maps of, 105; arts and crafts in, 117; pine furniture of, 125; ironworks of, 134; earthenware and potters of, 136; glass of, 136–37; lighting devices of, 137; country art of, 140; textiles of, 142–43

New France. *See* Canada

New Hampshire, architecture of, 48, 58, 61; furniture of, 126–27

New Hampshire Historical Society, 22

New Haven, Conn., 92; architecture of, 62. *See also* Yale University

New Jersey, architecture of, 64–65; maps of, 107; furniture of, 126; silversmiths of, 132; forges and furnaces of, 133; glass of, 137

New Jersey Historical Society, 106

New Mexico, architecture of, 76–78; religious folk images in, 138, 140

Newport, R.I., architecture of, 62; arts and crafts in, 124

New Spain. *See* Spanish Southwest

Newspapers, 108, 111, 112; advertisements of craftsmen in, 117–18

Newton, Roger H., "Bulfinch's Design for Library of Congress," 5

New York, architecture of, 63; portraiture of, 82; silversmiths and goldsmiths of, 82–83; arts and crafts in, 117; weaving in, 142; state parks and historic sites of, 144

New York City, Hudson-Fulton Celebration of, 38–39; American Academy of Design in, 42; views and maps of, 79–80; book trade in, 109–10, 111; cabinetmakers of, 126; silversmiths of, 127, 131

New-York Historical Society, Belknap Collection of, 82–83; *Dictionary of Artists*, 84; portrait collection of, 101

New York History, 144

New York Public Library, 108

New York State Historical Association, 144

Nichols, Charles L., *Isaiah Thomas*, 111

Nichols, Frederick D., ix; *Jefferson's Architectural Drawings*, 17, 30, 53; *Early Architecture of Ga.*, 73

Noël Hume, Ivor, ix, 23–24; *Here Lies Virginia*, 23, 69

Norfleet, Fillmore, *Saint-Mémin*, 93

Norman, John, 105

North Andover, Mass., Parson Barnard House, 32–33, 60

North Andover Historical Society, 32

North Carolina, architecture of, 71–72; maps of, 105; book trade in, 112–13; silversmiths of, 131

Northcott, Virginia W., "Alexander Hamilton," 97

Norton, Paul F., 149; "Latrobe and Dickinson College," 5

Norton family, 135

Nova Scotia, architecture of, 56–57

Nutting, Wallace, *Furniture of Pilgrim Century*, 121; *Furniture Treasury*, 121

Nye, Russel Blaine, *Cultural Life*, 46

O

Oakland Art Museum, 79

O'Connor, William Van, 145

Oglethorpe, James E., 78–79

Ohio, architecture of, 74–75, 83; artists of, 83; silversmiths of, 132

Ohio Valley, early maps of, 104

Old Northwest, architecture of, 74–75

Old Ship Church, Hingham, Mass., 9, 59

Old Sturbridge Village, 16, 17

Old-Time New England, 38, 149

Oliver, Andrew, ix, 18; *Faces of a Family*, 98

Oliver family, 98

O'Neal, William B., *Checklist*, 53; *Jefferson's Building*, 53–54; *Jefferson's Fine Arts Library*, 54

Ontario, Canada, architecture of, 57

Ormsbee, Thomas H., 145; *Amer. Furniture Makers*, 121–22

Oswald, Eleazar, 113

P

Padover, Saul K., *Thomas Jefferson and National Capitol*, 80

Painting and painters, 20, 27–28, 81–102, 138–40

Palardy, Jean, *Early Furniture of French Canada*, 126

Palmer, Brooks, *Book of Amer. Clocks*, 118

Papermaking, 110, 111, 113

Papworth, Wyatt, 13

Paris, France, 82

Park, Helen, "Architectural Books," 49

Park, Lawrence, "Joseph Badger," 87; "Joseph Blackburn," 88; *Gilbert Stuart*, 95

Parker, Barbara N., "Robert Feke," 5; *Belknap Collection*, 82–83; *John Singleton Copley*, 89

Parker family, 110

Parslow, Virginia D., *Weaving and Dyeing*, 142

Parsons, John Fitch, 124

Payne, Elizabeth H., *Pitts Family Portraits*, 98–99

Peabody Institute Library, 104

Peabody Museum of Salem, publications of, 12–13; Saltonstall portraits in, 99; *Portraits of Shipmasters and Merchants*, 101; navigating instruments collection, 116

Peachey, James, 80

Peale, Charles Willson, 27, 82, 83, 84, 93, 99; biography and list of works, 92

Peale, James, 27, 84

Peale, Rembrandt, 27

Peale, Titian, 92–93

Peale Museum, 67

Pearce, Mrs. John N., 68

Peat, Wilbur D., *Indiana Houses*, 75; *Portrait Painters*, 85–86
Pelham, Henry, 27
Pelham, Peter, 105
Pencil Points, 151
Pennsylvania, architecture of, 55, 65–67; prints and paintings in, 79; clocks and clockmakers in, 117
Pennsylvania Germans, 65; tombstones of, 102; bookplates of, 104; fraktur-writings of, 112; ironwork of, 134–35; folk art of, 139–40; textiles of, 143
Perkins, Augustus T., *John Singleton Copley*, 89
Peterson, Charles E., 149; "Notes on Old Cahokia," 75
Peticolas, Philippe A., 27
Peto, Florence, *Amer. Quilts and Coverlets*, 142
Pewter and pewterers, 133, 149–50
Pewter Collectors' Club of Amer., *Bulletin*, 149–50
Pfeiffer, Gladys, *America's Fabrics*, 141
Philadelphia, Pa., Centennial Exposition in, 36, 43; and Quaker esthetic, 46; Independence Hall, 47, 65; architecture of, 55, 65–67; Germantown, 66; Du Simitière's museum in, 89–90; book trade in, 109–10; bookbinding in, 114; clockmakers of, 117; arts and crafts in, 118; furniture of, 125; silversmiths of, 130–31
Phillips, John M., 127; *Belknap Collection*, 82–83; *Yale Univ. Portrait Index*, 102; *Amer. Silver*, 128; *Early Amer. Silver*, 128–29
Phillips, P. Lee, *Maps of Amer. in Library of Congress*, 106
Phyfe, Duncan, 122, 126
Pierce, Richard, 111
Piscataqua River, 58
Pittsburgh, Pa., early glass of, 136
Pitts family, 98–99
Place, Charles A., *Charles Bulfinch*, 51
Poesch, Jessie, *Titian Ramsay Peale*, 92–93
Porter, A. Kingsley, *Spanish Romanesque Sculpture*, 28
Portrait painting, 81–102; by subjects, 97–100; institutional collections of, 100–102
Portsmouth, N.H., 90; architecture of, 58; cabinetmaking in, 126–27
Pottery and potters, 135–36, 139–40
Potts, William J., "Du Simitière," 89–90
Powers, Beatrice F., *Decorated Tinware*, 135
Pratt, Matthew, 84, 93
Prime, Alfred Coxe, *Arts and Crafts*, 118
Prince, Samuel, 126
Princeton, N.J., architecture of, 64–65
Princeton University, portrait collection of, 101
Princeton University Library, *Amer. Book Illustrators*, 106–7
Printer, James, 111
Printing and printers, 24, 108–14
Prints and printmakers, 103–8
Providence, R.I., Old Baptist Church, 48; Athenaeum, 55; architecture of, 61–62
Prown, Jules, ix, 89
Public Record Office, London, Copley Papers in, 89

Q

Quakers, and the arts, 26, 46
Quebec, Canada, architecture of, 57–58; silver of, 132; textiles of, 140–41
Quebec, Historic Monuments Commission, *Old Manors*, 57; *Les vieilles églises*, 57
Quinn, David B., *Amer. Drawings of John White*, 96
Quynn, Dorothy M., "Godefroy," 52

R

Radoff, Morris L., *Buildings of State of Md.*, 67
Ramsay, John, *Amer. Potters*, 135
Randall, Richard H., Jr., "Seymour Furniture," 123; "Boston Chairs," 126; *Decorative Arts of N.H.*, 126–27
Ravenel, Beatrice St. J., *Architects of Charleston*, 14, 72

Rawlings, James S., *Va.'s Colonial Churches*, 69–70
Reath, Nancy A., *Weaves of Hand-Loom Fabrics*, 143
Reed, Henry H., *Amer. Skyline*, 80–81
Reinert, Guy F., *Coverlets of Pa. Germans*, 143
Remick, Christian, 93
Revere, Paul, 105, 130; house of, 31–32; engravings by, 104
Reynolds, Helen W., *Dutch Houses*, 63
Rhode Island, architecture of, 61–62; book trade in, 109
Rice, Howard C., Jr., ix; edition of Chastellux by, 30; "Saint-Mémin," 93; *N.J. Road Maps*, 107
Rice, Norman S., *Albany Silver*, 132
Richardson, Edgar P., viii, ix, x, 7–8, 10, 147; *Painting in Amer.*, 86; *Romantic Painting*, 86; *Washington Allston*, 87
Richmond, Va., architecture of, 70
Riley, Phil M., *Samuel McIntire*, 54; *Colonial Architecture of Salem*, 60; *Colonial Architecture of Phila.*, 65
Ringe, Donald A., 145
Ripley, S. Dillon, 15
Rivington, James, 110
Robacker, Earl F., *Pa. Dutch Stuff*, 140
Robertson, Archibald, 27
Robertson, James and Alexander, 110
Robertson, Walter, 27
Rockefeller, John D., Jr., 31
Roe, F. Gordon, *Windsor Chairs*, 122
Rogers, Bruce, 98
Rogers, Meyric R., 128, 144; *Interior Design*, 46
Rose, Harold W., *Colonial Houses of Worship*, 49
Rosenbaum, Jeanette, *Myer Myers*, 130
Roos, Frank J., Jr., *Writings*, 49–50
Rossiter, Henry P., *Karolik Collection*, 86
Roy, Antoine, *Lettres, sciences, arts*, 46
Roy, Pierre-Georges, 57
Royal Commission on Historical Monuments, 20–21, 22
Royal Ontario Museum, 80

Rush, William, 102–3
Rushlight, 150
Rushlight Club, 137, 150
Rutledge, Anna W., *Artists in Life of Charleston*, 86

S

Sack, Albert, *Fine Points*, 122
St. Augustine Historical Society, 73
Saint-Mémin, C. B. J. Fevret de, 82, 93–94, 99
Sale, Edith T., *Interiors of Va. Houses*, 70
Salem, Mass., 90; architecture of, 54, 60
Salem East India Marine Society, 116
Saltonstall, Senator Leverett, 99
Saltonstall family, 99
Samford, C. Clement, *The Bookbinder*, 114
Samplers, 141
Sandwich glass, 136
Sanford, Trent E., *Architecture of the Southwest*, 78
San Francisco, Calif., architecture of, 76
Sargent, Henry, 27
Savage, Henry L., *Nassau Hall*, 65
Savannah, Ga., 73, 78–79
Sawitzky, Susan, "Reuben Moulthrop," 92
Sawitzky, William, 95; *Ralph Earl*, 90; "Reuben Moulthrop," 92; *Matthew Pratt*, 93; *Catalogue, Historical Soc. of Pa.*, 101
Scarff, John H., *William Buckland*, 50
Schimmel, Mr., 103
Schlesinger, Arthur M., *History of Amer. Life*, 41
Schwartz, Marvin D., ix
Scotland, architecture of, 10
Scott, Mary Wingfield, *Houses of Old Richmond*, 70
Scully, Vincent J., Jr., *Architectural Heritage of Newport*, 62
Sculpture, 102–3
Sellers, Charles C., ix, 27–28; *Benjamin Franklin*, 18, 97; *Amer. Colonial Painting*, 82; *Charles Willson Peale*, 92; *Portraits and Miniatures*, 92
Serial publications, 143–51

Sewall, Samuel, 111
Seymour, George D., "Henry Caner," 51–52
Seymour, John and Thomas, 123
Shakers, furniture of, 119; architecture of, 143
Sharples, James, 82
Sharples family, 94, 99
Shelburne Museum, 118
Shelley, Donald A., *Catalogue of Portraits, N.Y. Historical Society*, 101; *Fraktur-Writings*, 112
Sheppard, Dr. Francis, 21
Sherman, Frederic F., *Richard Jennys*, 91
Shipcarvers, 102
Shipton, Clifford K., viii; Evans microcard edition of, 24; *Isaiah Thomas*, 112
Shurtleff, Harold R., *Log Cabin Myth*, 50
Silver and silversmiths, 82–83, 127–32
Simon, Grant M., *Historic Germantown*, 66
Simons, Albert, 72
Singleton, Esther, 146; *Furniture of Our Forefathers*, 122
Sinnott, Edmund W., *Meetinghouse and Church*, 50
Sizer, Theodore, "Col. John Trumbull," 5; *Autobiography of Trumbull*, 96; *Works of Trumbull*, 96
Skillin family, 102
Smibert, John, 28, 81–82, 94, 99
Smibert, Nathaniel, 94
Smith, Alice R. H., *Dwelling Houses*, 72
Smith, Frances R., *Architectural History*, 78
Smith, George, 122
Smith, Priscilla, *Early Maps of Carolina*, 105
Smith, Robert C., "Jennings's Liberty," 5
Smithsonian Institution, viii, 15, 25; *Adams-Clement Collection*, 97
Society for the Preservation of New England Antiquities, 23, 38, 43, 141, 149
Soderholtz, E. E., 37
Sommer, Frank H., III, ix, "Emblem and Device," 115

Sonn, Albert H., *Amer. Wrought Iron*, 135
Soria, Martin, *Art and Architecture*, 77
South Carolina, architecture of, 72; early watercolors of, 79; artists of, 95–96; maps of, 105; arts and crafts in, 118; silversmiths of, 131
Southeastern North America, maps of, 104
Southern states, architecture of, 68–74
Sower, Christopher, Jr., 114
Spanish Southwest, architecture of, 44–45, 75–78
Spargo, John, *Potters and Potteries of Bennington*, 135–36
Spawn, Willman, "Aitken Shop," 114
Speare, Eva A., *Colonial Meeting-Houses*, 58
Spencer, Eleanor P., *Architecture of Baltimore*, 67
Spendlove, F. St. G., *Face of Early Canada*, 79–80
Sprats, William, 55
Staten Island, N.Y., architecture of, 63
Stauffer, David McN., 105; *Amer. Engravers*, 107
Stearns, Martha G., *Homespun and Blue*, 143
Steere, Richard, 111
Stephens, Stephen DeWitt, *The Mavericks*, 107
Steuart, Andrew, 112
Stiegel glass, 137, 139
Stockton, Richard, 64
Stokes, I. N. P., *Iconography*, 18–19, 80; *Amer. Historical Prints*, 107
Stonecutters, 102, 139–40
Stoneman, Vernon C., *John and Thomas Seymour*, 123
Stoney, Samuel G., *This Is Charleston*, 14, 72; *Plantations*, 72
Stoudt, John J., *Pa. Folk-Art*, 140
Stow, Charles M., 146
Strickland, William, 55
Stuart, Gilbert, 83, 84, 94–95, 99
Sturbridge Village, Mass., 136, 137, 140, 142
Suffield, Conn., furniture of, 123–24
Suffolk County Registry of Probate, 43
Sully, Thomas, 95

Summerson, Sir John, 21
Survey of London, 20–21
Sutton, Walter, *Western Book Trade*, 112
Swan, Abraham, *The British Architect*, 48
Swan, Mabel Munson, 123
Sweeney, John A. H., ix; *Grandeur on the Appoquinimink*, 67

T

Taft, Lorado, *History of Amer. Sculpture*, 103
Tallmadge, Thomas E., *Architecture in Old Chicago*, 75
Tatum, George B., 64, 145; *Penn's Great Town*, 66
Tebout, Tunis, 134
Textiles, 140–43
Theus, Jeremiah, 95–96
Thomas, Isaiah, 111–12; *History of Printing*, 112
Thomas Jefferson Memorial Foundation, *Monticello Family*, 98
Thompson, Edmund, *Maps of Conn.*, 108
Thomson, Charles, 115
Thornton, William, 80
Thwing, Leroy, *Flickering Flames*, 137
Ticknor, George, 10
Tin and tinsmiths, 134–35
Tinkcom, Harry M., *Historic Germantown*, 66
Tocqueville, Alexis C. H. C. de, 26
Tolles, Frederick B., viii, 26; "Of the Best Sort," 46
Tolman, Ruel P., *Edward G. Malbone*, 92
Tombstones, 102, 139–40
Tools, woodworking, 118
Topography, 78–81
Town planning, 62, 78–81
Towner, Lawrence W., viii, 14
Tracy, Berry B., *Classical Amer.*, 46
Traquair, Ramsay, *Old Architecture*, 57–58; *Old Silver*, 132
Traveller's Directory (1804), 107
Tremaine, Marie, "Canadian Life and Print," 112
Truett, Randle B., *Monticello*, 54
Trumbull, John, 5, 27, 82, 84, 96
Tryon, Gov. William, 71

Tuckerman, Henry T., 36
Tunnard, Christopher, *Amer. Skyline*, 80–81
Turner, Frederick Jackson, 41
Turner, James, 105
Tweed, William Marcy, 122

U

United States Capitol Historical Society, *We, the People*, 68
University of Virginia, 53–54; museum exhibition on Jefferson, 97–98
University Press of Virginia, 28

V

Valentine Museum of Richmond, 70, 101–2
Valentiner, W. R., 147
Vanderlyn, John, 82
Van Nostrand, Jeanne, *Calif. Pictorial*, 81
Vaughan, Malcolm, 144, 145
Vermont, architecture of, 59; book trade in, 111
Victoria County Histories, 25
Virginia, architecture of, 10, 47, 50, 52–54, 68–71; portraiture of, 86; St.-Mémin in, 93; silversmiths of, 131
Virginia Gazette, 110
Virginia Historical Society, portrait collection of, 100–101

W

Wainwright, Nicholas B., *Colonial Grandeur*, 66–67
Wallace, David H., *Dictionary of Artists*, 84
Wall decoration, 138
Wallis, Frank E., 37
Walpole Society, 17; print exhibition of, 106
Walsh, Richard, *Charleston's Sons of Liberty*, 118
Walters Art Gallery, 104
Waring, Janet, *Amer. Stencils*, 138
Warner family, 99
Warren, William L., "William Sprats," 55; "Peter Banner," 62
Washburn, Wilcomb W., viii, x; on role of Smithsonian Institution, 25

Washington, George, 80, 94, 99–100, 127

Washington, D.C., 51, 67–68, 79–80, 91

Waterman, Thomas T., *Dwellings*, 50; *Domestic Colonial Architecture*, 70; *Mansions*, 70; *Early Architecture of N.C.*, 71

Watkins, Lura W., *N.E. Potters*, 23, 136; *N.E. Pottery*, 136; *Amer. Glass*, 137

Watkins, Walter K., "John Coles," 88

Weaving, 141–43

Weddell, Alexander W., *Va. Historical Portraiture*, 86; *Portraiture in Va. Historical Soc.*, 100–101

Weeks, Stephen B., *Press of N.C.*, 112–13

Wehle, Harry B., *Amer. Miniatures*, 87

Weis, Frederick L., *Checklist of Portraits*, 100

Weitenkampf, Frank, *Amer. Book Illustrators*, 106–7; *Century of Political Cartoons*, 108; *Political Caricature*, 108

Wenham, Edward, 146

West, Benjamin, 5, 82, 83, 84, 96

Western Reserve, 74

Wharton, Francis, 37

Wheeler, Anne B., *John Singleton Copley*, 89

Wheeler, Joseph T., *Maryland Press*, 113

Whiffen, Marcus, *Eighteenth-Century Houses*, 18, 71; *Public Buildings*, 18, 71; "Early County Courthouses," 71

White, John, 96

White, Margaret E., 126

White, Robert L., 145

Whitehead, Russell F., 150–51

Whitehill, Walter Muir, 101; *Boston*, 19, 81

White House Historical Assoc., *White House*, 68

White Pine Series, 150–51

Whitley, William T., *Gilbert Stuart*, 95

Whitney Museum of American Art, 90

Wilder, Mitchell A., *Santos*, 140

Wildung, Frank H., *Woodworking Tools*, 118

William and Mary. *See* College of William and Mary

Williams, Carl M., *Silversmiths of N.J.*, 132

Williamsburg, Va., excavations in, 23–24, 69; architecture of, 31, 70–71; printers of, 110; bookbinders of, 114; cabinetmakers of, 125; silversmiths of, 132. *See also* College of William and Mary; Colonial Williamsburg

Williamson, Scott G., *Amer. Craftsman*, 119

Wilson, Kenneth M., *Glass in N.E.*, 137

Winchester, Alice, 146; *Primitive Painters*, 139

Winship, George P., *Cambridge Press*, 113

Winslow, Ola Elizabeth, *Amer. Broadside Verse*, 113

Winterthur Museum, viii, ix, 16, 17, 119; Downs Manuscript Library, 23, 25; print exhibition of, 106; silver of, 128

Winterthur Portfolio, 151

Wisconsin, architecture of, 75

Wood-carving, 139–40

Wooden ware, 133–34

Woodworking tools, 118

Woolfenden, William E., ix

Worcester Art Museum, 83, 90, 105

Wren, Sir Christopher, 70

Wright, Joseph, 82, 84

Wright, Louis B., *Cultural Life*, 47

Wright, Patience, 82, 103

Wroth, Lawrence C., *Colonial Printer*, 28, 113; "First Work with Amer. Types," 113–14; *Printing in Colonial Md.*, 114; *Abel Buell*, 129

Wyoming Historical and Geological Society, 79

Y

Yale University, 51–52; early buildings of, 62; portrait collection of, 102; Garvan Collection of silver, 128–29

Z

Zenger, John Peter, 110

Zieber, Eugene, *Heraldry*, 115–16